German and Netherlandish Sculpture

1280-1800

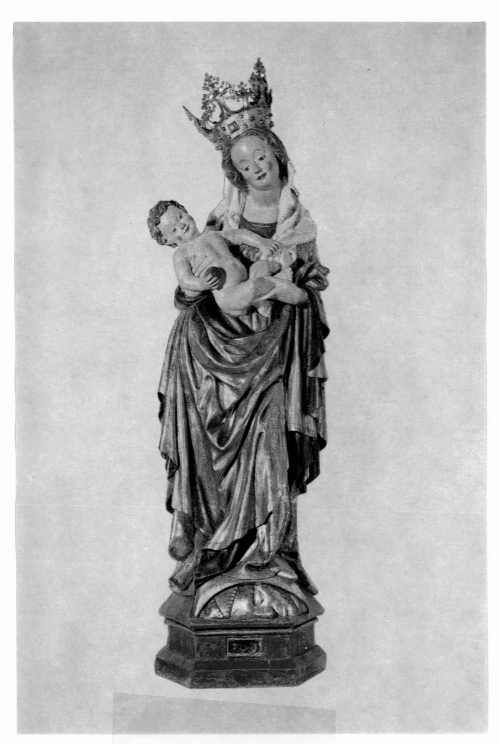

Madonna and Child, Tyrolese, c. 1430
(Cat. no. 9)

German and Netherlandish Sculpture

1280-1800

The Harvard Collections

By

Charles L. Kuhn

HARVARD UNIVERSITY PRESS · CAMBRIDGE · MASSACHUSETTS · 1965

Distributed in Great Britain by Oxford University Press, London

Publication of this volume has been aided by a grant from the Ford Foundation

Typography by Burton Jones

Text printed by Harvard University Printing Office, Cambridge, Massachusetts

Illustrations printed by W. S. Cowell Ltd., Ipswich, England

Bound by Stanhope Bindery, Boston, Massachusetts

Library of Congress Catalog Card Number: 65–19824

Preface

THE works of sculpture treated in this catalogue are in the collections of the Fogg Art Museum and the Busch-Reisinger Museum, each a part of Harvard University and dedicated to assembling objects pertinent to its program of instruction. For this reason, some items of interest principally as teaching pieces and having but slight artistic merit have been acquired. Since a catalogue in order to be useful should be complete, all works of sculpture are included regardless of quality and irrespective of their material. In addition to objects carved in stone and wood or cast in bronze, the reader will find works in ivory, beaten copper, gilded silver, and even plaster. The only pieces of sculptural interest that have not been catalogued are the porcelain figures of the eighteenth century. These cannot logically be treated apart from porcelain tableware. A separate publication of eighteenth-century porcelains in the University collections is contemplated for the future.

Most of the sculpture here described is German or Austrian in origin. The works produced in Belgium and Holland have been included because, during the period under consideration, the Low Countries played a vital role in the development of Central European art. This vast geographic area, although today divided by many political boundaries, since the early Middle Ages has been a cohesive cultural unit. Since a catalogue of modern German art at Harvard was published in 1957, the present volume deals with sculpture to the end of the eighteenth century.

Although the bibliography of German sculpture is extensive, very little has been published in English. Therefore an introductory essay has been prepared for the non-specialist. The selected bibliography that follows consists of publications of a general nature chosen for the importance of their content or for their illustrative material. More specific bibliographical references are given in the catalogue itself.

Catalogue entries are arranged as far as possible in chronological order. The sequence of the plates, however, has been dictated by art-historical and aesthetic considerations. Each entry contains an attribution note and, in some instances, a short essay dealing with special aspects of the work under discussion.

The publication of a catalogue of the University collections of German and Nether-

landish sculpture was first suggested to me by Professor Theodor Müller, Director of the Bavarian National Museum in Munich. It is a great pleasure to acknowledge his constant help and his valuable ideas with regard to many of the attributions. Mr. Jaap Leeuvenberg, Curator of Sculpture at the Rijksmuseum, Amsterdam, Professor Klaus Lankheit of the Technische Hochschule, Karlsruhe, Dr. Max von Freeden of the Main-fränkisches Museum, Würzburg, Mr. William H. Forsyth of the Metropolitan Museum in New York, Mr. Harry Grunther of the American Numismatic Society, Dr. Hanns Swarzenski of the Museum of Fine Arts in Boston, Professor Erich Meyer of the Hamburg Museum für Kunst und Gewerbe, and Dr. Helmut Seling, Munich, have aided me with information on numerous points. The resources of the Zentralinstitut für Kunstgeschichte in Munich and the Koninklijk Instituut voor het Kunstpatrimonium in Brussels were made readily available to me and I am grateful to their directors and staffs. It is an especial pleasure to thank Miss Louise Lucas of the Fine Arts Library of Harvard for her tireless help. Her wisdom, great professional skill, cheerful and patient assistance made possible much of the compilation of the catalogue. Many points were suggested to me by students and colleagues at Harvard. Professor John Coolidge steadily encouraged the project and generously took over some of my duties in order to give me time for research. To Dr. Julia G. Phelps, Professors Jakob Rosenberg and Seymour Slive I am also greatly indebted.

A special note of appreciation is due Mrs. Frank Manuel for her quick intelligence and editorial skill in preparing this manuscript.

The Ford Foundation's grant-in-aid to Harvard University was of very considerable assistance in assuming part of the financial burdens of research, manufacture, and distribution of this book.

C. L. K.

Cambridge, Massachusetts
February 1965

Contents

List of Illustrations ix

The Harvard Collections in Their Art-Historical Context 1

Selected Bibliography of German Sculpture 35

Catalogue 41

Index of Sculptors 143

Plates following page 146

List of Illustrations

FRONTISPIECE **Madonna and Child, Tyrolese, c. 1430** (Cat. no. 9)

PLATES

I **Seated Monk, Upper Rhenish, c. 1280–1290** (Cat. no. 1)

II **Prophet or Saint, Burgundian, c. 1425–1450** (Cat. no. 5)

III **Prophet or Saint, Burgundian, c. 1425–1450** (Cat. no. 6)

IV **Console, Netherlandish, c. 1425–1450** (Cat. no. 7)

Fragment from a Resurrection, Netherlandish, c. 1550 (Cat. no. 38)

V **God the Father, Rhenish, c. 1325–1350** (Cat. no. 2)

Altar Cross, Franco-Flemish, c. 1350 (Cat. no. 4)

VI **Pietà, Austrian, c. 1420** (Cat. no. 8)

VII **Pietà, details** (Cat. no. 8)

VIII **Madonna, Swabian, c. 1430** (Cat. no. 10)

IX **Madonna, detail** (Cat. no. 10)

X **Madonna and Child, Tyrolese, c. 1430** (Cat. no. 9)

XI **Kneeling Angel, Pietro Alamanno (?), c. 1450–1460** (Cat. no. 11)

XII **Pair of Angels, Austrian, c. 1490** (Cat. nos. 13–14)

XIII **Saint Lawrence, Upper Rhenish, c. 1490** (Cat. no. 12)

XIV Saint John the Evangelist, Lower Swabian, c. 1490–1500 (Cat. no. 16)

XV Saint John the Evangelist, detail (Cat. no. 16)

XVI Nativity, Rhenish (?), c. 1470–1480 (Cat. no. 18)

XVII Adam and Eve, Upper Rhenish, c. 1490–1500 (Cat. no. 19)

XVIII Saint Catherine, Circle of Veit Stoss, c. 1500 (Cat. no. 21)

XIX Nativity, Upper Rhenish, c. 1500 (Cat. no. 22)

XX Madonna and Child, German, c. 1325–1350 (Cat. no. 3)

Madonna and Child, South German, c. 1480–1490 (Cat. no. 15)

XXI Heraldic Epitaph, South German (?), c. 1500 (Cat. no. 20)

XXII Education of the Virgin, Franconian, c. 1510–1520 (Cat. no. 25)

XXIII Education of the Virgin, side view (Cat. no. 25)

XXIV Madonna and Child and Saint Anne, Rhenish-Westphalian, c. 1490 (Cat. no. 17)

Madonna and Child and Saint Anne, Swabian, c. 1510–1520 (Cat. no. 29)

XXV Triptych of Saint Anne, Thuringian, 1516 (Cat. no. 28)

XXVI Saint Michael, Danube School, c. 1510–1520 (Cat. no. 27)

XXVII Saint Michael, front view (Cat. no. 27)

XXVIII Saint John the Baptist, Follower of Hans Leinberger, c. 1515 (Cat. no. 26)

XXIX Madonna and Child, Middle Rhenish (?), c. 1520 (Cat. no. 31)

XXX Triptych of the Madonna in Glory, Lower Saxon, 1524 (Cat. no. 30)

XXXI Jesse Tree, Circle of Heinrich Douvermann, c. 1520–1530 (Cat. no. 32)

XXXII Annunciation, Brabant, c. 1500–1510 (Cat. no. 24)

Madonna and Child, Malines, c. 1500 (Cat. no. 23)

[x]

XXXIII **Standing Warrior, Netherlandish, c. 1530, two views** (Cat. no. 35)

XXXIV **Medal of the Fall and Redemption of Man, Hans Reinhart, 1536, obverse and reverse** (Cat. no. 34)

 Triumph of a Sea-Goddess, Peter Floetner, c. 1530 (Cat. no. 33)

XXXV **Christ Child, Swabian, c. 1530–1540** (Cat. no. 36)

XXXVI **Wild-Man Candle Holder, Nuremberg (?), c. 1525–1550** (Cat. no. 37)

XXXVII **Chandelier, South German or Swiss, c. 1550–1575** (Cat. no. 39)

 Chandelier, South German or Austrian, c. 1675–1700 (Cat. no. 62)

XXXVIII **Series of Five Triumphs, Netherlandish, end XVI century** (Cat. nos. 43–47)

 Justice (Cat. no. 43)

 Folly (Cat. no. 44)

 Church (Cat. no. 45)

 Humility (Cat. no. 46)

 Poverty (Cat. no. 47)

XXXIX **Saint John the Evangelist, Netherlandish, c. 1550** (Cat. no. 40)

 Way to Calvary, South German (?), c. 1550–1575 (Cat. no. 41)

 Saint Martin and the Beggar, Lower German (?), late XVI century (Cat. no. 42)

XL **Coconut Goblet, Hans Müller of Breslau, c. 1600** (Cat. no. 50)

XLI **Angel, South German, c. 1600–1620** (Cat. no. 53)

XLII **Virgin in Glory, Augsburg, c. 1600** (Cat. no. 51)

XLIII **Virgin in Glory, rear view** (Cat. no. 51)

[xi]

XLIV Model of a Nautilus Goblet, Nuremberg (?), c. 1650–1675 (Cat. no. 60)

Kneeling Magdalen, Franz Schwanthaler (?), c. 1730 (Cat. no. 76)

Madonna, after Ignaz Günther, c. 1760 (Cat. no. 86)

XLV Knife Sheath, German, 1626, four views (Cat. no. 56)

Crocodile Sand Container, Nuremberg, c. 1575–1600 (Cat. no. 49)

XLVI Saint John the Evangelist, Netherlandish, c. 1575–1600 (Cat. no. 48)

XLVII Christ Crowned with Thorns, South German, c. 1600–1620 (Cat. no. 52)

XLVIII Personification of Death, Upper Rhenish, c. 1600–1650 (Cat. no. 54)

XLIX Personification of Death, rear view (Cat. no. 54)

L Personification of Death, Upper Rhenish, c. 1600–1650 (Cat. no. 55)

LI Personification of Death, rear view (Cat. no. 55)

LII Saint Sebastian, Erasmus Kern, c. 1625–1650 (Cat. no. 59)

LIII Rape of Proserpine, South German (?), c. 1625–1650 (Cat. no. 61)

LIV Bust of Christ, François du Quesnoy, c. 1630 (Cat. no. 57)

LV Bust of the Madonna, François du Quesnoy, c. 1630 (Cat. no. 58)

LVI Saint Michael, South German, c. 1700–1710 (Cat. no. 69)

Medal of Leopold I, Austrian, c. 1710–1740, obverse and reverse (Cat. no. 71)

LVII Beggar, Wilhelm Krüger, c. 1730 (Cat. no. 70)

Sacrifice of Isaac, South German, late XVII century (Cat. no. 63)

LVIII Madonna, Michiel van der Voort, c. 1720 (Cat. no. 66)

LIX Madonna, detail (Cat. no. 66)

LX Bust of Democritus, Netherlandish, early XVIII century (Cat. no. 67)

LXI Bust of Heraclitus, Netherlandish, early XVIII century (Cat. no. 68)

LXII Return of the Holy Family from Egypt, Meinrad Guggenbichler, c. 1690 (Cat. no. 64)

LXIII Crucifixion, Austrian, early XVIII century (Cat. no. 72)

LXIV Virgin, detail of Crucifixion (Cat. no. 72), Plate LXIII

 Saint John, detail of Crucifixion (Cat. no. 72), Plate LXIII

LXV Head of Saint Joseph, detail of Return of the Holy Family (Cat. no. 64), Plate LXII

 Head of Saint John, detail of Crucifixion (Cat. no. 72), Plate LXIII

LXVI Crucifixion, Upper Austrian, c. 1700–1725 (Cat. no. 73)

LXVII Crucifixion, details (Cat. no. 73)

 Madonna and Child, German or Netherlandish, c. 1675–1700 (Cat. no. 65)

 Madonna Immaculata, Austrian, c. 1730–1750 (Cat. no. 77)

LXVIII Reclining Nymph, Georg Raphael Donner, c. 1739 (Cat. no. 78)

LXIX Magdalen in the Desert, Viennese, c. 1740–1750 (Cat. no. 79)

LXX Judith with the Head of Holofernes, Würzburg (?), c. 1740–1750, three-quarter view (Cat. no. 80)

LXXI Judith with the Head of Holofernes, front view (Cat. no. 80)

LXXII Saint Ambrose (?), Austrian, c. 1725–1750 (Cat. no. 81)

LXXIII Saint Augustine, Austrian, c. 1725–1750 (Cat. no. 82)

LXXIV Angel Annunciate, Austrian, c. 1700–1725 (Cat. no. 74)

LXXV Virgin Annunciate, Austrian, c. 1700–1725 (Cat. no. 75)

[xiii]

LXXVI **Head of an Angel, Bavarian, c. 1760** (Cat. no. 85)

Pair of Hovering Angels, Bavarian, c. 1750–1760 (Cat. nos. 83–84)

LXXVII **Female Figure, Ferdinand Dietz, c. 1755–1765** (Cat. no. 87)

LXXVIII **Spring, Johann Joachim Günther (?), c. 1760–1765** (Cat. no. 88)

LXXIX **Summer, Johann Joachim Günther (?), c. 1760–1765** (Cat. no. 89)

LXXX **Autumn, Johann Joachim Günther (?), c. 1760–1765** (Cat. no. 90)

LXXXI **Winter, Johann Joachim Günther (?), c. 1760–1765** (Cat. no. 91)

LXXXII **Spring, detail** (Cat. no. 88), Plate LXXVIII

Winter, detail (Cat. no. 91), Plate LXXXI

LXXXIII **Summer, detail** (Cat. no. 89), Plate LXXIX

Autumn, detail (Cat. no. 90), Plate LXXX

LXXXIV **Bust of a Man, Johann Gottfried Schadow (?), 1797** (Cat. no. 92)

LXXXV **Bust of a Woman, Johann Gottfried Schadow (?), 1797** (Cat. no. 93)

The Harvard Collections
in Their Art-Historical Context

The Harvard Collections
in Their Art-Historical Context

IN recent years the role played by the Low Countries in the development of German sculpture has been increasingly emphasized by art historians. The destruction of so much religious sculpture by wars, iconoclasm, and the suppression of Catholicism in Holland makes it difficult to hypothesize the evolution of plastic art in the Netherlands; but there can be no doubt that it contributed much to German art. German sculpture, too, has suffered severe losses, but because of the extent of the territory and the enormous productivity, especially during the late Middle Ages and the Baroque era, enough remains to permit a more complete reconstruction of its history.

In the period under discussion, from the Gothic style of the thirteenth century to the classic revival of the late eighteenth, Italy and France gave much to the plastic arts of Central Europe. Often, however, Germany was receptive to the new influences only as they were interpreted and transmitted by the Netherlands. The very names of sculptors who left their impress on German art in the late Middle Ages are revealing: Nicholas of Verdun, Claus Sluter, and Nikolaus Gerhaert van Leyden. The Italian High Renaissance was slow to penetrate Germany, but the Late Renaissance as translated by such Netherlanders as Cornelis Floris, Jean Boulogne of Cambrai (better known as Giovanni Bologna), Adriaen de Vries, and Hubert Gerhard, was in consonance with German taste. Again during the Baroque period, the Central Europeans tended to look to Rubens or to the Netherlanders in the circle of Bernini at Rome, rather than to Bernini himself, for inspiration. The eighteenth century saw the construction of numerous, and often vast, palaces, churches, and monasteries, especially in Franconia, Bavaria, and Austria. Artists were attracted from all over Europe, and the talents of sculptors from France and Italy as well as from the Netherlands found ready employment at these huge sites. During the late eighteenth and early nineteenth centuries the Greek revival was a truly universal movement that left its mark both in Europe and America.

[1]

Sculpture in Germany, then, did not evolve in independence from the rest of Europe. Its characteristic style reflects a Central European taste often acting upon and recasting foreign innovations.

Transitional Gothic (c. 1180–1230)

Gothic sculpture, essentially French in character and origin, was introduced into Germany by two means: the importation of small objects and the training of German stone workers at French building sites. While the sculpture of Germany was subject to general European trends, during the Gothic period certain distinctive traits became evident. In religious art, German sculpture was more concerned with clarity of content and with a direct appeal to the individual than with monumentality or complex dogma. This was to create a style closely related to mysticism and the subjective experiences of the worshiper, who through contemplation and identification with the Lord was able to attain a state of grace. The German need for expressive content may account for the fact that the best Gothic sculpture was intended to be seen in the dim, multicolored light of the church interior, a setting that enhanced its emotional impact. Whereas in France façade and portal sculpture was the rule, in Germany it was the exception, and it rarely attained the character of true architectural sculpture such as that adorning the exteriors of the great French cathedrals.

In view of the German preference for religious art to embellish church interiors, it is not surprising that the earliest examples of the new style were precious objects of enamel, gold, and ivory, many of which entered Germany by way of Cologne. During the twelfth century Cologne had become a great center of learning and of the arts. For hundreds of years the archbishops of Cologne had been members of the imperial family or closely associated with it. By the second half of the twelfth century their temporal holdings included much of the Lower Rhine and Meuse Valleys, and after the death of Henry the Lion in 1179 Archbishop Philip I of Heinsberg obtained the western part of the Duchy of Saxony as a fief with the title Duchy of Westphalia. The towns of the Low Countries belonging to the Archdiocese of Cologne were economically and artistically flourishing, and sent many of their products to the episcopal see. In the Meuse Valley a highly skilled goldsmith trade had developed, its craftsmen becoming noted especially for their shrines and reliquaries. In general plan these box-like structures were patterned after ecclesiastical architecture. Rectangular or cruciform, they had pitched roofs and arcaded sides where holy figures were depicted. The whole work was customarily covered with gold and decorated with brightly colored enamels.

In the last two decades of the twelfth century, one of the leading Meuse goldsmiths, Nicholas of Verdun, broke away from the frozen, conventionalized severity of Romanesque figure style and introduced a more organic and dynamic handling of the human form. Several of his shrines were imported into Germany, where they had an immense

influence and initiated a vital and long-lived tradition. The small gilded copper relief of God the Father in the Busch-Reisinger Museum (Catalogue number 2, Plate V), although dating from the middle of the fourteenth century, is still related to the goldsmithy of Nicholas of Verdun. The general shape of the plaque indicates that it was intended to fit beneath a Gothic arch, and its lozenge-patterned background resembles those found frequently in the early Gothic shrines. The piece may well have come from a reliquary where it was one of a series of figures surmounted by architectural elements.

The transitional Gothic style was by no means confined to goldsmithy. The bronze baptismal font at Hildesheim with its delicate low reliefs beneath trefoil arches suggests some of the shrines. The great wooden Crucifixions in Saxony and the earliest of the stone carvings at the Cathedral of Bamberg, while not directly connected with the goldsmith works, owe them a spiritual debt.

The High Gothic Style: First Phase (1230–1280)

The Meuse goldsmiths and their German imitators had prepared the way for an understanding of and a direct contact with the French High Gothic style of architectural sculpture. The second manner in which French Gothic was introduced was through the training of German sculptors in France. Bands of stone workers wandered from one French cathedral site to another. Masons and sculptors, both belonging to a shop directed by a Master of Works, were scarcely differentiated. Some of these itinerant workers eventually found employment in Germany, and thus became agents for transmitting many of the complex facets of French Gothic culture.

A welter of new concepts was influencing the art of the period. Some knowledge of ancient philosophy had been kept alive throughout the early Middle Ages, but during the Crusades Europeans were brought into fresh contact with classical thought. Out of this confrontation came an intellectual rebirth, evidenced in the founding of the University of Paris at the opening of the thirteenth century. The need to fit classical erudition into a Christian schema encouraged a tendency to systematize and classify learning, often to the point of pedantry. Such illustrated manuscripts as the *Bible Moralisée*, the complicated iconographic schemes for the decoration of cathedrals, and the "system" for the construction of the Gothic church testify to this preoccupation. An aspect of the revival of interest in the ancients was the recourse to antique models, or Byzantine ivories deriving from them, as prototypes for sculpture. Gothic figures are often clad in drapery that recalls the classical. The human forms under the drapery, however, although suggesting living organisms, never have the true logical articulation of classical art. While the great Gothic portal statues were placed on jambs rather than in niches and thus have an independent existence as plastic forms comparable to freestanding classic figures, their design is governed by and in harmony with that of the architecture.

The Crusades continued, with diminishing success, until about 1290, by which

time all of the Holy Land had been lost. Nevertheless, the lofty ideals that had originally been associated with them, the noble concepts of knighthood, frequently found their finest expression in thirteenth-century sculpture. Chivalry remained a potent force in the literature and the visual arts of the time.

The spirit and institutions of religion itself underwent significant changes during the thirteenth century. The growth of urban centers and the belief that all classes should be admitted to worship within the house of God led to an increase in the size of congregations. The humane ideals of the Franciscan and Dominican orders played an important role in modifying the austerity of earlier worship and its exclusive and limited character. The love and sympathy for all God's creatures preached by these mendicant friars also inspired a new interest in representing human emotions in the arts.

Not all of the many innovations that emerged in France seemed to interest or to be understood by the German stone workers trained there. The so-called rational system of architectural construction, for example, was among the last to be employed in Germany. The first "French" Gothic cathedral to be erected on German soil, Magdeburg, imitated only the plan of a French building, and failed to use the "system" of the flying buttresses. On the other hand, a religion that emphasized compassion and the concomitant artistic interest in the rendering of human emotions appealed profoundly to such German sculptors as the leading master at Naumburg, some of whose carvings surpassed the French in variety and intensity of expression. The crusading spirit of knighthood also was readily embraced in Germany and was extraordinarily tenacious there. In 1226 a knightly brotherhood was formed, partly religious and partly military in character, known as the *Deutsche Ritterordung* (Knights of the Teutonic Order). Its chief goal was the conquest and colonization of Prussia. The campaign was successfully concluded by 1283, but the Order remained in existence for many years thereafter. The famous Bamberg Rider and the equestrian statue of Otto the Great at Magdeburg translated into stone the ideals of the crusader.

The sculpture of the cathedrals of Rheims, Chartres, and Noyon markedly influenced developments in Germany. Some of the stone carvers trained at these sites became masters of works at Bamberg, Magdeburg, Mainz, Naumburg, and Strassburg, where their French manner is evident, though it is always responsive to local or personal taste. A Fogg Museum example dating from the end of this phase of sculpture is the sandstone Antonite monk (Catalogue number 1, Plate I). The Antonites were an organization dedicated at first to the aid of victims of an illness known as "Saint Anthony's Fire." Soon the general care of the sick became their concern. They were originally laymen, but in 1218 the papacy recognized their work and permitted them to take monastic vows. The rapid growth of the Order was in part a reflection of the new humanitarianism that was entering the Church. By the end of the thirteenth century, the Antonites were made canons regular with the rule of Saint Augustine, and their hospitals (and cemeteries) dotted France and the Rhine Valley. The Fogg Museum figure represents one of their

[4]

number, wearing the distinctive Tau cross on his shoulder. The sculpture was made at about the time the Order received full papal recognition. In style it has some relationship to the work of the leading sculptor at Strassburg in the first quarter of the thirteenth century — the Ecclesia Master, so-called from the figures of the Church and Synagogue on the south transept portal. These two tall, slender, elegant figures embodying the highest chivalric ideals of feminine beauty are obviously different from the bulky, block-like Antonite monk. Their clinging drapery is in contrast with the sober, heavy robes that envelop the seated figure. And yet its drapery, with deeply-carved folds between the knees, still follows the contours of the body and reflects the human organic structure. A series of verticals, as in the work of the Ecclesia Master, dominates the arrangement of the garment, the strongest of which leads one's eye to the raised right hand and shoulder. This impression of strong verticality is checked by minor horizontal accents formed by the thong and by the transverse of the cross. Verticalism, interrupted and to an extent controlled by horizontals, is typical of the design of French Gothic architecture and of the sculpture that adorns it. Thus the modest torso suggests some of the major new conceptions that were incorporated in High Gothic sculpture.

The High Gothic Style: Final Phase (1270–1350)

During the first half of the fourteenth century, two distinct trends are observable in German sculpture. The first is a continuation of the earlier chivalric ideals, which by now had become a stereotyped convention. The second, born of the rise of mystical cults, was progressive and had a more enduring effect.

At almost the very moment when the conquest of Prussia had been completed, the nascent power of the middle class began to manifest itself. Throughout the thirteenth and fourteenth centuries there was a shift of population from rural to urban communities. The cities, growing in importance, banded together for mutual protection and for the promotion of trade and commerce. Indeed, the powerful group of German cities known as the Hanseatic League was able to establish a monopolistic control of trade in the very areas that had so recently been conquered by the Knights of the Teutonic Order. Although the knight had lost his military *raison d'être* and his power had been successfully challenged, chivalric ideals continued to influence much of German culture. The knight had won his title and his lands by the sword. Now, war-like games within his castle became the substitute for military exploits. As chivalry developed into a fixed, codified system of conduct, an equally conventionalized style flourished in the pictorial arts.

The tall, elegant, youthful figures in German sculpture of the period are standardized types, clad in garments with rich and decorative folds unrestrained by architectural design. The graceful, over life-size choir statues of Cologne Cathedral are among the finest representatives of this phase of Gothic sculpture. Often, however, the figures

assume mannered postures and simpering, over-refined expressions. The complex play of lines of drapery in some of the architectural sculpture destroys any suggestion of monumentality. Even the dimensions tend to contract, as in the sculpture of the vestibule of the Cathedral of Freiburg i.B. The late chivalric style is by no means confined to architectural sculpture. It frequently appears in funerary statues and in devotional images intended to serve the individual worshiper.

Such works as the Madonna and Child in the transept of the Cathedral of Paris were animated by the same spirit as German "chivalric" sculpture, but it may well have been the works of Northeast France and the Low Countries that were the direct models for many German artists. This area was enormously productive in the late thirteenth and early fourteenth centuries. Scriptoria manufactured in great profusion illuminated manuscripts, which were exported to England, the Ile de France, and the Rhine Valley. The manuscripts illuminated by Johann von Valckenburg in Cologne at the end of the thirteenth century are certainly inspired by the Franco-Flemish style. French ivory carvings with the self-conscious complexity of the late chivalric style were also widely exported. Their counterparts in Germany are the *Minnenkäste*, small jewel boxes decorated with amorous scenes and courtly games.

The gilded silver figure of Christ on the Altar Cross in the Busch-Reisinger Museum (Catalogue number 4, Plate V), a Franco-Flemish work of about 1350, in many ways illustrates late chivalric ideals. The face has the same broad brows, narrow eyes, long nose, and small mouth found in sculpture and painting all over Northern Europe in the early fourteenth century. Even the intricacy of the loincloth is a feature of this style. The seated Madonna and Child of the first half of the fourteenth century (Catalogue number 3, Plate XX) is based on a French prototype in either ivory or stone, though it has none of the grace or elegance of the original model. Several stone Madonnas of this type, made in the Rhine Valley, retain the decorative line which is one of the great charms of the late chivalric style.

The sculpture that accompanied the rise of mysticism in Germany and the intensified interest in holy relics was far more forward-looking in its content than the chivalric style, and presaged many of the developments in the plastic arts. The Late Gothic altarpiece had its beginnings at this time. At first a series of compartments to contain sacred relics were placed at the back of the altar. Usually made of stone, they followed the form of a Gothic arcade. As relics increased in number the compartments were multiplied, often becoming smaller in scale. Sometimes wooden wings or shutters were added to the stone reliquary shrine. By the second half of the fourteenth century wood was employed for the entire structure. Often rows of polychromed figures bedecked the central panels and shutters, and sometimes the wings would be closed to reveal painted scenes on their exteriors. These retables, completely divorced from architecture, were to become the greatest achievements of ecclesiastical art in the fifteenth and sixteenth centuries.

The emerging mysticism of the early fourteenth century involved a form of worship

quite different from that dependent upon the official liturgy of the Church. Mysticism emphasizes individual worship and the attainment of a state of grace through prayers and right conduct without adherence to prescribed ritual. Periods of contemplation produced visions and revelations in which the worshiper himself became an actor in the Biblical event.

Just as mysticism became dissociated from ecclesiastical orthodoxy, so the devotional images which served the mystical cults often departed sharply from the conventions that dominated the late chivalric style. The revelations recorded by Saint Bridget of Sweden and various German nuns are so vivid and graphic that they might almost be read as literal descriptions of the cult images made to serve and to assist them in their devotions. Such an image is the Crucifix in St. Maria im Kapitol, Cologne, in which the sculptor uses every means at his command to evoke the death agonies of the Saviour. The head, pierced by a heavy crown of thorns, droops to one side, the rib cage protrudes, the abdomen is sunken, the flesh is torn and lacerated, and blood gushes forth from the five wounds. The horror is exaggerated in order to move the beholder to understand and to feel in sympathy the same torments. A similar intention, although with a somewhat different emphasis, is embodied in the devotional image known as the *Vesperbild*. It is a type of Pietà which depicts the dead Christ held on the lap of the Madonna. Sometimes attention is focused upon the agonies endured by the Saviour. At other times the body of Christ is disproportionately small, so that it almost becomes an attribute of the sorrowing Virgin and a means of concentrating attention upon her grief. Frequently her contorted visage expresses anguish without restraint, as though she were screaming her emotional pain. The *Vesperbilder* were among the most popular devotional images, and vast numbers of them still exist in German churches and public collections. In the late fourteenth and early fifteenth centuries Germany produced hundreds of *Vesperbilder*, many of them intended for export to Italy. In some instances German masters established their workshops in Northern Italy in order to be closer to that particular market. With time the expressive content of the sculpture changed, and artists no longer strove to convey the violent suffering demanded by fourteenth-century religious passion. In the Busch-Reisinger Museum *Vesperbild* (Catalogue number 8, Plates VI, VII), dating from the early fifteenth century, the restraint and quiet grief of the Madonna make her unusually poignant, while the rigid corpse of Christ is still reminiscent of the drastic pathos of earlier Pietàs.

Other types of fourteenth-century devotional images play upon wholly different emotions and often have a lyrical or even a familial feeling. Among the earliest are Christ and Saint John groups, whose style is in harmony with late chivalric ideals, but whose content suggests the affectionate bond between the Saviour and his favorite and youngest Apostle. Visitation groups tend to have a gentle genre spirit readily understood by the ordinary man. Among the first reflections of urban culture are devotional images invested with the spirit of normal family relationships so close to the heart of the burgher. Such

[7]

subjects as the Madonna and Child and Saint Anne (known as the *Anna Selbdritt*) or Saint Anne teaching her young daughter, which continued to inspire artists for many centuries, are exemplified by several late pieces in the Busch-Reisinger Museum (Catalogue numbers 17, 25, 29, Plates XXII–XXIV).

The New Naturalism (1350–1385)

Sculpture in Germany during the first half of the fourteenth century had been affected by many different factors — the fixed and often frivolous conventions of the late chivalric style, the heightened realism of some of the mystical cult images, and an earthy, familial lyricism. During the second half of the century, the worldliness of an emerging burgher class and the deep mystical piety proved to be the most fertile sources of inspiration for German artists. In the personality of the Luxemburg emperor, Charles IV (1346–1378), both currents fused. He was a profoundly religious man, a mystic, who at the same time knew how to estimate the value of worldly things. He recognized the importance to the Empire of a dawning capitalism and maintained close contact with the merchants and cities of the Hanseatic League.

Not infrequently a naturalistic style in the plastic arts accompanies economic prosperity built on individual enterprise. During the second half of the fourteenth century the German capitalist economy was still in its infancy. Nonetheless, the arts began to take cognizance of the physical aspects of the world and to seek new ways in which to express this interest. Though their solutions were primitive, they were in the direction of the modified naturalism that flowered in the fifteenth century.

In the painting of the first half of the fourteenth century, with a few isolated exceptions resulting from contact with Italian art, Northern artists made no attempt to give their figures a spatial setting. As in all High Gothic painting, the human figure was placed *in front* of a decorative background. Though its drapery had substance, the figure as a totality lacked plastic bulk. After 1350 a change is manifest. The abstract background no longer forms the picture plane but is pushed behind it to act as a backdrop for a shallow, stagelike rectangular space *in which* the figures are set. The complex drapery of the late chivalric style is simplified and the decorative patterns are minimized or eliminated altogether. The human body is given the simplicity of a geometric form with the highest values concentrated in the center and the darker ones confined to the edges. This method of modeling imparts a strong feeling of high relief to the forms. Female costumes are rendered with greater attention to contemporary fashion, the tight-fitting bodices emphasizing plastic form. Males are often represented with strange shapes resembling nothing so much as an hourglass. The swelling torso tapers to a narrow waist, which has the appearance of being constricted by a girdle. If one may judge by extant examples of plate armor and funerary sculpture, this hourglass shape was very much in vogue.

[8]

As was true in the development of the late chivalric style, the Low Countries contributed to the formation of the new realism. One of its leaders was Jean Bandol, a native of Bruges and court painter to Charles V of France (1364–1380), a great bibliophile. Many of the books written for the monarch's library contain illuminations that embody these concepts of solid form in easily perceived space. The style, by no means confined to the French court, appeared all over Northern Europe. It may be seen in the Bohemian paintings of Master Theodoric and his school. It has representatives in the territory dominated by the Hanseatic League — for example, Master Bertram, whose influence (like that of the League) crossed the Channel to England.

The new interest in a ponderous three-dimensional figure style is apparent in the sculpture of the period. One of the chief exponents of the new style in the West was also a Netherlander, André Beauneveu (act. c. 1360–1400) who, like Jean Bandol of Bruges, was employed by Charles V of France. The tombs commissioned by the Valois monarch, now in Saint Denis, have recumbent figures of the deceased rendered in a manner that emphasizes their plastic bulk. Costumes are simplified and do not distract the attention of the beholder from the great three-dimensional bodies. The heads tend to assume an almost spherical shape and the features are only slightly individualized.

The chief representative of the new realism in Germany was Peter Parler (c. 1330–1399), whose very name is sometimes used as a label for the period of the 1370's and 1380's — "Die Parler Zeit." Peter Parler was a member of a family of stone carvers organized as a migratory workshop and resembling in some ways the wandering bands of masons and carvers of the High Gothic period. The shop worked at various sites in the Rhine Valley and in Swabia. Peter was summoned to Prague by the Emperor Charles IV to succeed Matthew of Arras as Master of Works of the Cathedral. The choir was completed under his direction, and he carved a series of portrait busts and tombs of churchmen and members of the court of the Luxemburg emperors. These have plastic forms and simplified surfaces comparable to the sculpture of Beauneveu.

There is no true example of the Parler style in the Harvard collections. The figure of Christ on the Altar Cross (Catalogue number 4, Plate V), previously cited as illustrating the persistence of the High Gothic style, has some qualities that anticipate the plasticity of the 1370's. Although the work dates from the mid-fourteenth century, almost a generation earlier than the sculpture of Peter Parler and Beauneveu, the anatomy of the torso already has been simplified to the point where it is nearly cylindrical.

The Soft Style (1380–1430)

In the last works of the Parler school in Prague, the statues of Charles IV and Wenzel (1378–1419) on the tower defending the Karlsbrücke, there are discernible new elements that were to dominate the next phase of German sculpture. The two seated

emperors are still composed as massive plastic forms. The drapery over their knees, however, begins to move and sway in complex decorative folds that presage the courtly style soon to appear all over Europe — the "International Style" of painting, or the "Soft Style" of sculpture.

The defeat of the Knights of the Teutonic Order at Tannenberg in 1410 hastened the end of knighthood as a military and cultural force in Germany. As the principalities and cities grew in importance, there developed a local pride which had in it the seeds of nationalism, though the regionalism of a burgher civilization was only incipient. In Western Europe, culture radiated from the courts of the Valois brothers, especially at Bourges, Angers, Dijon, and Paris. Under the leadership of Philip the Hardy, the holdings of the House of Burgundy became more and more extensive. His marriage to Margaret of Flanders tied the Netherlands to the Burgundian dukedom, thus legalizing politically an artistic union that had already been long established. The Burgundian court at Dijon assembled elaborate objects of goldsmithy, tapestries, paintings, and sculpture. Its opulent banquets, complicated protocol, and magnificent dress were emulated by monarchs, princes, and lesser nobility throughout Northern Europe.

The paintings commissioned by this aristocratic patronage or reflecting courtly influences are in what has been termed the "International Style." They retain the plastic figures of the preceding generation. Their three-dimensional quality, however, is often obscured by elaborate curvilinear drapery. In some instances, faces have become more individualized and true portraiture is approximated. The simple, stagelike, rectangular space used by the painters of the 1370's now becomes deeper and irregular in plan until eventually a real landscape makes its appearance. Such French and Netherlandish manuscript illuminators as the Master of the Boucicault Hours and Pol de Limbourg and his brothers are leaders in the development of naturalistic landscape. They render a world that has become larger and more beautiful in men's eyes, a world that has taken on new color and richness and is filled with a multitude of objects. A wealth of detail implies the creative fecundity of the Deity whose presence is in all things. The people in these scenes, whether holy figures, lords and ladies, servants, or peasants, are all God's creatures, and thus in spite of individual differences are part of a divine unity. The older hieratic scaling disappears and is sometimes replaced by social scaling in which members of the aristocracy are represented as physically larger than servants or peasants.

The counterpart of the International Style of painting is the "Soft Style" (*weiche Stil*) of sculpture, so called by German art historians. It received its name from an increased use of such soft materials as freshly quarried alabaster, terra cotta, and even cast stone. The desired complexity was more easily achieved in these media than in stone or wood (which nonetheless continued to be employed). Whether the patrons were guilds, burghers, churchmen, or noblemen, the sculpture responded to a courtly taste for rich profusion and elaborate decoration.

The sculptors translated the space of the paintings by a number of different means.

Sometimes in architectural sculpture the figures were set in the world of the beholder himself. The statue *inhabits* the buildings rather than *adorns* them. A telling example may be seen on the church at Mühlhausen, where the Emperor Charles IV with his Empress and companions are placed on a balcony high above street level. The Emperor bends over a balustrade and makes a gesture as though acknowledging the plaudits of his subjects gathered in the street below. The small scenes typical of the Netherlandish polychromed wood altarpieces often had naturalistically rendered interiors. A window in the rear wall may be indicated, suggesting that the space extends beyond the actual confines of the room.

In funerary sculpture of the Netherlands the portraits of the deceased and his family are often placed in the same niche-like space as the holy figures which they adored. The artistic handling of flesh-and-blood donors was undifferentiated from that of their patron saints or the Madonna and Child who might be the object of their worship. The saints and sinners and the Mother of Christ herself were all aspects of God's creation and as such belonged to the same universe. The distinction between the heavenly hosts and the world of men was thus broken down in sculpture as it was in painting.

This concept is illustrated by the work of the Dutchman, Claus Sluter (act. c. 1380–1406), who was called to Dijon from Brussels in 1385 by Duke Philip the Hardy to work on the nearby Carthusian monastery at Champmol. The church was intended to be the burial chapel of the Burgundian dukes, and its main portal was decorated by Sluter. A dynamic and vigorous standing Madonna holding her Child is on the trumeau. On the jambs at either side kneel Philip the Hardy and his wife, Margaret of Flanders, accompanied by their patron saints, John the Baptist and Catherine. The five figures are joined formally and psychologically as a single whole in a unified space. They are placed above the eye level of the beholder, who seems to be invited into their world as he ascends the steps to the doorway. These stone figures have the precisely individualized features of particular human beings.

Sluter's naturalism extends further than the areas of spatial concepts and actual portraiture. The four prophets on the "Well of Moses" are sharply differentiated from one another by their features, gestures, and costumes. The surfaces of their garments are rendered with such close attention to texture that the unique quality of each belt buckle, collar, or strand of hair is conveyed. These inanimate things, too, we must infer, bear witness to the infinite variety of the Lord's creations.

Sluter, although his drapery is complex and voluminous, still respects the plastic bulk of the figure beneath, as did the carvers of the previous generation. His activity in Brussels before 1385 survives only in a few fragments from the decoration of the façade of the City Hall. A small sandstone console in the Fogg Museum (Catalogue number 7, Plate IV), although dating from the fifteenth century, harks back to Sluter's restless and ample drapery style of the 1380's. The two figures of prophets or saints in the Fogg collection are much closer to Sluter's work for the Burgundian court (Catalogue num-

bers 5, 6, Plates II, III). In spite of damage and the fact that they could have been made decades after Sluter's death, much of his voluminous drapery and powerful movement still remain. The figures are badly weathered, but in some of the areas protected from the elements Sluter's interest in accurate rendering of surface textures is reflected.

It seems clear that Sluter played a part in the development of the Soft Style in Germany. One of the most appealing German sculptors working in this manner was the so-called Master of the Beautiful Madonnas. His origin as well as the chronology of his works are still disputed by art historians. He is well-named, for the Madonnas carved by him and his school are graceful, aristocratic, engaging young mothers, often depicted playing with their plump, curly-haired babies. The Madonnas found in Breslau, Thorn, Krumau, and elsewhere were widely imitated throughout Germany and Austria. The polychromed wood Madonna and Child in the Busch-Reisinger Museum (Catalogue number 9, Plate X, and frontispiece) belongs to this category, for its ultimate source is one of the creations of the Master. The young mother, calm and reflective, is a gentle princess. Her aristocratic air is heightened by an elaborate jeweled crown and golden cape. She gazes at her Child, whom she supports by firmly pressing her hand against His chest. The soft flesh of the Infant yields to the pressure, showing the artist's keen interest in surface detail.

The Master of the Beautiful Madonnas also produced a number of Pietàs or *Vesperbilder*. His Virgins of the Pietà, too, are lovely young noblewomen, clad in rich garments with edges that form sinuous, curvilinear patterns. The elaborate, ornamental drapery tends to stress their earthly beauty. Like the Madonnas, the Pietàs also inspired numerous works by imitators and followers. The Busch-Reisinger *Vesperbild* (Catalogue number 8, Plates VI, VII) is related to this group, though, as described earlier, it was a type of devotional image that made its appearance in Germany in the early fourteenth century. The drapery of the Madonna in the Cambridge piece is typical of the *weiche Stil* of the early fifteenth century. Unlike the Pietàs of the Master of the Beautiful Madonnas, however, the Virgin is not represented as an elegant princess whose polite sorrow is expressed by a tilt of the head and a suggestion of tears in the eyes. In the Cambridge group, physical beauty is subordinated to the communication of deeply-felt grief. Mary's face is swollen with weeping and conveys the utter exhaustion produced by profound emotion. Her eyes are closed and one covered hand lifts her veil to wipe her face. There is a loneliness and isolation to the figure that is accentuated by the compactness of the composition. The harshly angular dead Christ is rather a symbol of the Madonna's sorrow than a naturalistic representation.

The last phase of the Soft Style is distinguished by a growing complexity of drapery and a preoccupation with elaborate decorative effects. The folds multiply and are more deeply undercut, creating a repetitive alternation of light and shade; eventually, reflecting the influence of Netherlandish painting, they will become sharp and angular. The seated Swabian Madonna in the Busch-Reisinger Museum (Catalogue number 10,

Plates VIII, IX) illustrates this final phase of the Soft Style, before angular drapery makes its appearance. The enormous intricacy of the cape, with its deeply undercut folds and the veritable cascade of linear patterns on the right side, almost defies analysis. It contrasts markedly with the rather simple plastic forms of the upper part of the body, encased in a snug dress. The face has something of the earthly prettiness admired by a bourgeois society. Although the drapery is still "soft" in character, the work shows that a new style is germinating.

The drapery of the small Kneeling Angel of about 1450–1460 (Catalogue number 11, Plate XI) reveals the early beginnings of the new style. The blocklike mass of the figure is hidden by parallel folds that bend at acute angles as they reach the ground. This angularity is to become all-pervasive as the influence from the Low Countries intensifies.

The Late Gothic (1440–1520)

The Late Gothic period corresponds roughly to the dates of the reigns of Frederick II (1440–1493) and Maximilian I (1493–1519). During these years the middle class became the dominant force in German culture. The Hanseatic League retained its monopoly in the Baltic and North Sea areas, while elsewhere other trading associations, banking houses, guilds, and individual merchants accumulated great wealth. Their influence and the shift of population enabled the cities to emancipate themselves entirely from the old feudal lords and to recognize allegiance to the emperor alone. These free cities or *Reichstädte* became a sort of microcosm of the Empire itself. Citizenship with its attendant rights and privileges was eagerly sought and was a source of pride and self-esteem. One remembers how Albrecht Dürer in Venice, while bitterly complaining of his treatment in the North, nonetheless proudly signed one of his pictures "Albrecht Dürer, Germanus." A few years later, on another work, he appended the word "Noricus" to his signature.

By the mid-fifteenth century most German cities could boast of paved streets, rare in other parts of Europe at this time. Such travelers as Aeneas Sylvius Piccolomini (Pope Pius II) noted the splendors of the German towns, adding that they were as clean as if they had just been built. The new affluence of the burghers and guilds brought into being a great number of art patrons, whose demands stimulated and promoted enormous productivity. This culture, fostered by individual successes in commerce and trade, created an ambiance in which powerful artistic personalities with highly distinctive styles could flourish. Such sculptors as Gregor Erhart, Erasmus Grasser, Adam Kraft, Hans Leinberger, Michael Pacher, Tilman Riemenschneider, Veit Stoss, and Peter Vischer the Elder developed their own methods of expression within the conventions of the Late Gothic style. As heads of ateliers they left their stamp on the production of their shops. Unlike Italian artists, who had attained the social status of intellectuals, the

German masters, however, were still regarded only as skilled craftsmen, working within the corporate structure of the medieval guild.

The patrons of German art, though chiefly members of the middle class, had inherited from the past piety and mysticism, as well as a forthright naturalism. The aristocrat was often lampooned, especially in graphic art, but clearly the German burgher secretly admired and often aped the nobility and adopted their exaggerated trappings as a sign of prestige. Heraldic devices were enormously popular. Craftsmen used armorial shields as workshop marks and inn-keepers employed them as signs. Montaigne was impressed equally by the cleanliness and by the numerous heraldic devices that he found in Germany during his travels of 1580–81. His diary contains the following passage: "The Germans are very fond of coats-of-arms; in every inn you will find hundreds that gentlemen who have lodged there have had painted on the walls; and all the windows are decorated with these emblazonments." * In the Late Gothic period large polychromed wood plaques, decorated with coats of arms and crests, were made in great number as epitaphs, and great clusters of them were placed high on the piers and walls of the churches, enlivening the interiors with elaborate ornament and brilliant hues. This type of epitaph, known as a *Totenschild*, is represented in the Busch-Reisinger Museum by a characteristic example of about 1500 (Catalogue number 20, Plate XXI).

The typical Late Gothic ecclesiastical structure was a modestly proportioned building of the hall-church type (with vaulting of nave and side aisles the same height). The decoration of the exteriors was usually simple, but the interiors were crowded with elaborately carved choir stalls, tabernacles, devotional images, polychromed carved and painted altarpieces, all bathed in the variegated colored light of the stained glass windows. The profusion of carving and painting, glittering gold against deep shadows, must have created an atmosphere of exaltation and mystery. The agitated effect produced by the church furnishings was intensified by the interior details of the edifice itself. Piers were decorated with membering that had little or nothing to do with architectural function. Similarly, the vaulting was obscured by a network of ribs, sometimes so deeply profiled that they stood out as sharp, linear decoration against the shadows which they themselves cast. This other-worldly emotionalism was the heritage bequeathed by fourteenth-century mystical piety.

One of the greatest glories of the German churches were the carved and painted winged altarpieces. These usually consisted of a box-like central section or *Schrein* containing polychromed sculpture. The hinged wings were sometimes carved and sometimes painted. Above the *Schrein* was the elaborate tracery of the superstructure (*Aufsatz*), and immediately beneath it the oblong predella, frequently filled with sculpture and having its own pair of painted wings. A baldacchino, which might occupy as much as a third of the *Schrein*, would cast deep shadows on the background, obliterating any visible spatial boundary and giving an impression of endlessness. Sometimes the back-

* *The Works of Montaigne*, edited by W. Hazlitt (London, 1842), p. 545.

[14]

ground contained a painted landscape or, if the scene was an interior setting, simulated or real openings to achieve the same illusion. Rarely was it allowed to define or limit the space. The figures placed in the *Schrein* seemed to merge with the dim, indistinct shadows as their deeply undercut drapery produced a surface of changing light and shade. The gilding and polychromy blended with the colored light of the interior. Thus sculpture lived in a mysterious world of light and shade and color. The paintings on the wings of the altarpiece were the immediate neighbors of the carved figures in the *Schrein*. Since the sculpture was essentially pictorial and visual, rather than plastic and tactile, it is not surprising to find that it was often influenced by the painting of the period which is found in combination with it.

The two complete altarpieces in the Busch-Reisinger Museum give some idea of this strange, crowded world of color, light, and shadow (Catalogue numbers 28, 30, Plates XXV, XXX). The earlier of the two, a rather provincial work of 1516, combines polychromed sculpture with paintings on the exterior of the wings. It has neither predella nor *Aufsatz*. The later one, dated 1524, consists of polychromed sculpture only. It has a predella, but the *Aufsatz* has been simplified and consists wholly of an inscription.

The effect of the Late Gothic altarpiece is better illustrated by the group of the Madonna and Child and an Angel, once part of a Nativity in a Late Gothic altarpiece (Catalogue number 22, Plate XIX). Although only a fragment, it combines two aspects of Late Gothic culture, earthy naturalism and deeply-felt mystery. The polychromy and play of light and shade belong to pictorial, rather than plastic, art. The kneeling Madonna wears a mantle that sways and flutters in an arbitrary manner, having nothing to do with the position of the figure that it envelops. The calm majesty of the Madonna is a foil for this glittering, colorful movement. The major accent of the design is the dark vertical shadow between the two great opposing curves of the mantle. The shape of the clasped hands is repeated below by the sleeves and the V-shaped fold of the garment. The Christ Child and angel at the left balance the opulent and complex drapery at the other side. The whole lower part of the composition contrasts strangely with the quiet gravity and serenity of the Virgin's demeanor. The deeply undercut major accent robs her of any suggestion of corporeal existence and at the same time the meticulously detailed strands of her hair, her strong peasant hands, and the rounded forms of the plump Child have a close fidelity to nature. This combination of naturalistic and illogical elements denotes a syncretic style that embraces the worldly and the supernatural, the pictorial and the plastic. One can readily imagine the group set beneath a complex of Gothic tracery creating the sort of dimly-perceived background with which the shadows of the figures merged and from which the highlights shone forth.

The drapery style of Late Gothic sculpture abandons the decorative, rhythmic curves of the *weiche Stil*. In Germany a sharp, brittle angularity, first seen in the work of Netherlandish painters of the generation of Jan van Eyck and Robert Campin, replaces the curvilinear folds of the first third of the fifteenth century. In some German

[15]

sculpture of the 1440's the new style is foreshadowed, but its full-fledged introduction came by way of a Dutch sculptor, Nikolaus Gerhaert (c. 1425–1473) of Leyden. Appearing at Trier in the 1460's, he traveled widely, and had an enormous impact on the sculpture of Germany and Austria. At Trier, Strassburg, Constance, and Vienna he attracted pupils who carried on his style and spread his influence. His interest and talent in rendering naturalistically the textures of surfaces, his manner of suggesting reality in the spatial settings of his figures, his drapery which breaks into sharp, angular folds concealing the bodily forms beneath, all show his acquaintance with the mature work of such a painter as Jan van Eyck.

Several objects in the Harvard collections reflect the art of Nikolaus Gerhaert. A small statuette of Saint Lawrence (Catalogue number 12, Plate XIII) made about 1490 is carved with a skill that is almost worthy of the master himself. The tiny figure shows the artist's careful attention to surface textures. The shaved pate, curly locks, flesh of face and hands, and fringe of the costume are sharply differentiated from one another and are completely convincing visually. The drapery, combining vertical ridges with broken, irrational angles, totally ignores the human forms it ostensibly covers. Indeed, the body, since it is invisible, is neglected, while all that can be seen is represented with accentuated realism.

A second statue, Saint John the Evangelist (Catalogue number 16, Plates XIV, XV), illustrates the influence of Gerhaert's art as it was disseminated by the engravings of the Master E.S. The overwhelming impression imparted by the stance and mien of the Saint is one of restrained but great sorrow. The tilt of the head and the direction of the gaze indicate that the figure belonged to a Crucifixion group. The head, unusually large in proportion to the body (even for the Late Gothic period), and the strong vertical accents of the design suggest that the work was intended to be seen at an acute angle from below. Thus it may have formed part of the superstructure of a retable, which would account for the scant attention given to the back of the head. The contours of the figure are smooth and unbroken; they parallel the shadows and highlights of the deeply undercut drapery. The major folds lead to the arms, which are waist high, causing the cape to break into complex angular patterns. The round, rather plump hands, placed slightly to the left of the central axis, are balanced by the similarly shaped curvilinear folds over the left arm. These two elements, combined with the arms and the arrowlike lines at the neck where the mantle is held, tend to focus attention on the face, which is framed partly by them and partly by the tightly curled locks of the abundant hair. The face itself is worthy of the emphasis placed upon it by the artist. The brows drawn together, the slanted eyes partially closed, the parted lips, thin cheeks, and straining tendons of the neck are all suggestive of the shock and grief suffered by the Evangelist.

The emphasis on individual achievement in Late Gothic civilization, whether economic or artistic, has already been noted. In sculpture, the works of the great masters conform to the general style of the era, but nonetheless bear the stamp of their own

personalities. There are several examples in the Harvard collections which, although produced by assistants, clearly show the mark of the master under whom they worked. The dainty figure of Saint Catherine (Catalogue number 21, Plate XVIII) is strongly influenced by the Nuremberg sculptor Veit Stoss (c. 1450–1533), whose career began in Poland and whose stormy style is typical of the period. His famous altarpiece of the Death and Assumption of the Virgin in Cracow has the violent turbulence of a tidal wave. Stoss returned to Nuremberg in 1496, where his work continued to be distinguished for a time by this restless intensity. The Saint Catherine in the Busch-Reisinger Museum was produced by a close follower of Veit Stoss early in his Nuremberg period. It has the peculiar mannerisms of the master — a fold of the mantle held high, swinging, irrational curves, deeply undercut and fluttering drapery ends that resemble in shape the human ear.

The style of the leading Bavarian sculptor of the Late Gothic period, Hans Leinberger (act. 1513–1530), can be studied in the Saint John the Baptist by one of his many followers (Catalogue number 26, Plate XXVIII). The drapery of the seated Saint, although clearly Late Gothic in character, has been handled somewhat differently with respect to the human form beneath. Like the typical drapery of the period, it breaks into restless, fluttering patterns of movement and contrasting light and shade. The artist, however, does not allow the garments to violate the structure of the human body. The folds are no longer deeply undercut and, although they move without apparent logic, the organic forms beneath play a part in the general drapery design. This deviation from the late fifteenth-century manner is frequently encountered in the first quarter of the sixteenth century, as though it faintly reflected the classical Renaissance taking place south of the Alps. Leinberger was at home working on any scale, and he varied his style to suit the size of the statue he was carving. His over life-size Madonna of the Moosburg Altar, clad in a mantle that is formed of a series of great rhythmic, tubular accents, is a soaring, weightless, supernatural figure. In his tiny reliefs, the master uses a similar pattern, but it is composed of smaller linear accents. The seated Saint John has features of both his large-scale sculpture and his "cabinet pieces." Monumentality of form and sweeping accents are curiously combined with small, decorative, linear details such as the broken folds over the right knee and the tight, stylized treatment of hair and beard.

The Saint Michael (Catalogue number 27, Plates XXVI, XXVII), another work that has the imprint of a dominant artistic personality, also illustrates the close affinity of painting to sculpture. Made in the valley of the Danube, it greatly resembles the work of Albrecht Altdorfer and other painters of the Danube School. The narrative and psychological possibilities of the Late Gothic are fully explored in this work. The flow of the drapery, the position of the arms, the facial expression tell the tale of a mighty contest. The archangel regards his enemy with deep distaste. His lips are parted and drawn back with the exertion of combat, while his right hand is raised to give the final and fatal blow to his adversary. The great S-shaped curves swinging through the mantle carry the

[17]

eye of the beholder to the hand that is about to descend for the last thrust. The fluttering sash echoes the same movement in a minor key.

The Education of the Virgin and the Madonna and Child and Saint Anne have been discussed as depicting the domestic aspects of middle-class life (Catalogue numbers 25, 29, Plates XXII–XXIV). A comparison of the two works, carved at approximately the same moment, will point up the slow shift of emphasis that took place during the first quarter of the sixteenth century. The Swabian Madonna and Child and Saint Anne depicts Saint Anne as a rugged middle-class woman holding her grandchild on her knee. The Madonna is so small in scale as to suggest that Mary is a very young girl just learning to read from the book that she holds. The focus is on Saint Anne, a great blocklike figure who wears the concealing garments characteristic of Late Gothic style, while the Child and the Virgin are little more than attributes. The Anne in the Education of the Virgin also has an earthy quality, evident as she performs a maternal duty that is easily identified and understood. She is the strong, homey mother following with amused patience the halting efforts of her young daughter. By omitting the Christ Child the artist has achieved a more naturalistic representation of the relationship of mother and daughter. Anne's drapery, while restless, broken, and undercut, clings here and there to forms beneath, thus suggesting rather than denying the existence of the human body.

During the second half of the fifteenth century the great number of middle-class patrons created a market for inexpensive devotional figures and representations of Biblical scenes for private worship. The flourishing trade in engravings and independent woodcuts was one response to this demand. Another was the molded reliefs first developed in the Netherlands. Made of pipe clay, terra cotta, stucco, papier-mâché, and even plaster, they were soon exported to Germany and imitated by the German craftsmen themselves. The reliefs were especially popular in the Lower Rhine and Westphalia, where the polychromed plaster Nativity of the Busch-Reisinger Museum (Catalogue number 18, Plate XVI) may have originated. In this case, the plaster was probably carved rather than cast, and the parts were assembled on a wooden background painted to resemble a landscape.

The carved and polychromed altarpieces of the Low Countries proved a rich source of inspiration for German carvers of small Biblical subjects and devotional images for private use in the homes of the well-to-do. Unlike the German Late Gothic retables, the Netherlandish altarpieces usually consisted of a series of small scenes depicting the Life of Christ or the Life of the Virgin, or a saint's legend, each in a separate compartment beneath an elaborate baldacchino. The Annunciation in the collection of the Fogg Museum is a fragment from such an altarpiece (Catalogue number 24, Plate XXXII). Originally it was probably one of a series of scenes of the Life of Christ or the Virgin, all placed in naturalistic settings beneath the thin vertical tracery of baldacchinos. The figures were usually polychromed, with much use of burnished gold, giving an impression of precious goldsmithy.

The diminutive Madonna and Child of the Busch-Reisinger Museum (Catalogue number 23, Plate XXXII) is one of a long series of statuettes carved in Malines about 1500. It too bears witness to the interest in acquiring small devotional images for private use. The work demonstrates that the Netherlander, like the German, had intense civic pride, for the letter "M," the mark of the city, is carved on the back of the statue. The Malines figures and the Netherlandish altarpieces were often manufactured for export and were especially prized in Lower Germany.

The small figures of Adam and Eve in the Fogg Museum (Catalogue number 19, Plate XVII) may originally have been parts of a more extensive scene, but they too show the interest in small-scale sculpture, or *Kleinplastik*, that made its appearance in Germany before the end of the fifteenth century and greatly increased during the next hundred years.

The Beginnings of Humanism (1500–1550)

The first half of the sixteenth century was a period of turbulence. The Empire, divided into principalities, baronial estates, free cities, and ecclesiastical holdings, lacked cohesiveness. The Hapsburgs' family possessions rather than their imperial office gave them prestige. Maximilian's marriages to Mary of Burgundy and Bianca Sforza, and that of his son, Philip, to Juanna the Mad, eventually brought the Netherlands, Burgundy, Spain with its overseas possessions, and parts of Italy under Hapsburg control. At the opening of his reign, Maximilian summoned the Diet of Worms and an imperial court of justice, hoping to secure their support for initiating much-needed constitutional reforms. Power politics, economic instability, and social unrest hampered him, however. The landed nobility were unable to compete in large-scale mercantile and banking operations. Many sought economic salvation by marriage into wealthy burgher families. Such unions were frequently welcomed by the citizens of means, who put their excess capital into land for its prestige value in a society that still clung to the stratification of the Middle Ages. Jealousies of burgher, aristocrat, churchman, and peasant were becoming exacerbated.

The instability of the old order generated a bewilderment that is mirrored in much of the popular writing and preaching of the day. A feeling of rootlessness and confusion is expressed in such a passage as the following from Sebastian Brant's *Ship of Fools*:

> Our traveling will never end
> For no one knows where he'd wend
>
> We find no rest by day or night
> For none of us sees wisdom's light . . .*

* Edwin H. Zeydel, *The Ship of Fools by Sebastian Brant* (New York: Columbia University Press, 1944), p. 350, quoted by permission of the publisher.

The first authorized edition of the book appeared in 1494, and within a few years translations into the various dialects and vernaculars were widely published. The influence of the book can be detected in many writers, and even Erasmus, who addressed himself to a more sophisticated audience, clearly reflects the earlier publication in his *Praise of Folly*. Anticlerical attacks were not new, but they gained in bitterness as well as in volume. Martin Luther's preaching voiced the restless dissatisfaction of the times, and his publications in Latin and in German reached a large and sympathetic audience. When eventually he was declared a heretic by an edict of 1521, he and many of his followers were driven to an open rupture with the Roman Catholic Church.

Maximilian's numerous military campaigns required the formation of an army of professional mercenaries, known as *Landsknechte*, whose picturesque uniforms caught the imagination of many German artists. The uniforms survive today in the Swiss Guard of the Vatican and perhaps also in the "Beef-Eaters" at the Tower of London. The uniformed *Landsknecht* was frequently portrayed by graphic artists, and bronze workers used the form in their candlesticks. The bronze Wild-Man Candle Holder in the Busch-Reisinger Museum (Catalogue number 37, Plate XXXVI) has the military stance and wears the fierce guardsman moustache of the *Landsknecht* bronzes.

The Renaissance in Italy reached its height during Maximilian's reign. In several religious works of the first quarter of the sixteenth century we have noticed traces of Italian influence, which slightly modified Late Gothic style. The altarpieces of this period also show the tenacity of the earlier dynamic emotionalism, over which is a thin veneer of Italianism. The Breisach Altarpiece by the Master H. L. illustrates the continuity as well as the change. It has the violence of Veit Stoss, the complex superstructure, and the shadowy background, but the angular, undercut drapery is replaced by whirling, linear folds which sweep about the figures without infringing upon their organic structure. The Jesse Tree (Catalogue number 32, Plate XXXI), the predella of an altarpiece, has the same dynamism. The lively play of sweeping lines of vegetation must once have formed mysterious glittering accents against the dim background. The mannered postures of the figures at either end, David and Solomon, the puffed sleeves of their costumes and collars with broken contours are in perfect harmony with the agitated spirit of the design. The seed-pod at the left, for example, is echoed in a curious pictorial metaphor by the shape of David's sleeves. The work is Lower German in origin and closely related to the style of Heinrich Douvermann (act. 1510–1544). In his earlier works Douvermann was strongly influenced by the many altarpieces from the Netherlands that had found their way into Northern Germany. The Jesse Tree reflects his later style, when he had developed a type of composition less dependent on that of the Low Countries.

The Italian High Renaissance exerted a more direct influence on works designed for wealthy patricians or court circles. Italian humanism, however, though greatly admired by many German artists, at first had little appeal to the ordinary burgher, whose taste had been formed by the emotionalism and piety of the Late Gothic. Artists of the

first quarter of the sixteenth century vacillated between the demands of popular taste and that of more sophisticated circles. Albrecht Dürer throughout most of his career was preoccupied with the humanistic problem of ideal proportions for the figure. It is significant that in an engraving of 1504, one of his most successful solutions to the problem, he chose as his subject Adam and Eve rather than a classical theme. A series of sketches for this work indicated that his original intention was to depict Apollo. Engraving is a medium for mass consumption and Dürer may have felt that the god of antiquity would have but limited appeal.

The Emperor Maximilian was deeply impressed by Italian classicism, and in particular by its emphasis on individual fame and glory. A plan for his tomb in the Hofkirche at Innsbruck called for a series of gigantic figures of his ancestors, both legendary and actual, as watchers and mourners. The grandiose scheme was so costly that it had to be radically curtailed, and only a few of the huge figures were made. They stand solemnly around the sarcophagus, giving an impression of Roman imperial might. A number of artists were employed on the tomb, the most distinguished among them Peter Vischer the Elder (c. 1460–1529)and Hans Leinberger. Leinberger's figure of Albrecht of Hapsburg still has the illogical restless posture of the Late Gothic. Vischer's statues of King Arthur and Theodoric, on the other hand, display a logical articulation of the human form approximating Italian High Renaissance classicism.

Other statues for the tomb of Maximilian were completed after his death. They exemplify a style common to most of Northern Europe, with the superficial trappings of the Italian High Renaissance but no true understanding of classical grandeur. The Standing Warrior in the Fogg Museum (Catalogue number 35, Plate XXXIII) exemplifies this style, which reached into all artistic media — painting, sculpture, goldsmithy, even costume design. Like the funerary bronzes at Innsbruck, the Fogg Warrior exhibits a tendency to apply small decorative accents to the broader underlying surfaces, obliterating or concealing any suggestion of organic structure or Renaissance monumentality. The very complexity of the surface has a closer kinship to the Late Gothic than to the Renaissance. In costume design, the slashed garments with puffs of cloth drawn through the openings produce a similar nervous surface quality. The fashion persists into the second half of the sixteenth century, as in the lute player chandelier in the Busch-Reisinger Museum (Catalogue number 39, Plate XXXVII).

The famous Fugger banking family, on whom Maximilian largely relied for financial support, also commissioned a funerary project. The apse of the Church of Saint Anne at Augsburg was designed as a family burial chapel. The brothers Jakob and Ulrich Fugger initiated the enterprise and engaged for it a number of talented artists. The sculpture of the high altar represents a complete and unique break with Late Gothic tradition. This work by Hans Daucher (c. 1486–1538), a free-standing group consisting of the dead Christ supported by the Virgin and Saint John, owes a great debt to Italy in style as well as in concept.

[2 1]

The death of Maximilian in 1519 did not end the quarrels among Germans, Netherlanders, and French, which continued unabated during the reign of his successor Charles V (1519–1556). The Council of Trent (1548–1563) and Charles's abdication in 1556 punctuated but did not terminate these bitter disputes. Catholic and Protestant monarchs sought allies among the princes, whose influence, for a time eclipsed by the nascent bourgeoisie, was once more in the ascendant. While middle-class art patronage continued, there was a shift toward the princeling as a patron of importance. There had always been passionate collectors among noblemen, of course, but now the *Wunderkammer*, the private art gallery, made its appearance in palaces and in the homes of wealthy patricians. Inventories of many of the collections of aristocrats, bankers, and merchants attest to the widespread fashion and to the variety of objects. The sculptor answered the new demand with increased production of statuettes and small reliefs in alabaster, soapstone, and fine-grained boxwood. Bronze workers made statuettes and cast medals and plaques.

In Italy the art of the medalist made its appearance before 1400 and Italian medals were collected as early as 1402 by the Duc de Berry. It was only in the sixteenth century, however, that the portrait medal became fashionable in Germany. These brilliant examples of small-scale portraiture became so popular that likenesses were carved on the wooden pieces used in checkers or backgammon. Fine-grained wood and stone were employed in making the models for the medalist. Molds were fashioned from these models and the finished medal was cast in silver or bronze. A characteristic example, although not a portrait, is the silver medal by Hans Reinhart (1517–1581) that was commissioned by Johann Friedrich, Duke of Saxony (Catalogue number 34, Plate XXXIV). The court of Saxony had long been a center of humanistic studies. Dürer, Lucas Cranach, and the Venetian Jacopo dei Barbari were among the artists working there. And the Duke had offered asylum to Martin Luther. Cranach was official court painter to Johann Friedrich at the time Reinhart cast his medal and its complex iconographic scheme clearly owes much to the painter. Indeed, the same type of subject was employed by Cranach in his design for the title page of Luther's translation of the Bible.

The small reliefs and statuettes of German *Kleinplastik* soon began to use allegorical subjects and themes drawn from classical sources. A splendid example is the stone relief of the Triumph of a Sea-Goddess or Nymph (Catalogue number 33, Plate XXXIV) by Peter Floetner (1485–1546). Floetner follows the method of the medalist in carving models from which molds were made. In this case, he created a goldsmith's model, for the relief was probably intended as the base of a goblet or candlestick. The influence of Renaissance Italy — it is known that Floetner made at least one trip there — is obvious in the circular relief. The putti in the goddess's retinue, while lively and restless, are organic and rational in conception. In such a work as this German culture most closely approaches the Italian Renaissance.

The Late Renaissance (1550–1620)

Attempts in the first half of the sixteenth century to adopt the Italian style were finally successful after about 1550. Among the artists of the North, a predisposition to the piety and mysticism so strangely combined with naturalism in Late Gothic tradition had been an obstacle to understanding classical Italian art. It was only when some of the Late Renaissance artists of Italy developed an agitated, non-classical style of their own that their art became fully congenial to the sculptors of Central and Northern Europe.

The abdication of Charles V split the Hapsburgs into two branches, the Spanish and the Austrian. Ferdinand I (1556–1564), Charles's successor, was able to keep control over Naples, Milan, and the Netherlands. The Austrian Hapsburgs governed their lands from Prague, but the Empire had little or no power in Germany itself, which was divided by many rival princes and titled churchmen whose loyalty to the Emperor was purely formal. As patrons of art, these petty rulers frequently looked to foreign sources for guidance in fashion and culture. Somber Spanish court costume was adopted at every German court, while Italy and especially the Netherlands supplied the styles in the pictorial arts.

Early in the sixteenth century, the Low Countries had demonstrated in their painting a propensity to imitate the North Italian followers of Leonardo and the works of Raphael, whose cartoons were used by the Brussels tapestry weavers. This influence receded as an exaggeratedly attenuated Italian figure style made its appearance at the court of Francis I at Fontainebleau and diverted the artistic currents of the Netherlands both in sculpture and in painting. The religious and mythological paintings of Jan Massys were among the earliest to hint at Fontainebleau influence in the Netherlands. Later the far more sophisticated works of such painters as Bloemaert, Goltzius, and Spranger were eagerly collected by Rudolf II (1596–1612) at the Imperial Court of Prague.

German sculptors had some direct contact with Italy, but it was the Italian style as interpreted by the artists of the Netherlands that made its most lasting impression upon them. Strap and scroll ornament was introduced to Germany largely by such Netherlanders as Cornelis Floris (1518–1575) and Jan Vredeman de Vries (1527–c. 1604). It was termed the "Floris Style" and appeared in German architectural design, sculpture, goldsmithy, and even the plans for gardens. Italian figure style was imported by a second group of Netherlanders, especially active in Southern Germany. Like Cornelis Floris, a young Cambrai sculptor, Jean Boulogne, went to Italy to complete his training. Unlike Floris, however, he settled in Florence, never to return to the North. He became known as Giovanni Bologna (1529–1608) and soon his fame attracted many sculptors from the Low Countries and Germany. Chief among his Northern pupils were Adriaen de Vries (c. 1560–1627), Hubert Gerhard (c. 1545–1613), and Hans Reichle (c. 1570–

1642). These three men, along with their German imitators, were employed extensively by the Fuggers in Augsburg and at the Bavarian court in Munich, as well as in the Tyrol and even in Scandinavia. They produced fountain groups derived from those in Florence, architectural sculpture, and many small bronzes.

The silver Madonna on a Crescent with a sunburst of gilded rays behind her is a brilliant example of Augsburg goldsmithy of about 1600 (Catalogue number 51, Plates XLII, XLIII). The Virgin and the four small angels on the base are closely related to the bronze figures of Hubert Gerhard, while the silver ornament on the base is executed in the "Floris Style."

Many of the German sculptors active in Southern Germany were trained in Weilheim, where there was a concentration of craftsmen. Among them were Hans Krumper (c. 1570–1634), Hans Degler (act. 1591–1637), and, somewhat later, Georg Petel (1601–1634). Krumper's mature style is reflected in the large polychromed wood figure of an Angel (Catalogue number 53, Plate XLI); and the plump cheeks, curly hair, and beards of the Roman soldiers in the Christ Crowned with Thorns (Catalogue number 52, Plate XLVII) suggest some of the works of the Munich-Weilheim artists. The lively movement of the soldiers is not unlike that of the Late Gothic, while the Christ seems to have been derived from Dürer or Leinberger.

This strange eclecticism is not a rarity in the sculpture of the late sixteenth and early seventeenth centuries. The absence of national or local idiosyncrasies in this courtly art makes it difficult to attribute such works as the plaquettes of the Triumphs in the Fogg Museum (Catalogue numbers 43–47, Plate XXXVIII). First published as Italian, they are now generally regarded as products of Northern Europe, but there is no agreement as to whether their author was a German or a Netherlander.

The *Wunderkammer* was not always restricted in its contents to works of art. It often contained as well a variety of plant and animal forms, shells, and geological specimens. Demand stimulated the expansion of the goldsmith trade, the most productive centers of which were in Nuremberg and Augsburg. Skilled craftsmen frequently combined such natural objects as coconuts, coral, shells, and ostrich eggs with goldsmithy to make display pieces and table ornaments. In this way they satisfied the collectors' interest both in natural objects and in artifacts. The Coconut Goblet in the Busch-Reisinger Museum (Catalogue number 50, Plate XL) and the Model of a Nautilus Goblet (Catalogue number 60, Plate XLIV) exemplify this dual interest. In the Coconut Goblet the natural form itself is embellished with carving. The base, stem, and top of the goblet and the straps that hold the nutshell in position are decorated with a combination of scroll and strap work somewhat reminiscent of the ornament of the Floris Style and acanthus leaves typical of the Late Renaissance.

A taste for the curious and bizarre created a market for utilitarian objects in animal shape. The aquamanile of the Middle Ages had established a precedent, but the use of birds or reptiles for this purpose may have been inspired by the bronzes of Andrea Ricci

and Giovanni Bologna. The goldsmiths of the Late Renaissance produced an increasing variety and quantity of these zoomorphic forms, decorative and utilitarian. The silver Crocodile in the Fogg Art Museum (Catalogue number 49, Plate XLV), a sand container and originally part of a writing set, unites both aspects.

Finely-executed statuettes were greatly valued by collectors. The small bronzes of Adriaen de Vries and Hubert Gerhard, or even such a work as the gilded bronze Saint John the Evangelist in the Fogg Art Museum (Catalogue number 48, Plate XLVI) testify to this vogue. Humanistic themes were popular, as were personifications such as Vanity and various kinds of *memento mori*, enumerated in sixteenth-century inventories. Skulls, tiny skeletons, and small replicas of cadavers were much prized. The figurines of Death in the Busch-Reisinger Museum (Catalogue numbers 54, 55, Plates XLVIII–LI) are the works of a master who seems to have specialized in this subject. In spite of the decaying flesh and flaps of skin, these figures have a languorous grace that transforms them into objects of unusual beauty.

The Early Baroque Style (1620–1680)

The Counter Reformation produced only some isolated examples of religious art before the end of the sixteenth century. The Jesuit church of Saint Michael in Munich, designed, at least in part, by the Netherlander Frederik Sustris (c. 1520–aft. 1599), was finished in 1597. The huge figure of Saint Michael battling Satan on its façade was made by Hubert Gerhard. In Augsburg a large bronze Crucifixion by Hans Reichle was completed in 1605 for the Church of Saints Ulrich and Afra; and in the same Church Hans Degler carved the great high altar and two side altars, free-standing in the space of the transepts. The first German sculptor to understand true High Baroque style was Georg Petel, who was in direct contact with Bernini (1598–1680) in Italy, Van Dyck in Genoa, and more especially with Rubens in Antwerp. Petel's promising career, however, was tragically ended at the age of about 33, when he died during the siege of Augsburg (1634). Protestant resistance to the Catholic Reaction retarded the reawakening of church art and the faint and belated beginnings were interrupted by the devastation of the Thirty Years' War. This conflict, with Germany its battlefield, so ravaged the country that it was almost a generation after the Peace of Westphalia before church building and decoration were fully resumed. Thus it was not until much later that the art of Bernini and Rubens had its full impact and that an important style of religious sculpture emerged.

During the war and immediately following it, artistic activity continued and kept alive the high quality of craftsmanship that distinguished the Late Gothic and Renaissance periods. On the other hand, a nostalgic yearning for a more peaceful past may account for a revival style that made its appearance during the first half of the seventeenth century and that looked back at the great sculptural achievements of the "Dürer

Period" — the first two decades of the sixteenth century. This revival has only recently been identified by art historians, who have uncovered examples of seventeenth-century sculpture that were originally recorded as early sixteenth century. The two figures of Death already mentioned (Catalogue numbers 54, 55, Plates XLVIII–LI) demonstrate this retrospective tendency, recalling the many paintings, graphic works, and sculptures of the subject made in the first quarter of the sixteenth century.

The Late Gothic religious sculptural tradition was powerful enough to outlast the Late Renaissance and the Thirty Years' War. Many Late Gothic churches were "brought up to date" through replacement of their original furnishings with altarpieces of the late seventeenth and early eighteenth centuries. These retables, however, retained many of the features of Late Gothic altarpieces. They usually had a tripartite division in the manner of the earlier triptych. The space behind the scene represented has no boundaries and is allowed to extend unimpeded. The figures are often clad in deeply-undercut complex drapery. Sometimes the garments revert to the angular folds characteristic of the Late Gothic. This is true of the Busch-Reisinger Museum figure of Saint Sebastian (Catalogue number 59, Plate LII) by Erasmus Kern (act. 1624–c. 1650). The sharp, brittle folds of the loincloth are closer in style to the Late Gothic than to the Baroque. The human form is conceived more organically than in Late Gothic sculpture, but its agitated movement and minutely detailed naturalistic surface look back to the earlier style.

The sculptors of the Netherlands were much quicker to adopt the true Baroque style than were the Germans. Artists from the Low Countries such as Artus Quellinus (1609–1668) and François du Quesnoy (c. 1594–1643) actually worked in Rome with Bernini, one of the founders and chief representatives of the style. Others learned the new mode from the great Antwerp painter, Peter Paul Rubens, whose influence was so pervasive that it reached even the Northern pupils of Bernini.

The style of these Italianized Netherlanders is represented in the Harvard collections by the two busts of François du Quesnoy (Catalogue numbers 57, 58, Plates LIV, LV) who, like Jean Boulogne before him, resided in Italy during his productive years. Du Quesnoy, although closely associated with Bernini, did not slavishly imitate him. The gentle, tranquil spirit of the Virgin and the youthful Christ is close to the late antique and far removed from Bernini's dynamism.

Rubens is the likely source for a pair of busts of the Greek philosophers Democritus and Heraclitus in the Fogg Museum (Catalogue numbers 67, 68, Plates LX, LXI). The Antwerp master portrayed these subjects more than once, and an engraving after one of his lost designs may well have served as the model for the unknown Netherlander who carved them. Rubens' effect on the sculptors of Germany and Austria thus extended beyond the circle of those who had personal contact with him. Many of his compositions were diffused by graphic artists, who reproduced them on as large a scale as the medium of engraving permitted. A typical example of the transmission of Rubens' art through

engraved copies is the altarpiece of the Return of the Holy Family from Egypt in the Busch-Reisinger Museum (Catalogue number 61, Plates LXII, LXV), an early work by Meinrad Guggenbichler (1649–1723), whose activity was largely confined to the Salzburg area. He and the somewhat older Thomas Schwanthaler (1634–1707) were both inspired by a Rubens painting of the Return of the Holy Family which has survived only in engravings. Guggenbichler did not achieve the spatial unity of altarpiece and church interior that later marked the fully developed Baroque. His rather lyrical note, too, differs from true Baroque pathos; and the manner in which he uses small folds to break the plastic surfaces is reminiscent of Late Gothic sculpture.

The influence of Rubens is evident also in small-scale sculpture. The ivory Sacrifice of Isaac in the Busch-Reisinger Museum (Catalogue number 63, Plate LVII) has some kinship with a composition of the same subject made by Rubens for the ceiling of the Jesuit Church in Antwerp and preserved only in his preliminary sketches. In the ivory, Abraham's arms form an S-curve that is repeated in the major accents of the drapery, in the postures of Isaac and the angel, and even in the lizard on the base. The patriarch's whole body, following the same curve, is swayed by the force of his action. The spectator's eye, arrested by the faggots which form a horizontal accent, is then impelled upward to the climax of the drama, the angel of the Lord preserving the life of the young Isaac. The general composition with its flowing unity of form and dramatic intensity recalls the Rubens ceiling sketches, and the ivory group approaches the artistic goals of the High Baroque.

The High Baroque Style (1680–1730)

The power of the Spanish branch of the Hapsburgs began to decline toward the middle of the seventeenth century, at the very time that the young Louis XIV (1643–1715) found himself at the head of a strong state. The forcefulness of the Sun King advanced the cause of rule by divine right and its concomitant absolutism. In the absolute monarchy no rival could be permitted to dilute or infringe upon the authority of the king, who exercised control through a centralized bureaucracy over all aspects of the lives of his subjects. Baroque art has been described as translating into visual terms the fundamental conceptions of absolutism. Certainly the unity of parts radiating from and subordinate to a single compelling motive is apparent in much Baroque art. Bernini's colonnade attached to the Church of St. Peter in Rome reaches out to embrace the entire populace and to draw it toward the dominating structure of the Church itself. The palace at Versailles, which became the focal point of the French state, is also designed to carry out this role. The scale of the central pavilion emphasizes its commanding position. The approaches to the palace seem to converge on this principal architectural element, which is also the point of orientation for the gardens behind it. Promenades and avenues embellished by water basins, fountains, statuary, and terraces are all

integrated with the building to which they seem to owe their existence and to which they are subservient.

In Germany the heads of states small and large now looked to the French court rather than to Spain. The defeat of the Turks by Leopold I of Austria in 1683 delivered the Empire from a costly threat and gave added impetus to the construction of palaces, monasteries, and churches. Central Europe became dotted with lesser or greater Versailles designed to impress the world with the wealth and power of a prince or prince-bishop. The Schönbrunn Palace at Vienna is a characteristic example. Unity was not only the key to the relationship of buildings and adjacent gardens, but it was also the guiding principle of the interiors, where the arts of architecture, sculpture, and painting merged and where drama, music, and dance combined with the visual arts to serve the monarch and his court.

Similarly, there were vast undertakings in ecclesiastical architecture. The huge monasteries of Southern Germany and Austria rival the palaces in scale and grandeur. The church interiors, like those of the palaces, embody the concept of unity. Often the space was governed by a great cupola pierced with windows admitting the light of grace. Sometimes the ceiling is opened up by the art of the painter, who represents skies peopled by the heavenly hosts. The figures on the sculptured altarpieces or tabernacles seem to reach out and gather to themselves the space of the interiors, to coalesce with it. The substantial core of the structure, respecting the principles of classic design, distinguishes between vaults and supports, as in the monastic church at Banz. A kinetic quality, however, is often present in the curved moldings and broken entablatures, a first step toward the subsequent style which denies any distinction between supporting wall and ceiling. The dramatic arts also lent something to the design of church interiors. Galleries take on the appearance of loges. And the emotionalism and pathos of Counter-Reformation painting and sculpture have the hyperbole of the theater. In some of the churches of Southern Germany and Austria the church interior is a stage setting for the dramatic event depicted on the high altar. In the church at Weltenburg, for example, the oval of the nave is fundamentally a means of drawing attention to the altar, where the equestrian Saint George does battle in the golden light of concealed windows. Here a dramatic unity is achieved by the combined skills of architect, sculptor, and painter. When individual figures are removed from such settings and placed in the galleries of a museum, their effect is no longer enhanced by their relationship to the whole interior design and much of their impact is lost.

The violent pathos of the Baroque is nevertheless communicated in some isolated figures, such as the sorrowing Madonna in the Busch-Reisinger Museum (Catalogue number 66, Plates LVIII, LIX), probably from a Crucifixion. The strong plastic volume of the figure is shrouded by drapery that is deeply undercut and that seems to engulf the surrounding space. The folds of the drapery and the position of the arms lead the eye of the beholder to the face, which, framed by the deep shadows of the veil, is con-

torted by an overpowering grief. The figure is attributed to the Antwerp sculptor, Michiel van der Voort (1667–1737), author of several pulpits in the Southern Netherlands.

The inception of the Baroque style in the South we have seen in Guggenbichler's late seventeenth-century group of the Return of the Holy Family from Egypt (Catalogue number 64, Plates LXII, LXV). The High Baroque is illustrated by a life-size Crucifixion, also an Austrian work (Catalogue number 72, Plates LXIII–LXV), belonging to the Busch-Reisinger Museum. Originally the mourning figures of the Madonna and Saint John the Evangelist were set on a plane in front of the Cross. This suggests that they may once have occupied a niche membered by Corinthian pilasters or flanked by Berninesque twisted columns. Perhaps the group was free-standing, with windows behind it. Thus they were united with their architectural setting and with the interior space of the church itself. Space penetrates the plastic bulk of the figures through the device of deeply-undercut folds in the garments. The colossal scale and the unrestrained anguish communicated by facial expression and gesture are typical of the Baroque. Unity and dramatic effect are further achieved by the treatment of details and by the formal composition. The Saviour gazes upward as if seeking solace from the source of divine light. His body is carved with detailed anatomical accuracy, and originally the flesh tones, slightly greenish in hue, were spattered with blood. The loincloth, with its restless movement and jagged silhouette, seems agitated by His suffering. The void at the left, formed by the two sharp ends of the loincloth, is echoed by the similar but smaller space between the thumb and fingers of the upraised hand of the Madonna. At the right, the rounded form of the loincloth at Christ's waist is repeated by the rounded form of the drapery of Saint John. The two side figures are swathed in deeply-undercut drapery, the bulky folds of which swing in great diagonal curves that seem to envelop the figures as though they were free-standing. These same curves form part of the overall design welding the three figures into a formal and dramatic unity. A comparison of the slender figures of Mary and Joseph in the Guggenbichler altarpiece with the grandiose figures of the Crucifixion reveals the marked change within a generation. Joseph's thin, ascetic face has a spiritual quality that contrasts with the overstated piety of Saint John.

The life-size Church Fathers, Saint Ambrose and Saint Augustine (Catalogue numbers 81, 82, Plates LXXII, LXXIII), were probably pendant figures on a Baroque altar. The rather tranquil countenances have nothing of the intensity of the High Baroque. The surfaces of the bishops' robes are broken into a series of small folds that are linear in character. The proportions are more slender and the figures assume almost mincing postures. The drapery appears to flutter capriciously and not in response to any movements of the Saints themselves. The style of these figures looks forward to the period following the High Baroque.

The interest of the Late Renaissance in small-scale sculpture was maintained during the Baroque period. The Crucifixion in the Fogg Museum (Catalogue number 73, Plates LXVI, LXVII) was probably intended for the altar of a small chapel. The artist's

skill in handling detail is in the best tradition of German *Kleinplastik*. The minutiae of human anatomy, the precisely modeled ornament on the ewer, the tufts of vegetation, rocks, and stumps on the Mount of Golgotha, each rendered with exquisite accuracy, make the work something of a tour de force. The kneeling Magdalen in the Busch-Reisinger Museum (Catalogue number 76, Plate XLIV), probably by a member of the Schwanthaler family, must once have belonged to a similar Crucifixion. Her rich costume and inset jewelry mark her as the courtesan, repentant and grief-stricken, a figure with all the dramatic pathos of the Baroque.

The Rococo Style (1730–1780)

During the reigns of Louis XV of France (1715–1774), Maria Theresa of Austria (1740–1780), and Frederick the Great of Prussia (1740–1786), while the principles of absolutism were maintained, court circles seemed to react against the ponderous ceremony and protocol of Louis XIV. Pleasure palaces with great park lands were erected by the rulers of Europe, less from a desire to commune with nature than to escape from the stifling court atmosphere. The court of France remained the arbiter of taste, and patronage of the arts was still largely in the hands of princes and churchmen. French Rococo palace decoration gave a new name (*rocaille*) to the style of the period, which, however, was not an abrupt departure from the Baroque. Palace and park were still conceived as a single unit. A garden pavilion with large windows, usually on the central axis of the building, opened onto the main *allee* of the park, joining the building with the terraces, basins of water, fountains, and statuary in a dynamic whole. The spacious and lofty stairwells (*Treppenhäuser*) were opened out to the limitless skies by stucco and painting. A classic example is at Würzburg, with its Tiepolo ceiling paintings. The walls never terminate but fade into celestial regions peopled by creatures from Mount Olympus or by allegorical figures, perhaps personifications of the elements, the seasons, the four parts of the earth. The low treads of the monumental stairs seem to propel the visitor to the heavenly delights above.

The porcelain cabinets give some idea of the frivolity and gaiety of the court. These small rooms housed mythological and allegorical porcelain figures, dancing ladies and gentlemen, flirtatious couples, ladies at the hairdresser's, tradesmen, peasants, and characters from Italian comedy. True European porcelain originated early in the eighteenth century at the Saxon court, with its factory at Meissen. Soon almost every prince in Europe had stolen the "secret" of making hard paste porcelain and established factories of his own, many of which proved to be a source of revenue, in addition to providing decorative pieces for the court. Objects of other material were collected as well. During the reign of August the Strong of Saxony, the famous Grüne Gewölbe at Dresden boasted not only porcelains but goldsmithy, jewels, and carvings of amber and ivory. The little Beggar (Catalogue number 70, Plate LVII) by Wilhelm Krüger (1680–1756) in the

Busch-Reisinger Museum is a type of ivory carving much in vogue at the time. The coarse features, ragged garments, and physical deformities are rendered with merciless naturalism, and must have acted as a foil for the politely amorous ladies and gentlemen or the scrubbed and decorous peasants and tradesmen created by the porcelain workers.

The leading and most influential Rococo sculptor in Austria, Georg Raphael Donner (1693–1741), introduced a figure style that apparently drew inspiration from sixteenth-century rather than eighteenth-century French models. The Reclining Nymph of the Busch-Reisinger Museum (Catalogue number 78, Plate LXVIII) is a free adaptation of the famous "Nymph of Fontainebleau" made in the early sixteenth century. The lissome form with long legs, small breasts, and sloping shoulders comes close to observing the canon of proportions introduced by Late Renaissance Italian sculptors and painters at the French court. Donner's Nymph is based on a more logical organic conception of the human form, however, and the regular features of the face and languid pose seem almost classical if compared with the restless, illogical, nervous tension of much sixteenth-century work. Although the subject is derived from the antique, Donner depicts the nude nymph reclining on silken cushions, fondling her lap dog as if she were a court lady.

Donner's pseudo-classicism was adopted as the official style at the art academy in Vienna, whence it spread widely through Austria and Southern Germany. The small polychromed wood figure of the Magdalen in the Desert (Catalogue number 79, Plate LXIX) is related to the Donner style. The elegance of proportions, the gentle feminine beauty, and the detailed naturalism of the rocky desert, which is sprinkled with glittering bits of mica, catered to Rococo taste. The subject itself, a well-dressed sinner seeking salvation in the wilderness, must have appealed to a culture that was to produce a Marie Antoinette playing the role of shepherdess. The Magdalen assumes the pose of Michelangelo's "Night" on the tomb of Giuliano de' Medici, but the tortured strength of the Italian figure has been replaced by a subtle, restrained eroticism.

Like Donner's Nymph and the Magdalen, the alabaster figure of Judith with the Head of Holofernes (Catalogue number 80, Plates LXX, LXXI) was designed to grace a princely collection and like them it has a sixteenth-century source of inspiration. The elongated forms resemble those of the Late Renaissance. The facial type, headdress, and hair held by a jeweled band, as well as the subject itself, are frequently encountered in the late Renaissance works of such Netherlands artists as Hendrik Goltzius or Abraham Bloemaert. The long, clinging folds of the garments are scarcely noticed because of the enormous complexity and many minor accents of the fluttering, angular drapery ends.

These moving and intricate small forms appealed to the same taste that governed the decoration of South German Rococo church interiors. Instead of a single ruling element, such as an altar or the dome of a High Baroque church, there is a great profusion of stucco work, painting, and cabinetry in a unity that is the sum of its parts rather than the domination of the rest by one overriding force. Like the palace stairwell,

the Rococo church has no boundaries and makes no distinction among the arts. The walls are obscured not only by architectural membering but by a multiplicity of altars and church furniture liberally bedecked with pretty children or attractive maidens in the role of angels. Madonnas became elegant court ladies, and the whole lacy structure breathes worldliness. The substance and weight of the High Baroque are gone. The scale of some of these religious structures is sometimes enormous, like the churches of Ottobeuren or Vierzehnheiligen. Because of their airiness, however, they never dwarf or overwhelm the worshiper. The pair of Hovering Angels and the little Head of an Angel in the Busch-Reisinger Museum (Catalogue numbers 83–85, Plate LXXVI) are characteristic of the myriad small creatures to be found in the church interiors. On confessionals, choir stalls, altars, tabernacles, and walls they combine with white stucco clouds in a playful lighthearted naturalism which suggests that opulent gaiety may be found beyond the pearly gates along with the sobriety of salvation.

Courtly ideals invaded ecclesiastical art to such an extent that it is sometimes difficult to know whether a statue was originally intended for church or for palace. An example is the Female Figure (Catalogue number 87, Plate LXXVII) by Ferdinand Dietz (1708–1777), whose style was one of the most genial of the Rococo. In the absence of attributes, one can hardly ascertain whether the statue represents a female saint, an allegorical figure, or an antique goddess. Does the upward glance signify piety or coquetry? The figure could be part of an altarpiece, or fit into the decorative scheme of a balustrade or niche of a palace interior. The mincing gait, swirls of drapery, coyness of expression, and mannered gestures might well belong to the performance of a court dance. The billowing cape faintly recalls the antique, while the position of the legs, one for balance and one for support, is a veritable caricature of the classical stance.

Dietz is best known for his garden sculptures. Sandstone figures, usually painted white to suggest marble and to protect the surfaces, were disposed about the parks of a palace as individual elements of a vast organization combining art and nature. The four huge, over life-size figures of the Seasons in the Fogg Museum (Catalogue numbers 88–91, Plates LXXVIII–LXXXIII) attributed to Johann Joachim Günther (1717–1789) have long been recognized as among the most important surviving examples of Rococo garden sculpture. They have a unity of form and content that must have been greatly enhanced by their original outdoor setting. Each figure has the attributes of the season it represents. The statues turn toward one another, giving a sense of the cyclic character of nature itself. Spring and Summer are both female figures with the attenuated proportions, sloping shoulders, and small breasts that bespeak courtly elegance. Spring is an activist at whose feet a putto plays the season's game, marbles. Summer, protected from the heat by her straw hat, is relaxed and passive. With the aid of a putto she holds a sheaf of wheat, the attribute of Ceres, but her contemporary bonnet robs her of any resemblance to a classical goddess. Autumn is a descendant of Bacchus. He is a gay vintner, who grins drunkenly at the old man, Winter. Like the females, the male person-

[3 2]

ifications are accompanied by children, a faun eating grapes and a putto seeking shelter from the cold and fanning a charcoal burner with his breath. Vigorous, bearded Winter hauntingly echoes Michelangelo's hooded figure in the Deposition in the Cathedral of Florence. The winds blow the drapery of the Four Seasons in all directions, suggesting further their union with natural forces.

Neoclassicism

The classical revival of the late eighteenth and early nineteenth centuries brought to an end both the worldly frivolity of the Rococo palace and the airy lightness of Rococo ecclesiastical interiors. The movement was initiated in part by new archeological discoveries and in part by Winckelmann's *History of Ancient Art* (1764). The "noble simplicity" extolled by Winckelmann was antipathetic to Rococo complexity. The Greek Revival buildings had heavy screen walls that excluded the outside world, and their rectilinear designs were diametrically opposed to the complex curvilinear patterns of the Rococo. The Greek Revival in France became associated with the Revolution and with the worship of reason. It was a truly international movement, however, with outstanding representatives throughout Europe.

German sculpture during the second half of the eighteenth century was gradually modified by Neoclassicism. Even some sculptors whose principal works were purely Rococo were affected by the growing interest in the antique. It is not surprising that Winckelmann's native Prussia produced two of Europe's finest Neoclassic sculptors, Johann Gottfried Schadow (1764–1850) and Christian Daniel Rauch (1777–1857). Schadow was the official sculptor of the Prussian court during the reigns of the self-indulgent Friedrich Wilhelm II and his more austere successor, Friedrich Wilhelm III. Schadow's style is represented by two terra cotta portrait busts in the Fogg Museum (Catalogue numbers 92, 93, Plates LXXXIV, LXXXV), which date from the height of his career and are about contemporary with his most popular sculpture, the marble group of the Princesses Luise and Friederike. The countenances of the two busts convey the immediacy of presence and personalities of the sitters. Their naturalism is far removed from the chill lifelessness of many works by Greek Revival sculptors, whose art seems to strive in its classicism for the exactness of archeological replicas. Schadow's figures are people of his own day.

Neoclassicism brings to a close the long history of excellence in Central European sculpture. During the nineteenth century sculpture lagged behind the other arts. Only in the twentieth century did German sculptors achieve once again the powerful expressiveness that had so strongly marked the greatest work of their predecessors.

[33]

Selected Bibliography
on German Sculpture

GENERAL HISTORIES

Georg Dehio, *Geschichte der deutschen Kunst*, Berlin and Leipzig, 1919–1926
Adolf Feulner and Theodor Müller, *Geschichte der deutschen Plastik*, Munich, 1953
Georg Piltz, *Deutsche Bildhauerkunst*, Berlin, 1962

REGIONAL AND SPECIALIZED HISTORIES

Rochus Kohlbach, *Steirische Bildhauer vom Römerstein zum Rokoko*, Graz, n.d.
Wilhelm Pinder, *Die deutsche Plastik vom ausgehenden Mittelalter bis zum Ende der Renaissance* (Handbuch der Kunstwissenschaft), Potsdam [1924–1929]
Georg Troescher, *Kunst- und Künstlerwanderungen in Mitteleuropa*, Baden-Baden, 1953–1954
Fritz Witte, *Tausend Jahre deutscher Kunst am Rhein*, Berlin, 1932

MUSEUM CATALOGUES

AACHEN

Hermann Schweitzer, *Die Skulpturen-Sammlung im Städtischen Suermondt-Museum zu Aachen*, Aachen, 1910

BERLIN

Staatliche Museen zu Berlin, *Die Bildwerke des deutschen Museums*:
Vol. I. W. F. Volbach, *Die Elfenbeinbildwerke*, Berlin and Leipzig, 1923
Vol. II. E. F. Bange, *Die Bildwerke in Bronze und in anderen Metallen*, Berlin and Leipzig, 1923

Vol. III. Theodor Demmler, *Die Bildwerke in Holz, Stein und Ton: Grossplastik*, Berlin and Leipzig, 1930

Vol. IV. E. F. Bange, *Die Bildwerke in Holz, Stein und Ton: Kleinplastik*, Berlin and Leipzig, 1930

COLOGNE

Hermann Schnitzler, *Das Schnütgen-Museum, eine Auswahl*, 2nd ed., Cologne, 1961

DRESDEN

Jean Louis Sponsel, *Das grüne Gewölbe zu Dresden*, Leipzig, 1925–1932

FRANKFURT A.M.

Anton Legner, *Spätgotische Bildwerke aus dem Liebieghaus*, Frankfurt a.M., 1961

Anton Legner, *Bildwerke der Barockzeit aus dem Liebieghaus*, Frankfurt a.M., 1963

HANNOVER

Gert von der Osten, *Katalog der Bildwerke in der Niedersächsischen Landesgalerie, Hannover*, Munich, 1957

MUNICH

Kataloge des Bayerischen Nationalmuseums, München, Vol. XIII:

Part 1. Philipp Maria Halm and Georg Lill, *Die Bildwerke in Holz und Stein vom XII. Jahrhundert bis 1450*, Augsburg, 1924

Part 2. Theodor Müller, *Die Bildwerke in Holz, Ton und Stein von der Mitte des XV. bis gegen Mitte des XVI. Jahrhunderts*, Munich, 1959

Part 4. Rudolf Berliner, *Die Bildwerke in Elfenbein, Knochen, Hirsch- und Steinbockhorn*, Augsburg, 1926

Part 5. Hans R. Weihrauch, *Die Bildwerke in Bronze und in anderen Metallen*, Munich, 1956

NUREMBERG

Walter Josephi, *Kataloge des Germanischen Nationalmuseums: Die Werke plastischer Kunst*, Nuremberg, 1910

Hubert Wilm, *Mittelalterliche Plastik im Germanischen Nationalmuseum zu Nürnberg*, Munich, 1922

ROTTWEIL

Julius Baum, *Die Bildwerke der Rottweiler Lorenzkapelle*, Augsburg, 1929

STUTTGART

Julius Baum, *Kataloge der kgl. Altertümersammlung in Stuttgart*, vol. III: *Deutsche Bildwerke des 10. bis 18. Jahrhunderts*, Stuttgart and Berlin, 1917

Albert Walzer, *Schwäbische Plastik im Württembergischen Landesmuseum*, Stuttgart, 1958

VIENNA

F. M. Haberditzl, *Österreichische Galerie, Wien, Das Barockmuseum im unteren Belvedere*, 2nd ed., Vienna, 1934

Ernst Kris, *Goldschmiedearbeiten des Mittelalters, der Renaissance und des Barock*, Vienna, 1932

Leo Planiscig, *Die Estensische Kunstsammlung, Skulpturen und Plastiken des Mittelalters und der Renaissance*, Vienna, 1919

Leo Planiscig, *Die Bronzeplastiken*, Vienna, 1924

Julius von Schlosser, *Werke der Kleinplastik in der Skulpturen sammlung des a.h. Kaiserhauses*, Vienna, 1910

MEDIA AND TECHNIQUES

Wilhelm von Bode and W. F. Volbach, *Gotische Formmodel*, Berlin, 1918

Georg Habich, *Die deutschen Schaumünzen des XVI. Jahrhunderts*, Munich, 1929–1934

Hans Huth, *Künstler und Werkstatt der Spätgotik*, Augsburg, 1923

Otto Pelka, *Elfenbein*, 2nd ed., Berlin, 1923

Eugen von Philippowich, *Elfenbein*, Brunswick, 1961

Marc Rosenberg, *Geschichte der Goldschmiedekunst auf technischer Grundlage*, Frankfurt a.M., 1910–1924

Marc Rosenberg, *Der Goldschmiede Merkzeichen*, 3rd ed., Frankfurt a.M., 1922–1928

L. A. Springer, *Die bayrisch-österreichische Steingussplastik der Wende vom 14. zum 15. Jahrhundert*, dissertation, Würzburg, 1936

Hubert Wilm, *Die gotische Holzfigur, ihr Wesen und ihre Technik*, Leipzig, 1923

Hubert Wilm, *Gotische Tonplastik in Deutschland*, Augsburg, 1929

GOTHIC, 1200–1450

Ilse Baier-Fütterer, *Gotische Bildwerke der deutschen Schweiz, 1220–1440*, Augsburg, 1930

Hermann Beenken, *Bildhauer des vierzehnten Jahrhunderts am Rhein und in Schwaben*, Leipzig, 1927

[37]

Karl Heinz Clasen, *Die mittelalterliche Bildhauerkunst im Deutschordensland Preussen, Die Bildwerke bis zur Mitte des 15. Jahrhunderts*, Berlin, 1939

E. L. Fischel, *Mittelrheinische Plastik des 14. Jahrhunderts*, Munich, 1923

Max H. von Freeden, *Gothic Sculpture, the Intimate Carvings*, Greenwich, Connecticut, 1962

Hans Jantzen, *Deutsche Plastik des 13. Jahrhunderts*, Munich, 1944

Herbert Kunze, *Die Plastik des vierzehnten Jahrhunderts in Sachsen und Thüringen*, Berlin, 1925

Kurt Martin, *Die Nürnberger Steinplastik im XIV. Jahrhundert*, Berlin, 1927

Gertrud Otto, *Die Ulmer Plastik des frühen fünfzehnten Jahrhunderts*, Tübingen, 1924

Erwin Panofsky, *Die deutsche Plastik des elften bis dreizehnten Jahrhunderts*, Munich, 1924

Wilhelm Pinder, *Die deutsche Plastik des vierzehnten Jahrhunderts*, Munich, 1925

Alexander von Reitzenstein, *Deutsche Plastik der Früh- und Hochgotik*, Königstein, 1962

Hans Wentzel, *Lübecker Plastik bis zur Mitte des 14. Jahrhunderts*, Berlin, 1938

Erich Wiese, *Schlesische Plastik von Beginn des XIV. bis zur Mitte des XV. Jahrhunderts*, Leipzig, 1923

LATE GOTHIC 1450–1525

Julius Baum, *Gotische Bildwerke Schwabens*, Augsburg, 1921

Julius Baum, *Niederschwäbische Plastik des ausgehenden Mittelalters*, Tübingen, 1925

Julius Baum, *Die Ulmer Plastik um 1500*, Stuttgart, 1911

Günther and Klaus Beyer, *Mittelalterliche Bildwerke aus Thüringer Dorfkirchen*, Dresden, n.d.

Justus Bier, *Nürnbergisch fränkische Bildnerkunst*, Bonn, 1922

Alfred Ehrhardt, *Niederdeutsche Altarschreine*, Hamburg, 1938

Adolf Feulner, *Die deutsche Plastik des sechzehnten Jahrhunderts*, Munich, 1926

K. Garzarolli von Thurnlackh, *Mittelalterliche Plastik in Steiermark*, Graz, 1941

Karl Gröber, *Schwäbische Skulptur der Spätgotik*, Munich, 1922

Philipp Maria Halm, *Studien zur süddeutschen Plastik Altbayern und Schwaben, Tirol und Salzburg*, Augsburg, 1926–1927

Carl Georg Heise, *Lübecker Plastik*, Bonn, 1926

Walter Hentschel, *Sächsische Plastik um 1500*, Dresden, 1926

Edith Hessig, *Die Kunst des Meisters E.S. und die Plastik der Spätgotik*, Berlin, 1935

Heinrich Höhn, *Nürnberger gotische Plastik*, Nuremberg, 1922

Herbert Kunze, *Die gotische Skulptur in Mitteldeutschland*, Bonn, 1925

Friedrich Lübbecke, *Die Plastik des deutschen Mittelalters*, Munich, n.d.

[38]

A. Matthaei, *Werke der Holzplastik in Schleswig-Holstein bis zum Jahre 1530*, Leipzig, 1901

Willi Meyne, *Lüneburger Plastik des XV. Jahrhunderts*, Leipzig, 1959

Carl Theodor Müller, *Mittelalterliche Plastik Tirols*, Berlin, 1935

Theodor Müller, *Alte bairische Bildhauer vom Erminoldmeister bis Hans Leinberger*, Munich, 1950

Karl Oettinger, *Altdeutsche Bildschnitzer der Ostmark*, Vienna, 1939

Gertrud Otto, *Die Ulmer Plastik der Spätgotik*, Reutlingen, 1927

Walter Paatz, "Prolegomena zu einer Geschichte der deutschen spätgotischen Skulptur im 15. Jahrhundert," *Abhandlungen der Heidelberger Akademie der Wissenschaften, Philosophisch-historische Klasse*, 2nd session, Heidelberg, 1956

Walter Paatz, *Süddeutsche Schnitzaltäre der Spätgotik*, Heidelberg, 1963

Wilhelm Pinder, *Die deutsche Plastik des fuenfzehnten Jahrhunderts*, Munich, 1924

Max Sauerlandt, *Deutsche Plastik des Mittelalters*, Königstein, 1924

Alfred Schädler, *Deutsche Plastik der Spätgotik*, Königstein, 1962

Rudolf Schnellbach, *Spätgotische Plastik im unteren Neckargebiet*, Heidelberg, 1931

Otto Schmitt, *Oberrheinische Plastik im ausgehenden Mittelalter*, Freiburg i.B., 1924

F. Stuttmann and Gert von der Osten, *Niedersächsische Bildschnitzerei des späten Mittelalters*, Berlin, 1940

Grete Tiemann, *Beiträge zur Geschichte der mittelrheinischen Plastik um 1500*, Speyer, 1930

RENAISSANCE AND EARLY BAROQUE, 1520–1650

E. F. Bange, *Die deutschen Bronzestatuetten des 16. Jahrhunderts*, Berlin, 1949

E. F. Bange, *Die Kleinplastik der deutschen Renaissance in Holz und Stein*, Munich, 1928

E. W. Braun, *Kleinplastik der Renaissance*, Stuttgart, 1953

A. E. Brinckmann, *Süddeutsche Bronzebildhauer des Frühbarocks*, Munich, 1923

Adolf Feulner, *Münchner Barockskulptur*, Munich, 1922

Heinrich Höhn, *Nürnberger Renaissanceplastik*, Nuremberg, 1924

Simon Meller, *Die deutschen Bronzestatuetten der Renaissance*, Munich, 1926

Theodor Müller, *Deutsche Plastik der Renaissance bis zum Dreissigjährigen Krieg*, Königstein, 1963

Herbert Rudolph, *Die Beziehungen der deutschen Plastik zum Ornamentstich in der Frühzeit des siebzehnten Jahrhunderts*, Berlin, 1935

Max Sauerlandt, *Kleinplastik der deutschen Renaissance*, Königstein and Leipzig, 1927

A. E. Brinckmann, *Barock-Bozzetti: Deutsche Bildhauer*, Frankfurt a.M., 1924

A. E. Brinckmann, *Barockskulptur* (Handbuch der Kunstwissenschaft), Berlin, 1919

Heinrich Decker, *Barock-Plastik in den Alpenländern*, Vienna, 1943

Adolf Feulner, *Bayerisches Rokoko*, Munich, 1923

Adolf Feulner, *Die deutsche Plastik des siebzehnten Jahrhunderts*, Munich, 1926

Adolf Feulner, *Skulptur und Malerei des 18. Jahrhunderts in Deutschland* (Handbuch der Kunstwissenschaft), Potsdam, 1929

Max H. von Freeden, *Kleinplastik des Barock*, Stuttgart, 1951

Wilhelm Pinder, *Deutsche Barockplastik*, Königstein, 1933

Lothar Pretzell, *Salzburger Barockplastik*, Berlin, 1935

Alexander von Reitzenstein, *Deutsches Rokoko*, Berlin, 1937

P. Martin Riesenhuber, *Die kirchliche Barockkunst in Oesterreich*, Linz, 1924

Max Sauerlandt, *Die deutsche Plastik des achtzehnten Jahrhunderts*, Munich, 1926

Arno Schönberger, *Deutsche Plastik des Barock*, Königstein, 1963

E. Tietze-Conrat, *Österreichische Barockplastik*, Vienna, 1920

Catalogue

EXPLANATORY NOTE

Dimensions are given to the nearest one-eighth inch, and in the case of reliefs height precedes width.

Under the heading LITERATURE all publications that mention or reproduce the entry are listed. If such publications have any bearing on the attribution essay, they are cited again in the footnotes.

Catalogue

1. Seated Monk, Upper Rhenish, c. 1280-1290

Fogg Art Museum 1949.47.96; purchase, Alpheus Hyatt Fund. Red sandstone; h. 32 in. (81.2 cm.); back flat

Plate I

COLLECTIONS
Joseph Brummer, New York

LITERATURE
Museum of Fine Arts, Boston, *Arts of the Middle Ages: 1000–1400*, exhibition catalogue, February 17–March 24, 1940, no. 174, p. 54.

The figure is seated in a frontal position with both feet planted firmly on the ground. A fragmentary left hand rests on the knee. The right shoulder is slightly raised. A long cape is tied loosely across the breast with a doubled thong. On the left shoulder is a T-shaped cross, the Tau cross of the Antonite Order.

The losses of head, right arm, and left hand are relatively old. More recently, abrasions and chips have occurred on the ridges of the drapery.

In spite of the damage it has sustained, the statue clearly reflects the High Gothic style of the second half of the thirteenth century. Although the figure is bulky and block like in appearance, the drapery, falling in deeply-cut folds between the knees, follows the outlines of the human body. The costume, bent into sharp ridges, seems almost metallic. The minor folds take on the appearance of overlapping leaves or sheets of metal. The whole forms a linear design instead of creating an impression of sculptural bulk.

The treatment of the drapery recalls the manner of some of the Strassburg Cathedral workshops in the second half of the thirteenth century. The use of red sandstone is common to the Upper Rhine region. It is employed not only at Strassburg but also in such buildings as the cathedrals of Freiburg in Breisgau and Basel. The closest stylistic parallels to the Cambridge work are some of the statues in the interior of the

[43]

Strassburg Cathedral and on its west façade. The figure of Samson struggling with the lion from the northwest crossing pier is clad in garments which similarly conceal the body and at the same time emphasize its movement in battle with the beast.[1] From the west façade decoration, dated about 1280, some of the Prophets and Virtues, as well as the smaller figures holding musical instruments, are related to the Cambridge piece.[2]

The identification of the figure as an Antonite monk also points to Strassburg as a possible place of origin. The building of an Antonite cloister, hospital, and cemetery was completed in 1277. This establishment was situated in the Antoninergasse (now the Rue de l'Arc-en-Ciel) not far from the Cathedral itself. The original foundation was later abandoned and a new one built in 1383.[3] Our statue may once have adorned the earlier edifice and was probably carved about 1280–1290 by a craftsman who had been trained in one of the Cathedral workshops.

[1] Otto Schmitt, *Gotische Skulpturen des Strassburger Münsters*, Frankfurt a.M., 1924, fig. 32.

[2] *Ibid.*, figs. 90, 109, 116.

[3] Adolph Syboth, *Das Alte Strassburg vom 13. Jahrhundert bis zum Jahre 1870*, Strassburg, 1890, pp. 248 ff.; Hans Haug, "Le Christ de Pitié des Antonites de Strasbourg," *Archives alsaciennes d'histoire de l'art*, vol. XI, 1932, p. 94.

2. God the Father, Rhenish, c. 1325-1350

Busch-Reisinger Museum 1958.250; purchase, general funds. Gilded copper; 3¼ × 2¾ in. (8.2 × 7 cm.)

Plate V

COLLECTIONS
Ottmar Strauss, Cologne

LITERATURE
Hugo Helbing, Frankfurt a.M., *Sammlung Geheimrat Ottmar Strauss Köln*, sales catalogue no. 42, November 7, 1934, lot 99, p. 13, pl. 29.

The embossed relief represents God the Father or possibly Christ. He is seated, raising His right hand in a gesture of blessing, while His left grasps a book that rests on His knee. The halo has incised lines to indicate rays of light. The background is decorated with an incised lozenge pattern, the alternate compartments of which have been punched with an allover dot ornament.

Much of the gilding has been worn off. That which remains appears to be original. Six small holes on the edge of the relief were used to attach it to its background. The forehead is slightly dented.

[44]

The sculptor of the relief sought to achieve a plastic unity that was to be realized in sculpture and painting only in the 1360's and 1370's. Certain details, however, still hark back to the High Gothic. In spite of its broad folds, the drapery over the torso and knees ends in a series of decorative linear elements that suggest nothing so much as a comma or a curved keyhole.

This moment of stylistic transition from the linearism of the High Gothic to the more consistent plasticity of the later period is illustrated in several Rhenish works of the second quarter of the fourteenth century. A very close parallel to the Busch-Reisinger Museum piece can be found in the figure of Christ in the Coronation of the Virgin from the reliquary of Marsal, which Beenken connects with the Coronation of the Virgin of the Cathedral of Cologne.[1] Even closer in style are two small unpublished kneeling caryatid figures, of gilded bronze and belonging to the first half of the fourteenth century, in the Rijksmuseum, Amsterdam.[2] Thus the Busch-Reisinger relief can be considered Lower Rhenish and dated in the second quarter of the fourteenth century.

[1] Hermann Beenken, *Bildhauer des vierzehnten Jahrhunderts am Rhein und in Schwaben*, Leipzig, 1927, pp. 97–98, fig. 52.
[2] Inventory no. R. B. K. 16925 a/b.

3. Madonna and Child, German, c. 1325–1350

Fogg Art Museum 1955.110; gift, Seward W. Eric. Polychromed lindenwood; h. 21½ in. (54.5 cm.); back hollowed out

Plate XX

The Madonna, clad in red dress and blue cape, with her hair veiled in white, is seated on a bench. Her left hand steadies the Child on her knees, while her right, which probably once held a scepter, is extended forward. The Infant, fully clothed, raises His right hand in a gesture of benediction; in His left He holds an apple.
Only slight traces of the original polychromy remain and the chalk ground has been stripped from the heads and hands of both figures. The right hand of the Madonna is lost, as is her crown. The base has been considerably damaged by termites.

The poor condition and provincial character of the work create difficulties in localizing and dating it. The prototype of the image is certainly French, for it exists in ivory and stone in many French examples.[1] The Cambridge piece has none of the grace of its source and retains only a slight hint of the linear organization to be found in the drapery of the best French and German works. The sharp V-shaped folds between the Madonna's

[45]

knees and the lines formed by the drapery covering her legs are repeated in the major accents of the garment worn by the Christ Child. Somewhat similar figures of the seated Madonna and Child, carved during the first half of the fourteenth century in Germany, are in Maulbronn, Cappenberg, and the Landesmuseum at Darmstadt, the last having originated in the monastery at Schiffenberg.[2] The heavy, squat proportions of the Cambridge figures are especially close to the Schiffenberg Madonna and Child. We may conclude, therefore, that our work was created by a provincial artist, perhaps Rhenish, during the second quarter of the fourteenth century.

[1] A characteristic early fourteenth-century French example, in stone, is in the museum at Karlsruhe (Badisches Landesmuseum, Karlsruhe, *Meisterwerke aus den Sammlungen des wiedereröffneten Museums*, Karlsruhe, 1959, pls. 40–41).

[2] Wilhelm Pinder, *Die deutsche Plastik des vierzehnten Jahrhunderts*, Munich, 1925, pl. 19; *Westfalen*, vol. XXI, 1936, p. 178; *Kunst in Hessen und am Mittelrhein*, vol. I–II, 1962, p. 18.

4. Altar Cross, Franco-Flemish, c. 1350

Busch-Reisinger Museum 1961.57; purchase in memory of Eda K. Loeb. Silver gilded, copper gilded, and enamel; h. including base 12½ in. (32 cm.); h. of figure alone 2¾ in. (7 cm.); h. of base 4¼ in. (11 cm.); h. of cross 8¼ in. (21 cm).

Plate V

LITERATURE
Art Quarterly, vol. XXIV, no. 4, Winter 1961, p. 398.

The figure of Christ is of silver, gilded. It is attached to a gilded copper cross, the four arms of which end in trefoils. At the center of each trefoil is a circular enamel plaque with a symbol of an evangelist. Christ's halo also is enamel. The cross is decorated with jewel-like pieces of colored glass. A rectangular, glass-covered compartment above the head of the Saviour contains a relic consisting of bits of cloth. The rear surface of the cross is embellished with an incised vine ornament. The cross is fixed in a hexagonal base of gilded copper.

The figure of the Crucified Christ is in a good state of preservation, showing wear and abrasion only about the nose and knees. The gilding is probably renewed. There is evidence that the rest of the piece has been much restored. The vine ornament on the reverse is in a style typical of the early fifteenth century, and the copper base is also of later manufacture and rather poor workmanship. Although altar crosses often contained relics, the placing of the compartment above the head of Christ is unusual. Round plaques of the four symbols of the evangelists occur frequently on crosses but are generally larger in proportion to the work as a whole. It seems likely, therefore, that extensive reconstruction was carried out at an undetermined date.

[46]

The figure of the Saviour demonstrates the power and tenacity of High Gothic style, which exerted a strong influence well into the second half of the fourteenth century, especially on goldsmithy and ivories. This fact, as well as the universality of the concept of Christ on the Cross, creates problems in dating and localizing the figure. There are some details, however, around which at least a conjecture may be woven. Until the end of the thirteenth century the loincloth tended to hug the figure, forming part of a continuous contour. It is only later that the folds hang freely on either the right, left, or both sides. The bent arms and the position of the hands, palms out and almost vertical, are found most frequently (but not exclusively) in representations of the Crucifixion in illuminated manuscripts from Northeast France, the Low Countries, and England. On the other hand, this position is normal in almost all ivory carvings of the subject in the late thirteenth and throughout the fourteenth centuries.

The best evidence for dating the Christ is the plastic style of the figure itself. It is rather slender in proportions with an attenuated torso. The goldsmith designed the Saviour as a single plastic unit with a very strong feeling of roundness in form. This form with its sketchy anatomical detail contrasts with the limp folds of the loincloth on the right. There can be little doubt that the figure was made about 1350. It is very close to certain ivory carvings of the Crucifixion dating from the fourteenth century, which have the same slender proportions and simple plasticity.[1] Even more striking is the resemblance of the figure to the Crucifixion scene in a missal in the Bodleian Library, Oxford, Ms. Douce 313, fols. 4 and 234. This manuscript was illuminated about the middle of the fourteenth century and has long been recognized as of Flemish production.[2]

There are several works by goldsmiths that have a stylistic affinity with our Crucifix. On the reliquary of Saint Barnabas in Namur is a Christ on the Cross which in its plastic concept and position of the head, arms, and hands is very similar. Likewise a chalice in Aachen, presumably by an Aachen goldsmith of the second quarter of the fourteenth century, has an enameled Crucifixion very close to ours in the position of the Saviour.[3]

Our figure is almost identical with the Christ on an elaborately jeweled cross in the Museo Sacro of the Vatican. The Vatican cross is considered by Volbach to be a "Burgundian" work of the mid-fourteenth century.[4] There is no very convincing reason to consider the Vatican cross as a work made in Burgundy, for that province had not yet assumed the important role in art patronage that it was to play under Philip of Valois. The curve of Christ's arms, the hands in a vertical position with palms out, the rather erect body with head only slightly bent, and the simple rounded plastic form are all very close to the Busch-Reisinger example. We may conclude, therefore, that the Cambridge piece (and perhaps the Vatican one as well) was made shortly after 1350 in Northeastern France or the bordering areas of what is now Belgium.

[1] Raymond Koechlin, *Les Ivoires gothiques français*, Paris, 1924, nos. 315, 370, 372, 570, 585.

[2] G. Vitzthum von Eckstädt, *Die Pariser Miniaturmalerei von der Zeit des hl. Ludwig bis zu Philipp von Valois und ihr Verhältnis zur Malerei in Nordwesteuropa*, Leipzig, 1907, pp. 182–183. See also Millard Meiss, in *Gazette des Beaux-Arts*, vol. LVII, May–June 1961, pp. 291, 299, figs. 22, 33.

[3] Ferdinand Courtoy, *Le Trésor du Prieuré d'Oignies aux Soeurs de Notre-Dame à Namur et l'oeuvre du Frère Hugo*, Brussels, 1953, pp. 111–113, fig. 98, no. 32; Ernst Günther Grimme, *Aachener Goldschmiedekunst im Mittelalter*, Cologne, 1957, pp. 112 ff., pl. 6.

[4] W. F. Volbach, "Lo Sviluppo della Croce negli esemplari dei Museo Sacro Vaticano," *L'Illustrazione Vaticana*, vol. VI, 1935, p. 424, fig. 13.

5. Prophet or Saint, Burgundian, 1425–1450

Fogg Art Museum 1949.47.65; purchase, Alpheus Hyatt Fund. Sandstone; h. 49⅛ in. (125.5 cm.); full round

Plate II

The standing figure wears an outer garment suggestive of a monastic habit; its undergarment is encircled by a belt. The left hand holds an open book.

The surfaces of the headless statue have been badly weathered and chipped. Only those areas that are sheltered by the arms and folds of the drapery retain some of the original surface detailing. The hand holding the book is broken away at the wrist and the right arm is completely lost. Its stump has a dowel hole. There are indications of drapery at the back of the figure, but it has less undercutting and appears to have been less carefully finished.

For futher comments, see Number 6.

6. Prophet or Saint, Burgundian, 1425–1450

Fogg Art Museum 1949.47.69; purchase, Alpheus Hyatt Fund. Sandstone; h. 47⅝ in. (121.5 cm.); full round

Plate III

The pose of this figure is rather more dynamic than that of Number 5, described above. It too, however, is clad in what appears to be monkish raiment, with a belt encircling the undergarment. A closed book, partly hidden by a fold of the drapery, is held in the left hand.

The disintegration of the surfaces through weathering and mechanical damage is very severe, except for small areas sheltered by the outer garment. The missing head was once held in place by two dowels, the holes of which are visible at the top of the torso. Another pair of holes also suggests that the missing right arm was made of a separate piece of stone or that it was broken off and repaired at an undetermined date. The back is summarily carved.

The two headless figures resemble one another in style, state of preservation, and scale, and thus they may well have been pendants or parts of the same series of statues. The sculptor's apparent lack of interest in carving their backs and the rather slender profiles when seen from the sides suggest that they were wall figures, perhaps originally placed in niches.

The drapery style, proportions, and faint traces of the original detailed surface treatment indicate that their author was influenced by the tradition established by Claus Sluter's work at Dijon. The Dutchman's creations made such a profound impression on Burgundian sculpture that they were imitated for several generations after his death. Once a leader in a new and revolutionary style, the sculpture of Burgundy remained almost unchanged as the fifteenth century wore on. This conservatism, as well as the poor condition of the statues, poses problems in dating them.

The sculptor, although inspired by Sluter's work, does not fully understand his style. The figures at Dijon and the Champmol wear heavy, enveloping garments which, although restless and swirling, always respect the human body. The garments of the two figures in Cambridge have little to do with the organic forms beneath. The Joshua of Sluter's Well of Moses wears a belt that is supported by the left hip and hangs somewhat loosely on the opposite side. In the Fogg Museum figures the belts are placed so low that they have no relation to human anatomy.

The sandstone statues of Saint John the Baptist and Saint James Major in the Metropolitan Museum and the Cloisters, acquired from the same dealer as the statues in the Fogg Museum, have been proved to originate in Poligny.[1] A number of sculptors established workshops in or near this town, producing Sluteresque figures throughout most of the first half of the fifteenth century. Later many of them, removed from nearby churches, were placed in the Church of Saint Hippolyte, which was a veritable museum of Burgundian statuary. Some of these statues, in their dependence on Sluter and in their failure to grasp his style fully, resemble our two figures.[2] Thus it is possible that they came from the region of Poligny and should be dated between about 1425 and 1450.

[1] James J. Rorimer, "A Statue of Saint John the Baptist possibly by Claus Sluter," *Bulletin of the Metropolitan Museum of Art*, vol. XXIX, November 1934, pp. 192 ff.
[2] Georg Troescher, *Die Burgundische Plastik des ausgehenden Mittelalters*, Frank-

furt a.M., 1940, vol. I, pp. 116 ff., vol. II, plate LXXIX, figs. 329, 330, 331; Pierre Quarré, "La Collégiale Saint-Hippolyte de Poligny et ses statues," *Congrès archéologique de Franche-Comté*, Paris, 1960, pp. 209–224.

7. Console, Netherlandish, c. 1425–1450

Fogg Art Museum 1949.47.45; purchase, Alpheus Hyatt Fund. Sandstone; h. 5⅝ in. (14.4 cm.); w. 6¾ in. (17 cm.); d. 4¾ in. (12 cm.)

Plate I V

The console is formed by an angel in high relief holding an armorial shield. The legs are sharply bent to meet the horizontal wings. Above it are vestiges of the figure that it originally supported.

The surface is badly weathered and chipped. The lower half of the face, the left knee, and the surfaces of both hands have been lost. There are indications that the top of the shield may once have had a crest which is now missing. The sides of the console have been re-cut to form concave edges. The top of the console has been carefully smoothed to make a bracket of it.

Although the piece is severely damaged and was probably not of very high quality, sufficient remains to indicate that it is related to a series of figurative consoles carved in the Netherlands during the last third of the fourteenth century and first half of the fifteenth. The earliest of these are precious fragments, for they are the only evidence of the artistic milieu of Claus Sluter before he was summoned to Dijon in 1385 to work for the Burgundian dukes.

Among this early series are the consoles (now in the Gruuthuse Museum of Bruges) from the façade of the City Hall. On one, representing the Annunciation of the birth of Saint John to Zaccharias, is an angel somewhat similar to that of our work. The consoles of the Schepenhuis of Malines dated about 1384–1385 and attributed to Jan Keldermans and those from the Brussels City Hall (now in the Musée Communale), although superior in quality, also have some points of resemblance to the Cambridge piece.[1] A few of the Brussels examples (believed to have been carved in part by Sluter himself) depicting angels carrying musical instruments are distinguished by the same violent movement and sharply bent legs as the angel in the Fogg Museum.[2] The closest stylistic parallel is an early fifteenth-century wooden console in the Mayer van der Bergh Museum of Antwerp, decorated with an angel holding a book. The position of arms, legs, and wings, and the carving of hair and drapery are almost identical.[3] In view of these relationships, our console may be considered to be a Netherlandish work of the second quarter of the fifteenth century.

[5 0]

[1] *Gentse Bijdragen tot de Kunstgeschiedenis*, vol. X, 1944, p. 57.

[2] *Ibid.*, vol. I, 1934, p. 143, and vol. III, 1936, pp. 86 ff.

[3] Inventory no. 56 (photographed for the Koninklijk Instituut voor het Kunstpatrimonium, Brussels, negative no. 139649).

8. Pietà, Austrian, c. 1420

Busch-Reisinger Museum 1959.95; purchase in memory of Eda K. Loeb. Polychromed poplar wood; h. 36¼ in. (92 cm.); back hollowed out

Plates VI, VII

LITERATURE

Art International, vol. IV, no. 7, September 25, 1960, p. 48; *Art Quarterly*, vol. XXII, no. 2, Summer 1960, p. 184; *La Chronique des arts, supplément à la Gazette des Beaux-Arts*, no. 1105, February 1961, p. 22.

The Madonna is seated on a bench, holding the dead Christ on her lap. Her right hand supports His head and her left, covered by a veil, is raised.

The original polychromy has disappeared except for a few slight traces. The head of Christ shows signs of restoration.

The Busch-Reisinger *Vesperbild* is a characteristic example of the "soft style" of the early fifteenth century. The use of poplar wood suggests an origin in the southern section of Central Europe. The Pietàs of Salzburg and Bavaria differ from the Cambridge example in their pyramidal composition and the placing of the Virgin's hands over the clasped hands of Christ. However, several *Vesperbilder* from Bohemia and Southern Austria depict the Madonna raising her left hand to her veil in a gesture somewhat similar to the veiled hand of our figure. The slender proportions of the Madonna and her spiritual expression find their closest parallel in the work of the Master of Grosslobming and his circle.[1] The Grosslobming Master was the leading sculptor of his generation in Styria. Working almost exclusively in stone, his figures invariably have countenances that suggest an inner emotion similar to that of the Madonna of the Busch-Reisinger *Vesperbild*. The shapes of their faces differ, however, and only in the last works attributed to his hand do they resemble our Madonna.[2] Several examples of the school of the Grosslobming Master have elements close to the Cambridge statue. The seated Madonna in the Schnütgen Museum, Cologne, is composed in the same compact manner; a standing Madonna formerly in the Berlin Museum has similar drapery and raises her hand to her veil in a gesture recalling our figure.[3] Two figures

[51]

carved in wood also are related in their slender proportions and facial expressions. One is a Christ of the Resurrection in the Österreichische Galerie in Vienna,[4] and the other (attributed to Hans von Judenburg) is in the National Museum, Ljubljana.[5]

Although no exact parallel to the Cambridge *Vesperbild* has been found, the general relationship in style and expression to the Master of Grosslobming justifies attributing the work to a Styrian sculptor and dating it about 1420.

[1] K. Garzarolli von Thurnlackh, *Mittelalterliche Plastik in Steiermark*, Graz, 1941, pp. 35–44; Rochus Kohlbach, *Steirische Bildhauer vom Römerstein zum Rokoko*, Graz, n.d., pp. 321 ff.; Kunsthistorisches Museum, Vienna, *Europäische Kunst um 1400*, exhibition catalogue, May 7–July 31, 1962, nos. 383–386, with bibliography.
[2] Garzarolli von Thurnlackh, *Mittelalterliche Plastik in Steiermark*, pl. 50.
[3] Franz Kieslinger, *Zur Geschichte der gotischen Plastik in Österreich*, Vienna, 1923, pl. 33.
[4] Kunsthistorisches Museum, Vienna, *Europäische Kunst um 1400*, no. 386.
[5] E. Cevc, *L'Art du moyen-âge en Slovénie, Guide des collections artistiques de la galerie nationale de Ljubljana*, Ljubljana, 1956, vol. I, no. 7, pp. 24–25, pl. 8.

9. Madonna and Child, Tyrolese, c. 1430

Busch-Reisinger Museum 1963.2; purchase, Antonia Paepcke DuBrul Fund. Polychromed poplar (?); h. including pedestal 61 in. (155 cm.); back hollowed out

Plate X, frontispiece

COLLECTIONS
A. S. Drey, Munich
Walter von Pannwitz, Berlin

LITERATURE
Franz Wolter, "Bayerische Plastik des XV. und XVI. Jahrhunderts," *Festschrift des Münchener Altertums-Vereins zur Erinnerung an das 50jähr. Jubiläum*, Munich, 1914, p. 41, fig. 22; Otto von Falke, *Die Kunstsammlung von Pannwitz*, Munich, 1925, vol. II, no. 115, p. 12, pl. XXV; Carl Theodor Müller, *Mittelalterliche Plastik Tirols*, Berlin, 1935, pp. 57–58, 132, pl. 63, fig. 131; *Art Quarterly*, vol. XXVI, no. 2, Summer 1963, p. 252.

The crowned Madonna, holding the Christ Child, stands on a sickle moon beneath which is the face of a man with eyes closed. The whole is placed on a low pedestal containing a reliquary. The Virgin's head is inclined slightly to the left as she gazes at the Child. Her right hand, pressed firmly against the Infant's chest, supports His weight and her left hand holds His right leg. The lively Baby has an apple in His right hand and clutches the Madonna's veil with His left. The Holy Mother is clad in a golden cape

with blue lining. Her dress is of silver. Her golden crown rests on a white veil. Her light brown hair, like that of the Child, shows traces of gold paint. The moon and the human face which it frames are silver. The pedestal is painted bright red.

The statue is in an excellent state of preservation with no losses. The polychromy is original with relatively few areas of repaint. Some of the original gold leaf on the folds of the cape has been renewed and losses of the flesh tones on the Virgin's neck and on the Child's legs have been repainted. Slight losses and repairs are evident on the pedestal. There has been restoration of the polychromy of the eyes, eyebrows, and cheeks of both the Madonna and the Child.

There can be no doubt that the Madonna was created as a devotional image rather than as part of an altarpiece. This is indicated not only by the large scale of the figure but also by the fact that the pedestal upon which she stands serves as a reliquary. The sickle moon beneath her feet identifies her as the Virgin of the Apocalypse. The apple held by the Christ Child symbolizes the Fall of Man, while the thoughtful gaze of His Mother emphasizes the Redemption which will occur only upon the death of her Son. The face beneath the moon has been interpreted as that of Adam, deep in Limbo, his eyes closed, awaiting his ultimate forgiveness and rescue by the Crucified Christ.[1]

The Busch-Reisinger Madonna is a type of devotional image known as the *Schöne Madonna* (Beautiful Madonna), which was very popular in many parts of the German Empire in the early fifteenth century. There is a general similarity to all of the *Schönen Madonnen* but some variations exist in the way in which the Child is held. The full-length sculptured versions of the Cambridge type are numerous, but many of them show the Child held to His Mother's left. Among the earliest of these reversed or "mirror image" Madonnas is the example from Altenmark, probably exported to that monastery from Vienna or Prague and documented as having been in place by 1393. Others are the Madonna from Pilsen, the Colli Madonna in the Liebieghaus, Frankfurt, and the famous Virgin from Krummau, now in Vienna.[2] These are of carved or cast stone, but a substantial number of polychromed wood figures of the type are also in existence. One of them, dated 1429, is in Weildorf and, like the Cambridge figure, is standing on a sickle moon beneath which is the face of Adam. However, in her right hand she holds a scepter — a type that is believed to have been produced in Salzburg.[3] Müller has pointed out that Salzburg sculpture of the first quarter of the fifteenth century usually portrays relatively organic figures in spite of the richness of the drapery in which they are enveloped. A much less articulated style is employed by the sculptor of the Busch-Reisinger Museum Madonna. Although the drapery has a wealth of deeply-undercut folds and minor depressions, the dominant effect is that created by the blocklike mass of the figure. The material employed, probably poplar wood, indicates that the work may be South Tyrolese in origin. Its date is about 1430.

[5 3]

[1] Michael Hartwig, "Die 'Schöne Madonna' von Salzburg als Gnadenbild und ihr Verbreitungsgebiet," *Das Münster*, vol. I, 1947–1948, pp. 273 ff.

[2] For some years there has been disagreement among scholars concerning the chronology of the *Schönen Madonnen*. The older literature is cited in the most recent studies: Walter Paatz, "Prolegomena zu einer Geschichte der deutschen spätgotischen Skulptur im 15. Jahrhundert," *Abhandlungen der Heidelberger Akademie der Wissenschaften, Philosophisch-historische Klasse*, 2nd session, 1956; Dieter Groszmann, "Die Schöne Madonna von Krumau und Österreich," *Österreichische Zeitschrift für Kunst und Denkmalpflege*, vol. XIV, 1960, pp. 103–114; Kunsthistorisches Museum, Vienna, *Europäische Kunst um 1400*, exhibition catalogue, May 7–July 31, 1962, pp. 367–368.

[3] Theodor Müller, *Alte bairische Bildhauer*, Munich, 1950, fig. 59; idem, *Mittelalterliche Plastik Tirols*, pp. 56 ff.

10. Madonna, Swabian, c. 1430

Busch-Reisinger Museum 1936.35; purchase, special fund. Polychromed lindenwood; h. 24½ in. (62 cm.); back hollowed out

Plates VIII, IX

COLLECTIONS

Mrs. Chauncey J. Blair, Chicago

LITERATURE

Fine Arts Academy, Albright Gallery, Buffalo, *Catalogue of the Mary Blair Collection of Medieval and Renaissance Art*, 1915, no. 78; Fine Arts Academy, Buffalo, *Academy Notes*, vol. XI, no. 1, January 1916, p. 21; *Art News*, vol. XXXV, no. 25, March 6, 1937, p. 20; Charles L. Kuhn, "The Blair Madonna," *Germanic Museum Bulletin*, vol. I, no. 5, October 1937, p. 21; idem, "Eine fränkische Madonna des frühen 15. Jahrhunderts," *Pantheon*, vol. XIX, 1937, pp. 142–143.

The Madonna is seated on a bench, her head turned slightly to her right. Her left arm is raised as though she once held a small object, and her right arm and hand are in a position to support the Christ Child. Her dress and cape are gold, the cape lined with blue. Her white veil is decorated with red and black ornament.

Both hands of the figure are replacements. A mark on the right knee shows that the Infant Jesus was seated there. The Madonna may once have worn a crown but all traces of it have been obliterated. The polychromy has been partially restored but much of the original gold is preserved. The flesh tones of the face are considerably rubbed.

The restless pictorialism of the drapery is characteristic of the last phase of the "Soft Style." The figure has a distinct relationship to the "Beautiful Madonnas," a type of devotional image that influenced many artistic centers during the first quarter of the

[54]

fifteenth century. One center for sculpture of this type was the imperial city of Ulm, where the leading sculptor was Master Hartmann. This artist must have employed a large number of assistants, who spread his influence widely in Swabia. The Cambridge Madonna is stylistically related to the artists of the Hartmann circle. Master Hartmann directed the decoration of the west façade of the Cathedral of Ulm until at least 1421. Some of the soffit figures and especially the seated Madonna and Child on the forehall wall of the Cathedral by Hartmann's assistants have a strong stylistic connection with both the facial type and drapery style of our figure.[1]

Master Hartmann's influence is not confined to architectural sculpture but is found in much of the wood sculpture of Swabia and the Bodensee district. One of his very close followers was the sculptor of the altarpiece from Dornstadt (dated about 1430) now in the Stuttgart Provincial Museum.[2] The Saint Barbara from the central section of this work is so like the Cambridge Madonna that one may safely assign our piece to the same district and date, if indeed it is not by the same hand.

[1] Gertrud Otto, *Die Ulmer Plastik des frühen fünfzehnten Jahrhunderts*, Tübingen, 1924, p. 19 and figs. 4, 6, 7, 8.

[2] Julius Baum, *Deutsche Bildwerke des 10. bis 18. Jahrhunderts* (Kataloge der kgl. Altertümersammlung in Stuttgart, vol. III), Stuttgart and Berlin, 1917, no. 40, pp. 92–94; Albert Walzer, *Schwäbische Plastik im Württembergischen Landesmuseum, Stuttgart*, Stuttgart, 1958, pp. 28–29, pls. 23, 25, 26.

11. Kneeling Angel, Pietro Alamanno (?), c. 1450–1460

Busch-Reisinger Museum 1963.3; gift, Mr. and Mrs. Philip Hofer. Polychromed walnut; h. 9 in. (23 cm.); back slightly hollowed out

Plate XI

The angel, in a kneeling position, faces to the left. The head is slightly bowed and the hands are raised in a gesture of adoration. The figure is clad in a garment of gold. The brown hair is held by a band of the same color.

Only a few traces of the original polychromy remain. The wings have been restored and are painted in a brown tonality, although there are traces of silver leaf which may once have covered them. The fingers of the left hand have been lost.

The blocklike mass of the figure and the suggestion of angularity in the small folds of the drapery are characteristic of sculpture of the mid-fifteenth century in Southern Germany and the Tyrol. The scale of the angel and the posture of adoration suggest that it may once have formed part of a crèche.

[55]

A very close stylistic parallel is found in the work of the circle of Pietro Alamanno, a German sculptor who established his workshop in Naples, where he was active during the third quarter of the fifteenth century. He carved many figures of walnut for crèches. A number of the nineteen extant figures of the original forty-one that formed the crèche in the Church of San Giovanni a Carbonara have long, rounded, vertical and parallel folds of drapery that break into angular accents as they reach the ground, as does the Cambridge angel. The facial types of the Naples statues and their rather awkward un-articulated hands are also close to the Busch-Reisinger Museum figure.[1] We may conclude, therefore, that our statue, if not by Pietro Alamanno himself, was produced by a member of his workshop.

[1] Bruno Molajoli, *Sculture Lignee nella Campania*, exhibition catalogue, Naples, 1950, p. 138, no. 59, pls. 54, 55; Enzo Carli, *Bois sculptés polychromes du XIIème au XVIème siècle en Italie*, Paris, 1963, pp. 113–115, figs. CXXVIII–CXXIX, pl. 82.

12. Saint Lawrence, Upper Rhenish, c. 1490

Busch-Reisinger Museum 1962.110; purchase, Antonia Paepcke DuBrul Fund. Linden-wood; h. 11⅞ in. (30 cm.); back flat

Plate XIII

COLLECTIONS
Alfred von Sallet, Berlin
Friedrich Lippmann, Berlin
Walter von Pannwitz, Berlin

LITERATURE
Rudolph Lepke's Kunst-Auctions-Haus, Berlin, *Sammlung Friedrich Lippmann*, November 26–27, 1912, no. 136, p. 41, pl. 45; *Art Quarterly*, vol. XXVI, no. 2, Summer 1963, p. 252.

Saint Lawrence, clad as a deacon in a fringed habit, holds in his hands an open book that he appears to be reading. On the ground at the left is his attribute, the gridiron. The figure is in high relief.

The condition of the statuette is excellent: the only losses are part of a lock of hair and a slight chip on the right front of the base. On the back are two dowel holes.

The figure was originally published as possibly a Nuremberg work of about 1500, but closer stylistic parallels are to be found a decade earlier in the Upper Rhine region.

The Saint is one of many sculptures that show the influence of prints by the Master E.S. The handling of the drapery, the heavy locks of hair, the sober visage, and even the position of the hands are very like the Saint John Evangelist in the engraving of the Crucifixion (L. 32).[1] There is an even closer kinship with the figure of Saint Stephen on the stained-glass window at Oberehnheim i.E., attributed to the painter Theobald von Lixheim and dated 1485. The drapery, fold by fold, repeats that of our Saint Lawrence, and the faces, treatment of hair, and position of the head are identical.[2] Other stylistic parallels in the sculpture of this region may be found in statues associated with the circle of the Master of the Dangolsheim Madonna.[3] Thus an attribution to the Upper Rhine region and a dating of about 1490 seem reasonable.

[1] Edith Hessig, *Die Kunst des Meisters E.S. und die Plastik der Spätgotik*, Berlin, 1935, pl. 37b.

[2] Paul Frankl, "Der Glasmaler Theobald von Lixheim," *Zeitschrift für Kunstwissenschaft*, vol. XI, 1957, pp. 65 ff., figs. 13, 14.

[3] Theodor Demmler, *Die Bildwerke in Holz, Stein und Ton: Grossplastik* (Staatliche Museen zu Berlin, Die Bildwerke des deutschen Museums, vol. III), Berlin and Leipzig, 1930, no. 2240, pp. 144–146; Otto Schmitt, *Oberrheinische Plastik im ausgehenden Mittelalter*, Freiburg i.B., 1924, pls. 45, 49; Wilhelm Pinder, *Die Deutsche Plastik des fuenfzehnten Jahrhunderts*, Munich, 1924, pls. 70, 71.

13–14. Pair of Angels, Austrian, c. 1490

Busch-Reisinger Museum 1960.1, 1960.2; gift, Mrs. J. Louis Ransohoff in memory of her husband. Lindenwood; h. (each) 8¾ in. (22.2 cm.); full round

Plate XII

COLLECTIONS
J. Louis Ransohoff, Cincinnati

Each angel stands on a circular base and holds a candle stick, the shaft of which resembles a colonnette with twisted fluting.

Only slight damage has been sustained by the figures. The bases are later additions and the original polychromy has been removed.

Since they are in the round, the two angels must originally have been free-standing and were perhaps intended as finial figures for the superstructure of an altarpiece. In spite of a likely position high above the heads of the spectators, they are carved with great delicacy.

[57]

In general style the angels resemble those on the high altar of the church at Kefermarkt in Upper Austria.[1] The Cambridge figures are smaller in scale and somewhat more simplified in execution. They are closer to a pair of angels attributed to a follower of the Kefermarkt Master, now in the Museum Mittelalterliche Oesterreichische Kunst, Vienna.[2] Their slender proportions point to a date of 1485 or 1490. A pair of angels from Krems now in an Austrian private collection and dated c. 1480–1490 have similar proportions.[3]

[1] Florian Oberchristl, *Kefermarkt und sein gotischer Flügelaltar*, Linz, 1926; Hermann Ubell, "Der Wolfgangsaltar in Kefermarkt," *Kunst und Kunsthandwerk*, vol. XVI, 1913, pp. 1 ff., figs. 8–11, 17–19, 24, 25, 29, 30.
[2] Nos. 37 and 38; see Franz Kieslinger, *Mittelalterliche Skulpturen einer Wiener Sammlung*, Vienna and Leipzig, 1937, p. 18, no. 32, pl. 36.
[3] Rupert Feuchtmüller, *Die Sammlung S*, Vienna, 1926, no. 18.

15. Madonna and Child, South German, c. 1480–1490

Busch-Reisinger Museum 1963.34; gift, Mrs. Gertrude T. Beyer, Mrs. Anastasia T. Dunau, and Mrs. Margarete T. Munson in memory of their parents, Dr. Siegfried J. and Franziska Thannhauser. Lindenwood; h. 29¾ in. (75.5 cm.); back hollowed out

Plate XX

COLLECTIONS
Dr. and Mrs. Siegfried J. Thannhauser, Boston

The crowned Madonna holds the Child against her left shoulder with both hands. Mother and Child gaze directly at the spectator.

The statue is in very poor condition. The polychromy no longer exists and the entire surface has been ruined by the action of termites. The holes and tunnels in the Virgin's face and neck bored by these insects have been filled in and slight coloring has been added. The lower part of the work has been cut off and some of the edges of the drapery are broken. Both arms of the Child and His left leg are lost.

Despite extensive damage to the figure, the general drapery style is still evident. The series of V-shaped folds on the frontal axis of the Madonna and the deep undercutting at the sides are characteristic of much of South German sculpture in the last quarter of the fifteenth century. Close parallels are found in Upper Swabia and our work may well have originated in this district of Germany.[1]

[58]

¹ Julius Baum, *Deutsche Bildwerke des 10. bis 18. Jahrhunderts* (Kataloge der kgl. Altertümersammlung in Stuttgart, vol. III), Stuttgart and Berlin, 1917, no. 91, p. 134; Julius Baum, *Die Bildwerke der Rottweiler Lorenzkapelle*, Augsburg, 1929, pp. 34–35, nos. 68, 69, pls. 54, 55.

16. Saint John the Evangelist, Lower Swabian, c. 1490–1500

Busch-Reisinger Museum 1964.5; gift, Mrs. Solomon R. Guggenheim. Lindenwood; h. not including baseboards 49⅞ in. (126.5 cm.); h. of baseboards 1⅝ in. (4 cm.); back hollowed out

Plates XIV, XV

Saint John is standing quietly on a base carved to simulate rocky ground. His hands are clasped at his breast. A fold of his ample cape hangs over his left arm. His head is tilted back, and he gazes upward.

The figure was once polychromed, for traces of the chalk ground are visible in the deepest recesses of the drapery. A split in the rocky ground necessitated the addition of two boards as a supporting base. There is a light scattering of termite holes over the surface. Slight repairs were made at an undetermined date to the left cheek, bridge of the nose, brow, and folds of the mantle near the left leg. The back of the head is roughly finished.

Many of the artistic means employed by the sculptor to make a strong emotional impact are also to be found in prints by the Master E.S. In two representations of Saint John in a Crucifixion scene, the face of the Evangelist is framed by heavy locks of hair, by complex drapery over the arms, and by the hands (L. 31 and L. 32).

Several sculptures of the Upper Rhine region and Lower Swabia are similar in style to the Cambridge figure. The Saint John of the Crucifixion in the sacristy of the Cathedral of Freiburg i.B., dated late in the fifteenth century, makes dramatic use of vertical folds of drapery to emphasize the sorrowful expression of the face.¹ The spiritual visage of the Saint John from the Crucifixion at Saint Leonhard, Stuttgart, dated 1501 and carved by Hans Seyfer, recalls that of our figure and bears the marks of the same artistic milieu.² Still closer to the Cambridge statue are the two Saint John figures from Wimpfen and from the high altar of the Church of Saint Kilian at Heilbronn, believed by Schnellbach to have been derived from the same prototype.³ The Wimpfen saint has the parted lips, sunken cheeks, and strongly emphasized head that are present in the Cambridge Evangelist. The Heilbronn Saint John has even more striking resemblances to our figure. The altarpiece which it crowns is dated 1498 and has been attributed on stylistic grounds to Conrad Sifer and to Hans Seyfer.⁴ The figure is clad in

relatively simple drapery with deeply-undercut vertical folds. The head is tilted upward and the doleful face is framed by the arms, clasped hands, and heavy ringlets of hair. The detailed handling of the surface of the face and the sharply articulated fingers are the work of a master of greater skill than the artist who carved the Cambridge saint. The two are sufficiently similar, however, to warrant the conclusion that they are about contemporary and were created in the same general area.

[1] Otto Schmitt, *Gotische Skulpturen des Freiburger Münsters*, Frankfurt a.M., 1926, pl. 258.

[2] Julius Baum, *Niederschwäbische Plastik des ausgehenden Mittelalters*, Tübingen, 1925, pl. 48. I am grateful to Dr. Theodor Müller for suggesting the connection of the Cambridge Saint John with the style of the Seyfer circle.

[3] Rudolf Schnellbach, *Spätgotische Plastik im unteren Neckargebiet*, Heidelberg, 1931, p. 88, figs. 83–84.

[4] The artistic personalities of Conrad Sifer of Sinsheim and of Hans Seyfer of Heilbronn are not yet clearly differentiated. The documents indicate that they were relatives, possibly brothers, both active during the last two decades of the fifteenth and the early years of the sixteenth centuries in the Upper Rhine region and the Neckar Valley. See Schnellbach, *Spätgotische Plastik*, pp. 9 ff.; idem, in *Jahrbuch der preussischen Kunstsammlungen*, vol. L, 1929, pp. 105 ff. (fig. 7 is a good reproduction of the Heilbronn Saint John); Hans Rott, in *Oberrheinische Kunst*, vol. III, 1928, p. 68; idem, in *Zeitschrift für die Geschichte des Oberrheins*, new series, vol. XLIII, 1929, pp. 71 ff.; idem, *Quellen und Forschungen zur südwestdeutschen und schweizerischen Kunstgeschichte im XV. und XVI. Jahrhundert*, vol. III, *Der Oberrhein*, Quellen I (Baden, Pfalz, Elsass), Stuttgart, 1936, p. 267; *ibid.*, vol. III, *Der Oberrhein*, Text, Stuttgart, 1938, p. 121; Hans Reinhardt, in *Münchner Jahrbuch der Bildenden Kunst*, new series, vol. XI, no. 3–4, 1934–1936, pp. 233 ff.

17. Madonna and Child and Saint Anne, Rhenish–Westphalian, c. 1490

Busch-Reisinger Museum 1963.29; gift, Mrs. Gertrude T. Beyer, Mrs. Anastasia T. Dunau, and Mrs. Margarete T. Munson in memory of their parents, Dr. Siegfried J. and Franziska Thannhauser. Lindenwood (?); h. without base 13⅝ in. (35.3 cm.); full round

Plate XXIV

COLLECTIONS
Dr. and Mrs. Siegfried J. Thannhauser, Boston

Saint Anne, her hair covered by a veil or cowl, is seated on a high-backed chair. The Christ Child stands on her lap and touches an open book held by the Virgin.

The condition of the piece is poor. It is mounted on an oak base that is not original. The group is made of a soft wood, later stained to resemble oak. The entire surface

has suffered from the action of termites, and the work has been further damaged by two deep splits. The entire back of the head of Saint Anne is a restoration that still shows the marks of a rasp.

The group is clearly the work of a provincial craftsman. In spite of its poor state of preservation, certain obvious stylistic qualities facilitate localizing and dating it. The drapery and in particular the curiously high-domed heads are found consistently in Westphalia and the Lower Rhine district. Examples closely paralleling our piece belong to the museums of Münster, Berlin, and elsewhere.[1] From them one may infer that the Cambridge *Anna Selbdritt* was made during the last decade of the fifteenth century in Westphalia or the neighboring region of the Lower Rhine.

[1] Max Geisberg and Burkhard Meier, *Das Landesmuseum der Provinz Westfalen in Münster*, Berlin, 1914, vol. I, pp. 71–72, nos. 162, 163, 164; Fritz Witte, *Die Skulpturen der Sammlung Schnütgen in Cöln*, Berlin, 1912, pl. 42, figs. 2, 3, 4; Heiner Sprinz, *Die Bildwerke der Fürstlich Hohenzollernschen Sammlung Sigmaringen*, Stuttgart and Zurich, 1925, no. 66, pl. 39.

18. Nativity, Rhenish (?), c. 1470–1480

Busch-Reisinger Museum 1964.18; gift, Milton I. D. Einstein. Polychromed plaster on a fibrous ground supported by wooden armatures; 23¾ × 18¼ in. (60.2 × 46.5 cm.)

Plate XVI

COLLECTIONS
Milton I. D. Einstein, New York

The Madonna kneels before the Infant in the right foreground. In the opposite corner and with his back turned to them Saint Joseph draws water from a well. Behind the Madonna a thatched hut shelters the ox and ass. Above its roof the Annunciation to the Shepherds takes place. A landscape, partly modeled and partly painted, occupies the upper third of the composition. A frame on the sides and lower edge of the relief is decorated with a spiral vine ornament, punctuated at regular intervals by round rosettes, some of them filled with discs of opaque glass. The sides of the frame show hinge marks.

The relief is in very poor condition. Several coats of repaint of the sixteenth century and later obscure much of the detail. There are many cracks in the plaster and numerous repairs. Some losses are apparent, especially in the Saint Joseph, the landscape, and the upper edge of the frame. Some of the wooden armatures are new, and the glass discs in the rosettes of the frame are later additions.

[61]

The portrayal of the Nativity contains a combination of motives, some of which are typical of the second half of the fifteenth century while others go back to about 1400. The Christ Child lying on the fold of drapery of His kneeling Mother was depicted by Roger van der Weyden shortly after 1450 and was popularized in Germany by the engravings of the Master E.S. and of Schongauer. Saint Joseph, turning his back to the scene and performing the humble task of drawing water from a well, is related to a much earlier tendency to mock Mary's husband. About 1400, Joseph was frequently depicted as an old man engaged in some domestic and menial act. The twisted vine ornament interrupted by rosettes is not found until the second half of the century, when it occurs in sculpture and in graphic art.[1]

The *retardataire* concept of Saint Joseph, often combined with the more advanced motive of the Child lying on the Virgin's drapery, is common to a number of paintings and sculptures of Lower Rhenish or Westphalian origin.[2] In these districts the use of inexpensive materials such as pipe clay, papier-mâché, and plaster was introduced from the Netherlands and became especially popular.[3] Thus our relief can be dated about 1470–1480 and localized in the Lower Rhine or Westphalia.

[1] Theodor Müller, *Die Bildwerke in Holz, Ton und Stein* (Kataloge des Bayerischen Nationalmuseums München, vol. XIII, pt. 2), Munich, 1959, no. 179, pp. 181–183.

[2] The relief of the Nativity, about 1480, in the Predigerkirche at Erfurt, for example, depicts Saint Joseph, behind the Madonna, engaged in cooking gruel.

[3] Edith Hessig, *Die Kunst des Meisters E.S. und die Plastik der Spätgotik*, Berlin, 1935, pls. 6b–6c, 7a, and pp. 59 ff.; Burkhard Meier, "Jodocus Vredis und die Utrechter Bilderbäcker," *Westfalen*, vol. VII, 1915, pp. 105 ff.; Theodor Demmler, *Die Bildwerke in Holz, Stein und Ton: Grossplastik* (Staatliche Museen zu Berlin, Die Bildwerke des deutschen Museums, vol. III), Berlin and Leipzig, 1930, pp. 107–110; Otto Schmitt, *Oberrheinische Plastik im ausgehenden Mittelalter*, Freiburg i.B., pl. 29; Heiner Sprinz, *Die Bildwerke der Fürstlich Hohenzollernschen Sammlung Sigmaringen*, Stuttgart and Zurich, 1925, no. 26, pl. 14.

19. Adam and Eve, Upper Rhenish, c. 1490–1500

Fogg Art Museum 1957.219 a–b; gift, Mrs. Jesse Isidor Straus in memory of her husband. Lindenwood (?); h. of Adam 6½ in. (16.5 cm.), Eve 6¼ in. (16 cm.); backs flat

Plate XVII

COLLECTIONS
R. Lydig, New York
Jesse Isidor Straus, New York

LITERATURE

E. F. Bange, *Die Kleinplastik der deutschen Renaissance in Holz und Stein*, Munich, 1928, p. 58, pl. 58.

Both figures and bases are carved from single pieces of wood. They stand, with legs crossed, in curiously stilted frontal positions. Adam reaches with his left hand for the fruit held high in Eve's right. The tops of the rectangular bases have been given a texture to suggest the ground.

The general condition of the figures is excellent, but they have been painted with a brown pigment, then waxed and polished to simulate boxwood. The back of the figure of Eve shows the marks of the chisel. In the case of Adam, however, the marks of a saw are evident, indicating that the figure may have originally been a few millimeters thicker and later was pared down.

The figures of Adam and Eve show no trace of the influence of the Italian Renaissance nude, but have the slender proportions, the mannered stance, and the detailed anatomic realism of Northern Late Gothic. The nakedness of the pair is conceived as an attribute almost like the attributes employed to identify saints. This is common to medieval representations, and only when Italian Renaissance humanistic influence made itself felt in Germany were Adam and Eve in any way idealized.

The scale of the figures classifies them as *Kleinplastik*. It is unlikely that they were intended as cabinet pieces, however, and they are executed as though in high relief. Their flatness suggests that they were once attached to a background and formed part of a retable or some other piece of church furniture.

Bange points out their striking similarity to the figures of Adam and Eve in the background of a relief of Christ in the Garden of Gethsemane, formerly in the Sigmaringen Collection.[1] Our figures at one time may have formed a similar background note in a larger composition.

The absence of any idealization points to a date in the last years of the fifteenth century. The place of origin as the upper Rhine area is a reasonable conclusion. The Fogg Adam and Eve seem to be the immediate predecessors of the Basel Historical Museum's Adam and Eve by Hans Wydyz, active in Freiburg i.B. from 1497 to 1512.[2]

[1] W. F. Bange, *Die Kleinplastik*, p. 58; illustrated in Heiner Sprinz, *Die Bildwerke der Fürstlich Hohenzollernschen Sammlung Sigmaringen*, Stuttgart and Zurich, 1925, no. 53, p. 16, pl. 32.

[2] *Oberrheinische Kunst*, vol. III, 1928, pl. 43, fig. 1.

20. Heraldic Epitaph, South German (?), c. 1500

Busch-Reisinger Museum 1955.452; purchase, Museum Association Fund. Circular polychromed lindenwood relief; diam. 46½ in. (118 cm.)

Plate XXI

LITERATURE
Charles L. Kuhn, "The Busch-Reisinger Museum: Three Years of Collecting," *The American-German Review*, vol. XXII, no. 6, August–September 1956, p. 40.

The central area of the plaque is occupied by a heraldic shield with blue field diagonally crossed by a broad white band, surmounted by a brown gorget and a helm. The crest of the helm is a pair of horns, and its visor has but three bars. A curvilinear foliate ornament in white against a light red-orange background twines around the coat of arms. The entire plaque is encircled by an inscription between two rope-like borders.

The original polychromy has almost entirely disappeared and the whole surface shows evidence of frequent repaintings. The inscription is partially obliterated and has been repainted and darkened with crayon. Only a few letters can be deciphered and they give no clue as to a date or a proper name.

The early sixteenth-century heraldic epitaph or *Totenschild* sometimes reflects the functional armor of the period. The shield on our plaque resembles the tournament targe of the late fifteenth and early sixteenth centuries. The helm with its three-barred facepiece is a type used in pageants and ceremonies for members of the lesser nobility. The rope-like borders of the inscription are suggestive of the "rope" edging employed in the best Maximilian armor and are often found on *Totenschilder* of the early part of the century; an excellent example, dated 1510, is from the Figdor Collection.[1] The foliate decoration in the Cambridge epitaph is in low relief and rather linear in treatment, in contrast to later ornament, which is likely to be more plastic and profuse. For these reasons we may assume that the plaque was made about 1500 or shortly thereafter. Since the coat of arms cannot be identified, the place of origin is uncertain. It is probable, however, that it was Central or Southern Germany.

[1] Otto von Falke, editor, *Die Sammlung Dr. Albert Figdor, Wien*, sales catalogue, September 20–30, 1930, Berlin and Vienna, pt. I, vol. V, no. 559, pl. CXCVIII.

21. Saint Catherine, Circle of Veit Stoss, c. 1500

Busch-Reisinger Museum 1956.12; anonymous gift. Polychromed lindenwood; h. 13⅜ in. (46.6 cm.); back flat

Plate XVIII

LITERATURE

Charles L. Kuhn, "The Busch-Reisinger Museum: Three Years of Collecting," *The American-German Review*, vol. XXII, no. 6, August–September 1956, p. 20, fig. 2.

The standing Saint turns her crowned head slightly to her left. She holds a fragment of the wheel of torture in her right hand and a sword in her left. Her dress is gold and her cape is gold with a blue lining.

The figure has suffered some losses. The points of the crown are broken away and the edges of some of the folds of the cape are damaged. The gilding appears to be original, but the lining of the cape and the flesh tones of the face have been repainted.

The Saint Catherine certainly once formed part of an altarpiece. The drapery has many of the characteristics of Veit Stoss's work: deep undercutting, swinging curves contrasting with smaller angular accents, and the fluttering end resembling a human ear. The elegance and grace of the Saint Catherine and its slight proportions suggest a connection with the Stoss Madonna of about 1500, which originally adorned the house of the artist and is now in the Germanic Museum of Nuremberg.[1] Among the works of the school of Veit Stoss that particularly resemble our saint are the recumbent Saint Catherine carved before 1506 and the Rose Garland Altar of about 1500 from the Dominican Church of Nuremberg, both in the Germanic Museum.[2]

We may conclude from these comparisons that our Saint Catherine was carved by a member of the atelier of Veit Stoss after the master had left Cracow and settled in Nuremberg in 1496. It was probably made about 1500 or shortly thereafter.

[1] Walter Josephi, *Kataloge des Germanischen Nationalmuseums: Die Werke plastischer Kunst*, Nuremberg, 1910, no. 278, pp. 160–161.

[2] *Ibid.*, no. 264, p. 139; Berthold Daun, *Veit Stoss und seine Schule*, Leipzig, 1916, p. 128, pls. XXXVII–XXXVIII.

22. Nativity, Upper Rhenish, c. 1500

Busch-Reisinger Museum 1963.1; purchase, Antonia Paepcke DuBrul Fund. Polychromed lindenwood; h. 28¼ in. (72 cm.); w. 30½ in. (77.5 cm.); max. d. 9 in. (23 cm.); back flat

Plate XIX

COLLECTIONS

R. von Passavant-Gontard, Frankfurt a.M.
Walter von Pannwitz, Berlin

LITERATURE

Otto Schmitt and Georg Swarzenski, *Meisterwerke der Bildhauerkunst in Frankfurter Privatbesitz*, vol. I, *Deutsche und französische Plastik des Mittelalters*, Frankfurt a.M., 1921, no. 128, p. 27; *Art Quarterly*, vol. XXVI, no. 2, Summer 1963, p. 252.

The kneeling Madonna presses her hands together in an attitude of prayer. Her head is bare and her brown curly hair, bound with a fillet, hangs in a series of long strands. She wears a golden dress and a blue-lined golden cape, fastened by a strap across her chest. The plump Christ Child to her right is cradled in a fold of her cape, one end of which is held by an angel. The angel is also decked in gold, except for a bit of red ribbon beneath the chin. The Child's legs are bent and crossed at the knee, and His arms are extended toward His Mother. The base on which the figures are placed is painted green and brown.

The condition is excellent. The only losses are two toes from the right foot of the Christ Child. The polychromy is original and well preserved, with only a scattering of minor losses.

The relatively high relief of the Nativity indicates that it probably once adorned the central section of an altarpiece. The strong contrasts of light and shade, the glittering restlessness of the drapery, and the calm majesty of the Madonna must have been enhanced by the original setting of the group.

The work is said to have once been in the village of Tettnang near the north shore of Lake Constance, and an old photograph reveals that Saint Joseph was placed behind the Virgin.[1] Several works of sculpture from the Upper Rhine and Constance regions are stylistically related to the Cambridge piece. Among the earliest is the Annunciation group in the chapel at Meersburg, dating from the last quarter of the fifteenth century. The two sweeping curves of drapery on either side of a vertical central axis and the general shape of the Virgin's head invite comparison with our work.[2] A number of carvings attributed to Hans Olmütz, who was active in Silesia and the Lake Constance area, recall the Cambridge Nativity in technical achievement as well as in style.[3]

Even closer in drapery treatment is a Seated Madonna now in the Lorenzkapelle, Rottweil, attributed to a master of the Lake Constance region, and a Pietà of about 1500 in the Cathedral of Constance.[4] The facial types and the unbroken opposing arcs of drapery of the Constance Pietà markedly resemble the Cambridge relief.

[66]

This connection with Upper Rhenish sculpture points to a shop near Lake Constance and a date in the first years of the sixteenth century for the Cambridge Nativity.

[1] Dr. Theodor Müller kindly furnished me with information concerning the place of origin of the relief and the presence of Saint Joseph.

[2] Wilhelm Pinder, *Die Deutsche Plastik des fuenfzehnten Jahrhunderts*, Munich, 1924, pl. 72.

[3] Hans Rott, *Quellen und Forschungen zur südwestdeutschen und schweizerischen Kunstgeschichte im XV. und XVI. Jahrhundert*, vol. I, *Bodenseegebiet*, Text, Stuttgart, 1933, pp. 104, 218, figs. 51, 85.

[4] Karl Gröber, *Schwäbische Skulptur der Spätgotik*, Munich, 1922, pl. 45; Heribert Reiners, *Das Münster Unserer Lieben Frau zu Konstanz*, Constance, 1955, pp. 396–397, fig. 355.

23. Madonna and Child, Malines, c. 1500

Busch-Reisinger Museum 1964.22; Lucy Wallace Porter bequest. Polychromed nutwood; 14⅛ in. (36 cm.); back flat

Plate XXXII

COLLECTIONS

A. Kingsley Porter, Cambridge, Massachusetts

The Madonna, supporting the Child with her right hand, is clad in a dress and tight-fitting bodice, originally gilded. A fillet binds her hair. The Child, fully clothed, holds a sphere in His right hand. The back of the figure is marked with the letter "M."

Very little of the original polychromy remains. The right arm of the Child and the left hand of the Madonna are not original. The left side of the Virgin's face is restored and the upper part of her head, including the fillet around her hair, has been recut.

The Madonna is closely related in style to a series of statuettes carved of nutwood, many of which, like the Cambridge piece, have the mark of the city of Malines, the letter "M," incised in their backs.[1] All have in common the broad brow, rounded cheeks, and narrow eyes of the Cambridge Madonna. All wear similar costumes and show comparable treatment of the drapery. This series dates from the end of the fifteenth century to about 1510. The Cambridge Madonna clearly belongs to the group, and dates about 1500.

[1] Willy Godenne, *Préliminaires à l'inventaire général des statuettes d'origine malinoise présumées des XVᵉ et XVIᵉ siècles*, Brussels and Malines, 1958–1963; see especially pls. III, IV, VI, VII, XXIX, LVI, LXXIV, LXXVI, CVI.

24. Annunciation, Brabant, c. 1500–1510

Fogg Art Museum 1943.23; gift, Mrs. Mark A. Lawton. Oak relief; 13 × 12 in. (33 × 30.5 cm.); back flat

Plate XXXII

COLLECTIONS
Ralph Adams Cram, Boston
Mrs. Mark A. Lawton, Newton, Massachusetts

The angel standing at the left raises its hand in salutation. The Virgin, seated at the right on a cushion before a lectern, rests her left hand on an open book; her right hand is pressed to her breast. There are no traces of polychromy.

The relief has suffered some damage. The right hand of the angel is missing as are several fingers of the left hand. A break down the middle of the composition has been repaired. There is a split at the extreme right, extending through the lectern and the Madonna's drapery. Dowel holes on the base indicate that there may have been a vase of lilies between the two figures. Similarly a dowel hole on the top of the Madonna's head shows that she once had a halo. There are smaller losses on the lower edge of the relief.

The Annunciation was once part of a Netherlandish altarpiece and its style is similar to that found in Brabant. This is particularly true of the drapery, which is characteristic of work produced in that province about 1500. It forms a series of parallel ridges that follow the main forms of the figures and are separated from one another by shallow "valleys." Occasionally a fold will cut across a "valley," connecting the parallel ridges.[1] In our Annunciation the ridges themselves are flat rather than rounded, a feature of some Brabant sculpture such as the Annunciation Altar in the Musée Mayer van der Bergh, Antwerp, and the Musée Gruuthuse, Bruges.[2] Thus an attribution to Brabant seems justified.

[1] J. de Borchgrave d'Altena, "Des caractères de la sculpture brabançonne vers 1500," *Annales de la Société Royale d'Archéologie de Bruxelles*, vol. XXXVIII, 1934, pp. 188 ff., figs. 59, 60; Leo van Puyvelde, "Retables sculptés flamands," *Revue belge d'archéologie et d'histoire de l'art*, vol. VII, 1937, pp. 45–52; Borchgrave d'Altena, *Les Retables brabançons, 1450–1550*, 2nd ed., Brussels, 1943, pl. XXXI; idem, in *Annales de la Société Royale d'Archéologie de Bruxelles*, vol. XLII, 1938, p. 276, fig. 8; Johnny Roosval, *Schnitzaltäre in schwedischen Kirchen und Museen*, Strassburg, 1903, figs. 7, 8; idem, in *Revue belge d'archéologie et d'histoire de l'art*, vol. III, 1933, pp. 136 ff., fig. 3; Martin Konrad, *Meisterwerke der Skulptur in Flandern und Brabant*, Berlin, 1930, pls. 20, 53.
[2] Negative nos. 139684B and 133755B of the Koninklijk Instituut voor het Kunstpatrimonium, Brussels.

25. Education of the Virgin, Franconian, c. 1510–1520

Busch-Reisinger Museum 1941.35; gift, Mrs. Felix M. Warburg in memory of her husband. Polychromed lindenwood; h. 33 in. (84 cm.); full round

Plates XXII, XXIII

COLLECTIONS
Felix M. Warburg, New York

Saint Anne, seated on a folding chair, holds an open book in her right hand. Her left encircles the waist of her young daughter, Mary, who is reading from the book and whose right hand is raised for emphasis. Anne, veiled in white, wears a blue garment and gold mantle. The Virgin is dressed in gold. The back of the group is carved, with indications of the back of the chair and a fold of drapery hanging over it.

Most of the polychromy has disappeared and sufficient remains only to recall the original colors. A few inches of the base, including the feet of the chair, have been cut away. The first finger of the Virgin's left hand is missing.

Saint Anne instructing the Virgin is a rare iconographic motive until the late Middle Ages, although it is related to the *Anna Selbdritt*, which stems from the cult of Saint Anne in the thirteenth century.[1]

The dating of the group is fairly certain. The drapery, deeply undercut but in general suggesting the disposition of the bodies beneath it, is characteristic of the early years of the sixteenth century. The square-toed shoes of Saint Anne also point to a sixteenth-century date. Her folding-chair is rather rare; an almost exact duplicate formerly in the Figdor Collection, however, was regarded by Falke as Tyrolese, about 1510.[2]

A close parallel to the Cambridge group is to be found in the figures of the Virgin and Saint Anne in the *Schrein* of the Altarpiece of the Holy Kinship in the Bavarian National Museum in Munich, considered to be a Franconian or Swabian work of about 1510.[3] The handling of the drapery, the rather heavy hands of Saint Anne with the large knuckles, and the facial types of the female figures are identical in both works. The Munich altarpiece and the Cambridge group are strikingly similar to the much repainted standing Madonna in the Church of Saint Emmeran at Spalt, which was presented to that town by the humanist Georg Spalatinus in 1519.[4] The figures on the altar of Saint Willibaldus in the Cathedral of Eichstädt are also related to this group. Thus the Cambridge Education of the Virgin is very likely a Franconian work of about 1510–1520.

[1] Beda Kleinschmidt, *Die heilige Anna: ihre Verehrung in Geschichte, Kunst und Volkstum*, Düsseldorf, 1930, pp. 371 ff.

[2] Otto von Falke, *Deutsche Möbel des Mittelalters und der Renaissance*, Stuttgart, 1924, p. 140.

[3] Theodor Müller, *Die Bildwerke in Holz, Ton und Stein* (Kataloge des Bayerischen Nationalmuseums München, vol. XIII, pt. 2), Munich, 1959, no. 180, p. 184.

[4] *Die Kunstdenkmäler von Mittelfranken*, vol. VII, *Stadt und Landkreis Schwabach*, Munich, 1939, pp. 318, 320, fig. 325. The drapery of the *Anna Selbdritt* in the church at Kaldorf is also like the three works in question (cf. *ibid.*, vol. III, *Bezirksamt Hilpoltstein*, Munich, 1929, p. 200, fig. 154).

26. Saint John the Baptist, Follower of Hans Leinberger, c. 1515

Busch-Reisinger Museum 1957.124; purchase, Museum Association Fund. Polychromed lindenwood; h. 33⅞ in. (86 cm.); back flat

Plate XXVIII

COLLECTIONS

Dr. R. Oertel, Munich
Oskar Bondy, Vienna

LITERATURE

Otto Bramm, "Hans Leinberger, seine Werkstatt und Schule," *Münchner Jahrbuch der bildenden Kunst*, new series, vol. V, no. 2, 1928, p. 183; Rudolph Lepke's Kunst-Auctions-Haus, Berlin, *Sammlung Dr. Oertel, München; Bildwerke der Gotik und Renaissance in Holz, Stein und Ton*, May 6–7, 1913, no. 120, p. 35, pl. 74; *Die Kunstdenkmäler des Königreichs Bayern, Niederbayern*, vol. I, *Bezirksamt Dingolfing*, Munich, 1912, p. 193.

The left hand of the figure reaches forward to hold a book, on which rests a lamb. The right hand is raised to point at the animal. The Saint is clad in a wide-sleeved red mantle lined with green. The base is also greenish in color.

The thumb of the right hand and parts of the base have sustained slight damage. There is considerable repainting of the polychromy. This is particularly noticeable in the shirt of the figure, originally brown and now painted silver.

The style of the Saint John is strongly influenced by the work of Hans Leinberger. The facial type is closest to the very first works of Leinberger, such as the seated Madonna and Child of 1510–1515 in the Bavarian National Museum, Munich, or the Saint John Baptist and Saint John Evangelist of about 1516–1518, now in the Seminar Museum at Freising. The Cambridge Saint John is relatively flat (the maximum depth is about 6⅞ inches), but the sculptor has managed to give a great impression of depth within this compressed space. The same tendency appears in early Leinberger as well, particularly in the work of about 1515.[1] It is reasonable to conclude, therefore, that

the seated Saint John was carved by a pupil of Leinberger who was associated with the master during his earliest period of activity.

There have been several attempts to re-create the artistic personalities of the Leinberger followers.[2] The close stylistic kinship between the seated Saint John and certain works now generally attributed to a Leinberger follower known as the Master of Dingolfing has been recognized for some time. The facial type of our Saint with his slanting eyes, sharp features, and stylized hair is very close to several works by the Dingolfing Master. Particularly noteworthy in this regard is the standing Saint John Baptist of the parish church of Dingolfing of about 1520–1530.[3] Also, both saints hold the book in the same curious manner, with the left arm stretched across the lamb. This gesture is rather common among Leinberger shop pieces, although the seated Saint John in Cambridge seems to be the earliest known example.[4]

The known work of the Master of Dingolfing has a drapery style that is somewhat later than that of the Cambridge figure. It has a full-blown roundness and playfulness that are barely suggested by the garments of the seated Saint. Thus our figure, because of its closeness to early Leinberger as well as to the style of the Dingolfing Master, may well have been done about 1510–1515 while the latter was still under the close supervision of his master.

[1] Theodor Müller, *Die Bildwerke in Holz, Ton und Stein* (Kataloge des Bayerischen Nationalmuseums München, vol. XIII, pt. 2), Munich, 1959, pp. 207–208, no. 208; Georg Lill, *Hans Leinberger*, Munich, 1942, pp. 170–173, 174.

[2] Philipp Maria Halm, *Studien zur süddeutschen Plastik*, Augsburg, vol. II, 1927, 1–41; Otto Bramm, "Hans Leinberger, seine Werkstatt und Schule," pp. 116–189; C. Theodor Müller, "Hans Leinberger," *Zeitschrift für Kunstgeschichte*, vol. I, 1932, pp. 273–288; Lill, *Hans Leinberger*, pp. 253 ff.

[3] *Ibid.*, p. 256.

[4] Halm, *Studien zur süddeutschen Plastik*, vol. II, p. 256; Theodor Demmler, *Die Bildwerke in Holz, Stein und Ton: Grossplastik* (Staatliche Museen zu Berlin, Die Bildwerke des deutschen Museums, vol. III), Berlin and Leipzig, 1930, p. 264, no. 8166.

27. Saint Michael, Danube School, c. 1510–1520

Busch-Reisinger Museum 1949.162; purchase, Kuno Francke Memorial Fund. Polychromed lindenwood; h. 32¾ in. (83.2 cm.); back hollowed out

Plates XXVI, XXVII

COLLECTIONS
Oskar Bondy, Vienna

[71]

LITERATURE

Charles L. Kuhn, "Recent Acquisitions, Busch-Reisinger Museum," *The American-German Review*, vol. XIX, no. 2, December 1952, pp. 15–16, fig. 2.

Saint Michael is portrayed as if in combat with Satan. The archangel is clad in a white garment and a red cape held in place by a scalloped clasp and a blue ribbon beneath it. One end of the ribbon is tucked in at the waist while the other flutters restlessly. The right hand is raised as though holding a weapon. The left hand is more relaxed in front of the figure but the fingers are bent, indicating that it once held a pair of balances.

The figure has been mutilated by the cutting away of the lower portion, which probably contained a representation of Satan. Several of the fingers have been broken off and some losses have occurred to the edges of the cape, notably at the left. A section of the back of the head has been gouged out to make room for a sword, which was originally horizontal, repeating the direction of the large fold beneath the lowered left hand. The polychromy has been repainted in some areas, but much of it appears to be original. The blue is a fairly good grade of azurite.

The closest stylistic parallels are found not in sculpture but in the painting and graphic art of the Danube School. In the Crucifixion of 1511–1512 by Albrecht Altdorfer at Cassel, the drapery of Saint John Evangelist is handled in much the same manner.[1] Other works by Altdorfer created between 1510 and 1520 also exhibit this tendency. It is especially striking in the paintings of the Life of Saint Florian and the woodcut of the Annunciation of 1513 (B. 44).[2] The work of Wolfgang Huber, a master closely associated with Altdorfer, demonstrates similar handling of drapery.[3]

There are a number of plastic works attributed to the Danube School, some of which have a relationship to our Saint Michael. Among the closest are the Madonna from Hernstein of about 1510 and a praying Madonna from an altar in Krems.[4] These comparisons make it probable that the Saint Michael was created about 1510–1520 in the Passau-Linz area.

[1] Ludwig von Baldass, *Albrecht Altdorfer*, Zurich, 1941, pp. 236, 238.

[2] *Ibid.*, pp. 274, 275, 276, 287.

[3] Martin Weinberger, *Wolfgang Huber*, Leipzig, 1930, figs. 25, 26, 64; Erwin Heinzle, *Wolf Huber*, Innsbruck, n.d., pls. 27, 75, 77.

[4] Herbert Seiberl, "Über einige Bildhauerwerke der Wiener Donauschule," *Jahrbuch der Kunsthistorischen Sammlungen in Wien*, new series, vol. XIII, 1944, p. 239, fig. 213; Kunsthistorisches Museum, Vienna, *Altdeutsche Kunst im Donauland*, exhibition catalogue, June 24–October 15, 1939, nos. 213–223, pl. 12; Minoritenkirche, Krems-Stein an der Donau, *Die Gotik in Niederösterreich*, exhibition catalogue, May–October 1959, no. 207, pl. 17.

28. Triptych of Saint Anne, Thuringian, 1516

Busch-Reisinger Museum 1932.65; gift, Eda K. Loeb. Polychromed lindenwood; h. 47½ in. (125 cm.); w. of central section 40¼ in. (112 cm.); w. of wings 20 in. (50.7 cm.)

Plate XXV

COLLECTIONS
Dr. R. Oertel, Munich

LITERATURE
Rudolph Lepke's Kunst-Auctions-Haus, Berlin, *Sammlung Dr. Oertel, München; Bildwerke der Gotik und Renaissance in Holz, Stein und Ton*, May 6–7, 1913, no. 90, p. 26, pl. 58.

In the central section or *Schrein* are three standing saints: Saint Anne clasping the Madonna and Christ Child is in the middle, and flanking her are Saint Barbara with a chalice and Saint Catherine holding a sword and book. A bishop saint fills each of the wings. The five figures are on individual pedestals and all wear gilded pluvia. The upper part of the background is gilded; the lower two-thirds is painted green to simulate a textile. On the exteriors of the wings are painted two bishop saints standing in niches. The left wing is inscribed, "S. Nicolaus," the right "S. Donatus, 1516."

The sculpture is well preserved but the polychromy has been extensively repainted. The gold appears to be original. The crosiers held by the bishops in the wings have been lost.

The style of the altarpiece is somewhat *retardataire*. Although the work is dated 1516, the stiff, blocklike figures with their heavy, angular drapery completely concealing the forms beneath recall a sculptural style of a generation earlier.

This conservative art is common in much of Saxony and especially in Thuringia. It can be observed in an exactly contemporary triptych in the church of Frauenbreitungen near Meiningen, for example.[1] There are many other close stylistic parallels to be found in Thuringian sculpture of the first quarter of the sixteenth century, illustrated in the *Bau- und Kunstdenkmäler Thüringens*.[2]

[1] Oskar Doering, *Meisterwerke der Kunst aus Sachsen und Thüringen*, Magdeburg, n.d., pl. 95.

[2] Herzogthum Sachsen-Altenburg, vol. II, Westkreis, pp. 14, 75, 128, 131; Grossherzogthum Sachsen-Weimar, Verwaltungsbezirk Eisenach, p. 85; Verwaltungsbezirk Dermbach, p. 102; Herzogthum Sachsen-Meiningen, Kreis Meiningen, p. 56; Fürstenthum Schwarzburg-Rudolstadt, vol. I, p. 213.

29. Madonna and Child and Saint Anne, Swabian, c. 1510–1520

Busch-Reisinger Museum 1958.240; purchase, Museum Association Fund. Polychromed lindenwood; h. not including the modern base 18¾ in. (47.5 cm.); back hollowed out

Plate XXIV

LITERATURE
Art Quarterly, vol. XXIV, no. 4, Winter 1961, p. 398.

Saint Anne, seated on a bench, holds the Infant Jesus on her right knee and the Madonna at her left. The Virgin, wearing a gold dress and a simple band around her hair, has an open book in her hands. Saint Anne's dress also is gold, lined with blue, and her long white headdress is bound tightly beneath her chin.

The right arm of the Child is restored. Otherwise the carving is in good condition. Approximately one third of the original gold remains. The flesh tones and the blue lining of Saint Anne's dress are restored.

The style of the Cambridge *Anna Selbdritt* relates it clearly to Swabian sculpture of the first quarter of the sixteenth century. The large V-shaped folds of Saint Anne's drapery are broken here and there by small triangular or square strokes of the chisel resembling cross-sections of hollow cubes and pyramids. This curious mannerism appears in much of the sculpture of Ulm, for example in the stone figures of the west portal of the cathedral of that city, and in many of the works associated with the sculptor Daniel Mauch and his followers.[1]

The face of Saint Anne, framed by the white headdress, and in particular the strong line of the nose, follow a type found frequently in this group of works. It is strikingly similar, for example, to the fragmentary Holy Kinship from Reichenbach, now in Rottweil. The same facial type can be seen in the Holy Kinship in Berlin, the two Holy Kinships in the Bavarian National Museum in Munich, and the *Anna Selbdritt* in the Germanic Museum in Nuremberg. All of these works are associated with the school of Daniel Mauch. The tight, stylized curls of hair on the head of the Child also appear to be a mannerism of this school.[2] Thus our *Anna Selbdritt*, although somewhat heavier in proportions than the sculpture of Daniel Mauch, is related to it and is a Swabian work of the second decade of the sixteenth century.

[1] Gertrud Otto, *Die Ulmer Plastik der Spätgotik*, Reutlingen, 1927, figs. 145–148, 330, 359–361; Lore Göbel, "Beiträge zur Ulmer Plastik der Spätgotik," *Tübinger Forschungen zur Kunstgeschichte*, vol. XIII, 1956, figs. 16, 25, 29, 32, 45.

[2] Julius Baum, *Die Bildwerke der Rottweiler Lorenzkapelle*, Augsburg, 1929, no. 120, pp. 43–44, pl. 88; Theodor Demmler, *Die Bildwerke in Holz, Stein und Ton: Grossplastik* (Staatliche Museen zu Berlin, Die Bildwerke des deutschen Museums, vol. III), Berlin and Leipzig, 1930, no. 5607, pp. 221–222; Walter Josephi, *Kataloge*

des Germanischen Nationalmuseums: Die Werke plastischer Kunst, Nuremberg, 1910, no. 375; Theodor Müller, *Die Bildwerke in Holz, Ton und Stein* (Kataloge des Bayerischen Nationalmuseums München, vol. XIII, pt. 2), Munich, 1959, nos. 104, 105, pp. 118–119; Lore Göbel, "Beiträge zur Ulmer Plastik," figs. 27–30, 50.

30. Triptych of the Madonna in Glory, Lower Saxon, 1524

Busch-Reisinger Museum 1949.306; anonymous gift. Sculptured figures, polychromed lindenwood (?); cabinet work including the tracery, oak; h. 93 in. (237.5 cm.); w. of central panel 56½ in. (143 cm.), each wing 28¼ in. (71.7 cm.)

Plate X X X

LITERATURE

Charles L. Kuhn, "Recent Acquisitions, Busch-Reisinger Museum," *The American-German Review*, vol. XIX, no. 2, December 1952, p. 15, fig. 1.

The altarpiece is in the form of a triptych, with a predella and a superstructure containing the following inscription:

REGINA · CELI · LETARE · AL̄LA · QUIA · QUĒ[M] · MERUISTI · PORTARE · AL̄LA · RESOREXIT · [SICUT] · DIXIT · AL̄LA · ORA · P[RO] · NOBIS · DEŪ[M] · AL̄LA · ANNO · DN̄I · M · CCCCC · XXIIII ·

> Queen of heaven, rejoice, hallelujah
> Because you had the merit to bear, hallelujah
> Him who rose again, as he said, hallelujah
> Pray to God for us, hallelujah
> In the year of Our Lord 1524

In the *Schrein* or central section is a Madonna standing on a crescent and holding the Child. Behind her are the rays of sunlight. To the Madonna's right is Saint Erasmus and to her left, Saint Catherine. In the wings are the twelve Apostles in two zones of three each. In the predella are, from left to right, Saint Anthony, Saint Anne holding the Madonna and Child (*Anna Selbdritt*), Saint Vitus, Saint Margaret, and Saint Sebastian. Each figure of the triptych stands on its own small pedestal and is separated from its neighbor by colonnettes which support stem and leaf tracery.

Nearly all of the figures have sustained slight damage, largely confined to the fingers and hands. Many of the Apostles have lost their distinguishing attributes. The Madonna and Child of the *Schrein* have suffered most. The Virgin's left arm is missing and the Child has lost both of His arms and His left leg. The polychromy is damaged and repainted. Some of the original gold has been preserved, however. Hinge marks on the predella suggest that originally it was adorned with wings, probably painted. The *Aufsatz* with its inscription has been damaged: a small area of the central section is missing, and a word has been partially obliterated.

[75]

Two distinct styles are discernible in the Triptych of the Madonna in Glory. The figures in the central section and in the predella represent one style. Their proportions tend to be slightly attenuated, and the swirling lines of drapery point to the influence of the Middle Rhine. The Twelve Apostles in the wings are in the second of the two styles — simpler, less mannered, more solid, and squat. Both of these styles are found in Lower Saxony during the first quarter of the sixteenth century. The general type of the Madonna echoes that of the Virgin from the Altar at Isenhagen. The Apostles, also, recall the Isenhagen Altar, especially its Saint Andrew, which could have served as a model for the same saint in Cambridge. A group of apostles now in Braunschweig, too, are in this style.[1] Other Lower Saxon carvings resembling the figures of the *Schrein* and predella are very numerous and indicate the area around Hildesheim and Braunschweig as the place of origin of the altarpiece.[2]

[1] Herbert von Einem, "Die Plastiken des Marienaltares in Kloster Isenhagen," *Kunsthistorische Studien des Provinzial-Museums Hannover*, vol. III, 1931, pp. 39 ff., figs. 27–28; P. J. Meier, "Die Kanzel in der Kreuzklosterkirche zu Braunschweig," *Zeitschrift für Kunstgeschichte*, vol. III, 1934, p. 279, fig. 6.

[2] Gert von der Osten, *Katalog der Bildwerke in der Niedersächsischen Landesgalerie Hannover*, Munich, 1957, no. 131, pp. 130–131; Ferdinand Stuttmann and Gert von der Osten, *Niedersächsische Bildschnitzerei des späten Mittelalters*, Berlin, 1940, nos. 47, 73, 80, pls. 62, 92, and 97; V. C. Habicht, "Die Mittelalterliche Plastik Hildesheims," *Alt-Hildesheim*, no. 2, May 1920, pp. 28–29, fig. 3.

31. Madonna and Child, Middle Rhenish (?), c. 1520

Busch-Reisinger Museum 1963.100; gift, Mrs. Gertrude T. Beyer, Mrs. Anastasia T. Dunau, and Mrs. Margarete T. Munson in memory of their parents, Dr. Siegfried J. and Franziska Thannhauser. Lindenwood; h. 58 in. (147 cm.); back hollowed out

Plate XXIX

COLLECTIONS

Franz Wolter, Munich
Dr. and Mrs. Siegfried J. Thannhauser, Boston

LITERATURE

Franz Wolter, "Bayerische Plastik des XV. und XVI. Jahrhunderts," *Festschrift des Münchener Altertums-Vereins Erinnerung an das 50 jähr. Jubiläum*, Munich, 1914, pp. 65 ff., fig. 73.

The Madonna stands in a frontal pose. Her left hand supports the Child and her right is extended forward. The Infant holds an open book in His hands.

The statue was once polychromed, for a few traces of the gesso ground are still discernible. There is a scattering of termite holes and tunnels, but in general the surface is in good condition. The right hand is modern. An old reproduction of the figure shows that the original hand held a pomegranate. A deep crack in the right side of the figure was subsequently repaired. The top of the Madonna's head has a hole, now plugged, which indicates that she once wore a halo. The strands of hair hanging on the left and right sides were carved at a later date than the rest of the figure.

The drapery of the Madonna forms a series of tubular, U-shaped folds arranged one beneath another on the central axis. This design, frequently employed by Hans Leinberger, perhaps accounts for the original publication of the work as Bavarian.[1] The curious grimaces of the Virgin and the Christ Child, rather like archaic smiles, somewhat resemble the exaggerated facial expressions found on certain Austrian retables of the early sixteenth century.[2]

In other respects, the Cambridge statue differs from both Bavarian and Austrian work of the period and has stylistic qualities more common to the region of the Middle Rhine. The ponderous bulk, the smooth unbroken contours, and the elaborate linear treatment of the hair and drapery over the shoulders appear in many of the works by followers of Hans Backhoffen (act. 1505–1519). Examples are the Apostle series at Halle a.S., the Magdalen of the Crucifixion in the Cathedral of Trier, and the double tombs at Gauordernheim, Geisenheim, and Oppenheim.[3] Thus our statue is probably by the hand of a rather provincial craftsman working in the district of the Middle Rhine during the third decade of the sixteenth century.

[1] Franz Wolter, "Bayerische Plastik des XV. und XVI. Jahrhunderts," pp. 65 ff.
[2] Herbert Seiberl, "Der Zwettler Altar und die Auswirkungen des Kefermarkter Stiles im 16. Jahrhundert," *Jahrbuch der Kunsthistorischen Sammlungen in Wien*, new series, vol. X, 1936, pp. 105 ff.; Ernst Völter, "Der Altar von Mauer," *Zeitschrift für bildende Kunst*, vol. LXI, 1927–1928, pp. 309 ff.
[3] Paul Kautzsch, *Der Mainzer Bildhauer Hans Backhoffen und seine Schule*, Leipzig, 1911, pls. XIII, XVI, XVIII; Fritz Witte, *Tausend Jahre deutscher Kunst am Rhein*, Leipzig, 1932, vol. III, pl. 337.

32. Jesse Tree, Circle of Heinrich Douvermann, c. 1520–1530

Busch-Reisinger Museum 1957.125; purchase in memory of Eda K. Loeb. Polychromed oak; h. 9½ in. (24 cm.); w. 51 in. (129.5 cm.); back slightly hollowed out

Plate XXXI

Jesse, clad in white, is recumbent on a small mound in the center of the composition, with his feet to the left and his head supported by his left hand. The tree,

a complex vine ornament, originally sprouted from his chest. He is flanked by a pair of male figures, both attired in red costumes with white collars. They probably represent David, at the right, and Solomon, at the left.

The trunk of the tree is broken off at its source and many of the leaves and tendrils have disappeared. The polychromy is recent and badly pitted. The vine still bears a few traces of its original gilding. The hands of David are missing, but the position of the arms suggests that he once held a harp.

Although the motive of the Jesse Tree occurs often in German predellas, it is especially frequent in the Lower Rhine region, where it is found in the numerous altarpieces imported from Antwerp at the beginning of the sixteenth century.[1]

The typical Flemish retable of the early sixteenth century consists of many small scenes in both shrine and predella. The predellas are invariably composed in three parts with a central subject and one or more scenes to either side. When the Jesse Tree is depicted, it forms the main theme of the predella and Jesse himself is usually seated erect on a throne, but the tripartite division is retained. In Germany, on the other hand, the Jesse Tree predellas usually consist of a unified composition of this subject only.[2]

The closest stylistic parallel to the Cambridge piece is to be found in the work of Heinrich Douvermann, who was active in Kleve, Kalkar, and Xanten from 1510 to 1544. The Jesse Tree predella appears at least three times in his sculpture. The earliest example, the Altarpiece of Our Lady in the Stiftskirche of Kleve, was begun by Douvermann in 1510 and completed by Jakob Derricks in 1513. Here Jesse is seated erect on a canopied throne, the motive of the tree occupying the entire predella, but the composition still recalls strongly the Flemish three-part division.[3] Douvermann's purest altarpiece, entirely by his own hand, is the retable of the Seven Sorrows of the Virgin in the Catholic Church of Kalkar, documented 1518–1522.[4] Its predella has a more unified composition: Jesse is still seated and, as in the Busch-Reisinger Museum example, is flanked only by David and Solomon. The last and most elaborate of Douvermann's Jesse Tree predellas is on the high altar of the Cathedral of Xanten, completed by his son Johann in 1536.[5] Though seated, Jesse leans slightly to his left, his head resting on his left hand as in the Cambridge example. Large figures of David and Solomon are posed at either side, while scores of smaller half-length and full-length figures are attached to the vine. The intricacy and complexity of the vegetation almost obscure David, Solomon, and even Jesse.

The drapery style in the Cambridge Jesse Tree, with its long, sharp, converging folds, is very similar to that of Douvermann's work at Kalkar and Xanten. (The drapery of the Kleve altar consists of small angular broken folds very close to Flemish sculpture and quite different from Douvermann's subsequent style.) David's costume resembles that of David in the Kalkar Altar.[6] The vine ornament with its bursting seed pods and sharp ribbed leaves also appears to be related to Kalkar. Both lack the rounded forms that are so much a feature at Xanten.

We may therefore conclude that the Busch-Reisinger Museum Jesse Tree is by an artist of the circle of Heinrich Douvermann and that it was produced about 1520–1530, as its style has elements of both the Kalkar Altar of 1518–1522 and the Xanten Altar of about 1536.

[1] Paul Clemen, ed., *Die Kunstdenkmäler der Rheinprovinz*, Düsseldorf, vol. I, pt. 2, 1891, *Kreis Geldern*, pp. 69–70, pl. IV; vol. VIII, 1902, *Kreis Jülich*, pp. 20–21, pls. I–II, fig. 8, and p. 215, pl. X; Theodor Demmler, *Die Bildwerke in Holz, Stein und Ton: Grossplastik* (Staatliche Museen zu Berlin, Die Bildwerke des deutschen Museums, vol. III), Berlin and Leipzig, 1930, no. 8088, pp. 342–343; O. Schmitt and G. Swarzenski, *Meisterwerke der Bildhauerkunst in Frankfurter Privatbesitz*, Frankfurt a.M., 1921, fig. 176.

[2] Rolf Hetsch, *Die Altarwerke von Heinrich Douvermann*, dissertation, Würzburg, 1937, pp. 3–5.

[3] Clemen, ed., *Die Kunstdenkmäler der Rheinprovinz*, vol. I, pt. 4, 1892, *Kreis Kleve*, p. 97, pl. VII, fig. 52.

[4] Fritz Witte, *Tausend Jahre deutscher Kunst am Rhein*, Leipzig, 1932, vol. III, pl. 223.

[5] Richard Klapheck, *Der Dom zu Xanten und seine Kunstschätze*, Berlin, 1930, pp. 102–110; Witte, *Tausend Jahre deutscher Kunst*, vol. III, pl. 229.

[6] J. Heinrich Schmidt, *Kalkar; Die St. Nikolaikirche und ihre Kunstschätze*, Ratingen, 1950, fig. 95.

33. Triumph of a Sea-Goddess, Peter Floetner, c. 1530

Busch-Reisinger Museum 1951.213; purchase, Museum Association Fund. Steatite stone relief; diam. 6⅞ in. (17.5 cm.)

Plate XXXIV

LITERATURE

Charles L. Kuhn, "Recent Acquisitions, Busch-Reisinger Museum," *The American-German Review*, vol. XIX, no. 2, December 1952, pp. 19–20, fig. 4; idem, "An Unknown Relief by Peter Flötner," *Art Quarterly*, vol. XVII, no. 2, Summer 1954, pp. 108–115.

A circular relief depicts eighteen putti in a triumphal procession. The largest of the children is a girl riding a sea monster. Directly opposite her is a putto holding a pair of goats.

The relief is in excellent condition, except for a few areas that are rubbed. At some date after its completion, a hole was bored in the center and the surface was varnished. The gilded bronze band also was a later protective addition.

The steatite relief was designed as a model for the Nuremberg goldsmiths and was probably intended as the base for an elaborate ceremonial goblet or pitcher.

The attribution to Peter Floetner (1485–1546) has been verified through a preparatory drawing by that artist preserved in the Herzog Anton Ulrich Museum in Brunswick.[1] That the stone relief was used as a model is attested by the bronze cast in the Musée des Arts Décoratifs in Paris.[2] The classical subject shows strong Italian influence, and the carving dates from the late 1530's, when Floetner was producing his most humanistic works.

[1] Eduard Flechsig, ed., *Zeichnungen alter Meister im Landesmuseum zu Braunschweig*, Frankfurt a.M., vol. I, 1920–1921, no. 22; E. F. Bange, in *Jahrbuch der preuszischen Kunstsammlungen*, vol. LVII, 1936, p. 183, and vol. LIX, 1938, p. 232.
[2] Charles L. Kuhn, "An Unknown Relief by Peter Flötner," fig. 4.

34. Medal of the Fall and Redemption of Man, Hans Reinhart the Elder, 1536

Busch-Reisinger Museum 1961.124; purchase, general funds. Silver; diam. 2⅝ in. (6.5 cm.)

Plate **XXXIV**

COLLECTIONS
Adalbert von Lanna, Prague
Hans Mueller, Lebanon, Kentucky

LITERATURE
Wilhelm Ernst Tentzel, *Saxonia Numismatica*, Dresden, 1705, p. 98, pl. 8, fig. 1; Karl Domanig, *Die Deutsche Medaille in Kunst- und Kulturhistorischer Hinsicht*, Vienna, 1907, no. 762, p. 119, pl. 87; Rudolph Lepke's Kunst-Auctions-Haus, Berlin, *Sammlung des Freiherrn Adalbert von Lanna, Prag*, vol. III, *Medaillen und Münzen*, May 16–19, 1911; Anderson Gallery, New York, *Collection Hans Mueller*, sales catalogue, 1925, pt. III, nos. 88–89; Georg Habich, *Die Deutschen Schaumünzen des XVI. Jahrhunderts*, Munich, vol. II, 1932, pt. 1, p. 284, no. 1986, pl. CCXI, fig. 1; *Art Quarterly*, vol. XXV, no. 1, Spring 1962, p. 76.

Obverse:
Adam and Eve, flanking the Tree of Knowledge, occupy the center foreground. The serpent is coiled around the trunk of the tree; in its foliage squat an ape and a cock. A profusion of other animals — swan, swine, unicorn, elk, rabbit, ox, ass — crowd the space around the feet of Adam and Eve. To the left and right are the coats of arms of the Duchy of Saxony and of the Saxon Elector. Beneath the group extends a banderolle with the inscription: IOANNS FRIDERICVS · ELECTOR · DVX · SAX-

ONIE · FIERI · FECIT (Johann Friedrich Elector of Saxony ordered this to be made). In the background, a small scene of the Creation of Eve at the left is balanced at the right by the Expulsion from Paradise. Another inscription encircles the relief as a border: ET · SICVT · IN · ADAM · OMNES · MORIVNTVR · ITA · ET · IN CHRIS-TVM · OMNES · VIVIFICABVNTVR VNVS QVISQVE · IN · ORDINE · SVO (And just as all die in Adam so in Christ all shall live. Each one in his turn).

Reverse:

The Crucifixion scene fills the foreground. Behind it to the left rises a church, opposite which is depicted the Resurrection of Christ. The artist's monogram, HR, and the date, 1536, are incised at the foot of the Cross. Following the curve of the medal, a banderolle stretches across the base of the composition; it bears the inscription: SPES · MEA · IN · DEO · EST (My hope is in God). As in the obverse, the border is formed by an inscription which reads: VT · MOSES · EREXIT · SERPĒTĒ · ITA · CHR̄S · IN CRVCE · EXALTATVS · ET RESVSCITATVS · CAPVT · SERPĒTIS · CŌTRIVIT · VT · SALVARET · CREDĒTES (As Moses raised the serpent, so Christ, elevated on the Cross and resurrected, crushes the head of the serpent that He might save the faithful).

The Busch-Reisinger medal was derived from a simple wooden model which was in the Kunstgewerbe Museum in Leipzig before the Second World War. The cast was then embellished through a variety of techniques borrowed from goldsmithy. The artist's monogram and the date were incised or engraved in the silver surface. Details of foliage and curling strips of bark were added by means of silver solder. Microscopic examination reveals that originally the silver was gilded — noteworthy because silver with gilt was the material most commonly employed by German goldsmiths. Another cast of the medal still retains much of the old gilding.[1]

Hans Reinhart (1517–1581) spent much of his career at the Saxon Court. Thus it is not surprising to find in this medal certain elements that recall the works of Lucas Cranach the Elder, official court painter at the time. Like Cranach's "Paradise" painting in Vienna and his many representations of the Fall of Man, the obverse of the medal is enriched with a great variety of animals.[2] The elk and the rabbit, symbolic of the melancholy and sanguine tempers, are normal accessories in German representations of Adam and Eve.[3] The ape along with the serpent and the swine connote evil and sin. Many of the animals in the medal appear to have direct reference to the New Testament, however. The cock in the tree is associated with Peter's denial of Christ. The ox and ass are traditionally present at the birth of the Saviour. The swan, because of its beautiful song as it dies, sometimes suggests the Resurrection of Jesus. The unicorn, who can be captured only by a virgin, stands for purity. The animals therefore convey the same ideas of sin and death, redemption and eternal life, as are imparted by the inscription.

The reverse of the medal also gives evidence of the influence of Lucas Cranach.[4] Here is represented the final sacrifice of Christ for the salvation of mankind. His resurrection in the background at the right signifies the entry into Paradise and is the counterpart of the Expulsion on the obverse. The church at the left of the Crucifixion scene is

the new Paradise. The border inscription, like that of the obverse, clarifies and strengthens the pictorial representation.

[1] William W. Watts, *Works of Art in Silver and Other Metals, belonging to Viscount and Viscountess Lee of Fareham*, London, 1936, no. 70.

[2] Max J. Friedländer and Jakob Rosenberg, *Die Gemälde von Lucas Cranach*, Berlin, 1932, nos. 163, 166, 167, 287, 288.

[3] Erwin Panofsky, *Albrecht Dürer*, Princeton, 1943, vol. I, p. 85.

[4] Friedländer and Rosenberg, *Die Gemälde von Lucas Cranach*, nos. 61, 84, 302.

35. Standing Warrior, Netherlandish, c. 1530

Fogg Art Museum 1949.65; purchase, Annie S. Coburn Fund and gift from Dr. Fritz Talbot. Nutwood (?); h. 12⅝ in. (32 cm.); back flat

Plate XXXIII

COLLECTIONS
Hollingsworth Magniac, Paris
Edward J. Berwind, New York
Joseph Brummer, New York

LITERATURE
Christie, Manson & Woods, London, *Catalogue of the Renowned Collection of Works of Art, Chiefly Formed by the Late Hollingsworth Magniac. . .* (Known as the Colworth Collection), July 2, 4, 1892, no. 778, p. 171, pl. facing p. 182; Parke-Bernet Galleries, New York, *The Notable Art Collection belonging to the estate of the late Joseph Brummer*, sales catalogue, pt. 1, April 20–23, 1949, no. 500, p. 126; Theodor Müller, "Zur südniederländischen Kleinplastik der Spätrenaissance," *Festschrift für Erich Meyer zum sechzigsten Geburtstag*, Hamburg, 1957, pp. 194, 196, fig. 6.

The Warrior, clad in pseudo-classical armor, stands on a base carved to simulate rocky terrain. Originally he held a spear and his right arm extended across his torso.[1]

The condition is excellent except for the serious losses of the entire right arm, the left hand, and the spear. The back contains over a dozen small holes which were bored with an awl and have the appearance of dowel holes.

The Warrior, along with a number of other walnut and boxwood statuettes, has been the subject of a recent study by Theodor Müller. Müller has convincingly demonstrated that they are Southern Netherlandish in origin on the basis of their close stylistic connection with the paintings of Jan Gossaert and Bernard van Orley and the sculpture

of Konrad Meit, whose career terminated in Antwerp. In discussing our Standing Warrior, Müller compared it with a drawing by Jan Gossaert in Dresden.[2]

Several small-scale objects comparable in style should also be cited: the group of Princes Taking an Oath of Allegiance to an Emperor in the collection of the Metropolitan Museum in New York,[3] the standing Saint George and the Dragon in the Victoria and Albert Museum in London, and the pairs of warriors in high relief, holding coats of arms and forming parts of the decoration of the wooden beams in the City Hall of Audenarde. In the light of these comparisons, the Standing Warrior appears to be a Netherlandish work dating from the second quarter of the sixteenth century.

[1] Christie, Manson & Woods, London, *Collection of the Late Hollingsworth Magniac*, no. 778, p. 171, pl. facing p. 182.

[2] Theodor Müller, "Zur südniederländischen Kleinplastik der Spätrenaissance," p. 196, note 17; the drawing is reproduced in *Old Master Drawings*, vol. X, September 1935, p. 32.

[3] E. F. Bange, *Die Kleinplastik der deutschen Renaissance in Holz und Stein*, Munich, 1928, pl. 75. The London and Audenarde works are unpublished.

36. Christ Child, Swabian, c. 1530–1540

Busch-Reisinger Museum 1959.96; purchase, general funds. Polychromed lindenwood; h. 15⅜ in. (39 cm.); full round

Plate XXXV

The standing figure has the right hand raised in a gesture of blessing. It is polychromed in natural flesh tones with touches of gold paint in the hair.

The condition of the figure is excellent. Most of the polychromy is original, though there are some losses and touches of repaint, especially on the legs.

The standing Christ Child was a devotional image which, according to Hans Wentzel, originated about 1300.[1] Its popularity grew rapidly, reaching its height in the fifteenth and sixteenth centuries. The motive was frequently used in the graphic arts in the second half of the fifteenth century and was commonly employed in New Year greeting cards. For this reason it is sometimes called *Das Neujahrskind* (The New Year's Child).

The example in the Busch-Reisinger Museum has elements that survived from the Late Gothic period. The stance, with one foot sliding over the edge of the base, is typical of Late Gothic sculpture. The method of rendering the folds of flesh on the thighs by

[83]

means of simple, gouging strokes of the chisel is also characteristic of early examples. It lives on well into the sixteenth century, however, as can be seen in the Nude Boy in the Nuremberg Museum, produced about 1550 in the shop of Pankraz Labenwolf.[2]

The facial type of the Cambridge Christ Child is similar to that of several examples of Swabian sculpture in the first half of the sixteenth century.[3] The wavy hair and slender proportions of the figure indicate that it is relatively late. Thus it is Swabian, and possibly an Ulm creation of the second quarter of the sixteenth century.

[1] Otto Schmitt, ed., *Reallexikon zur deutschen Kunstgeschichte*, Stuttgart, vol. III, 1954, pp. 590–607.

[2] Walter Josephi, *Kataloge des Germanischen Nationalmuseums: Die Werke plastischer Kunst*, Nuremberg, 1910, p. 294, no. 481.

[3] Heiner Sprinz, *Die Bildwerke der Fürstlich Hohenzollernschen Sammlung Sigmaringen*, Stuttgart and Zurich, 1925, no. 78, pl. 48; see also Hugo Helbing, Frankfurt a.M., *Sammlung Geheimrat Ottmar Strauss, Köln*, sales catalogue no. 42, November 6–7, 1934, lot nos. 70–71, pl. 23.

37. Wild-Man Candle Holder, Nuremberg (?), c. 1525–1550

Busch-Reisinger Museum 1962.79; purchase in memory of Eda K. Loeb. Bronze; h. including base 10½ in. (26.6 cm.); h. of figure 8½ in. (21.5 cm.)

Plate XXXVI

COLLECTIONS
Helmhold Hoffmann, Tutzing, Bavaria

The figure is in a striding position, its feet touching two curved supports. The upraised right hand once grasped a candle. The left arm, with bent elbow and closed hand, swings out from the side. The body is covered with hair and a long moustache adorns the upper lip. The headdress resembles a turban. A sash encircles the waist and serves as a loincloth.

The surfaces are rubbed smooth and a slight dent has been inflicted on the top of the head. The object once held in the left hand has disappeared.

The production of figurative candle holders for domestic use had begun in the fifteenth century and became widespread during the sixteenth. For this reason the place of origin of our example is by no means certain, but there is some evidence that points to Nuremberg. A wild man of yellowish bronze now in the Germanic National Museum of that city (inventory no. Pl.O.2982) has the same patina and method of rendering the

hair on the body by incised lines. A second example attributed to Nuremberg is in the Maison Boucherie, Antwerp (inventory no. 236). The latter has a twisted head band similar to that of the Cambridge bronze. The stance of our figure is identical to that of a *Landsknecht* candle holder in the Brussels Museum, believed to have been made in Southern Germany about 1550.[1] The treatment of the moustache and the handling of the folds of the headdress and sash are similar to those in a Nuremberg *Landsknecht* also in the Germanic National Museum.[2] Our Wild Man probably dates from the second quarter of the sixteenth century and may well be a Nuremberg work.

[1] Provinciaal Museum voor Kunstambachten, Deurne-Antwerp, and Koninklijke Musea voor Kunst en Geschiedenis, Brussels, *Koper en Brons*, exhibition catalogue, April 13–June 10, 1957 (Deurne-Antwerp) and June 15–July 29, 1957 (Brussels), no. 243, fig. 37; Walter Stengel, "Nürnberger Messinggerät," *Kunst und Kunsthandwerk*, vol. XXI, 1918, pp. 228 and 237, fig. 31.

[2] An equally vigorous small bronze, with facial details handled similarly, is the Running Man in Festival Costume in the Untermyer Collection, published as a mid-sixteenth-century Nuremberg piece but once considered to be Netherlandish (Paul Cassirer, Berlin, and Hugo Helbing, Munich, *Die Sammlung Wilhelm Gumprecht, Berlin*, sales catalogue, 1918, vol. II, no. 107, pl. 13; *Bronzes, Other Metalwork and Sculpture in the Irwin Untermyer Collection*, New York, 1962, pl. 150, fig. 161).

38. Fragment from a Resurrection, Netherlandish, c. 1550

Fogg Art Museum 1949.47.48; purchase, Alpheus Hyatt Fund. Sandstone; h. 11⅛ in. (28.3 cm.); w. 31¼ in. (79.5 cm.); d. 7⅛ in. (18 cm.)

Plate IV

Three soldiers in fanciful armor sprawl on the ground, their heads thrown back as they gaze upward. They are carved in very high relief, with the side of a sarcophagus as a background. The two on the ends wear hats, while the center figure has a fillet binding his hair. The breastplate of the soldier at the left is adorned with a double-headed eagle; behind the figure a sword is visible. The center guard appears to be grasping a log or wooden club with his right hand, and a curved sword hangs at his side. The third companion leans on a shield decorated with the profile head of a Negro. A weapon resembling a scimitar is in its scabbard between his legs.

The surfaces are badly weathered and the faces of the men have been obliterated. Both hands of the soldier at the left are missing as are the left hand of the center guard. The soldier at the right has lost both arms, his right foot, and his entire left leg. The handle of his scimitar is also gone.

Representations of the Holy Sepulchre guarded by soldiers are common throughout the late Middle Ages and Renaissance. The upward gaze of the guards in our example

[85]

suggests that the sculptor represented the figures at the moment of the Resurrection. The imaginative costumes worn by the guards are intended to convey the idea of remoteness in time and place. It was a frequent practice in the sixteenth century to give the guards attributes connoting wickedness.[1] In our fragment the soldiers in the center and at the right have scimitars, weapons associated with the Turks. The Negroid head on the shield is commonly identified with the Moors and hence with paganism. The soldier at the left carries a regular European sword, but on his breast is the Hapsburg eagle. This, like the scimitars and Moorish head, may be construed as a symbol of villainy and immediately brings to mind the hatred of both the French and the Netherlanders for the Spanish Hapsburgs during the reign of Charles V. At about the time of the carving of our work, however, there was a momentary abatement of the hostilities between Charles and the French king. In 1540 Charles V, with the approval of Francis I, made a "triumphal entry" into Ghent with his Spanish troops, an action that was to subjugate much of the country.

The restless and rather awkward poses of the soldiers suggest that our sculptor had a knowledge of Netherlandish paintings of the second quarter of the sixteenth century, such as those by Pieter Coeck van Alost.[2] Therefore on the evidence of iconography, style, and political history, an attribution to a Netherlandish sculptor working in the mid-sixteenth century seems warranted.

[1] Marcel Aubert, *La Sculpture française du moyen âge et de la Renaissance*, Paris and Brussels, 1926, pl. XLV.

[2] Max J. Friedländer, *Die Altniederländische Malerei*, vol. XII, Leyden, 1935, p. 61, pl. XXV.

39. Chandelier, South German or Swiss, c. 1550–1575

Busch-Reisinger Museum 1961.110; purchase, Museum Association Fund. Polychromed lindenwood (?); h. of figure alone 10⅜ in. (26.5 cm.); full round

Plate XXXVII

COLLECTIONS
Julius Boehler, Munich
Albert Keller, New York

A three-quarter length figure of a fashionably dressed lady playing a lute forms the principal portion of the object. On the lower side is a coat of arms consisting of a shield with three parallel bands, topped by a plumed helmet. A pair of stag horns is

attached to the rear of the figure and supports four wrought-iron candle holders. The entire sculpture is painted in a red-brown monotone.

The condition of the figure is good except for the polychromy, which is not original. The iron chains and candle holders are later replacements.

This curious type of candelabrum, known as a *Leuchterweibchen*, was commonly found in public buildings and in the homes of the upper middle classes in the sixteenth century. The horns were often actual hunting trophies and the figures to which they were attached almost always women (a notable exception being the dragon chandelier from Dürer's house in Nuremberg). The figures of the candelabra were sometimes religious or, in the sixteenth century, classical. The most usual figure, however, was genre, as in the Busch-Reisinger example.

The Cambridge figure wears a costume with a high collar, short ruff, and puffed shoulders. This type of dress was in vogue from about 1560 to 1575.[1] The rather generalized treatment of the face suggests comparison with a somewhat later *Leuchterweibchen* from Biberach, now in Stuttgart.[2] The Cambridge work probably originated in Southern Germany or Switzerland.

[1] Erika Thiel, *Geschichte des Kostüms*, Berlin, 1960, pp. 192 ff.; André Blum, *The Last Valois, 1515–90*, trans. by D. I. Wilton, London, 1951, pls. 14, 18, 23, 48.
[2] Julius Baum, *Deutsche Bildwerke des 10. bis 18. Jahrhunderts* (Kataloge der kgl. Altertümersammlung in Stuttgart, vol. III), Stuttgart and Berlin, 1917, no. 375, p. 310.

40. Saint John the Evangelist, South Netherlandish, c. 1550

Fogg Art Museum 1954.59; gift, Rev. Arthur L. Washburn. Gilded bronze; h. 5¾ in. (14.5 cm.)

Plate XXXIX

The youthful Saint stands erect, turning his head slightly to his right. He is clad in a close fitting garment over which is a loose cape, clutched with his left hand. His right arm extends forward and the hand may once have held a chalice.

The gilding appears to be original. It is rubbed in several areas and has entirely disappeared from the back of the extended hand.

Originally the figure may have been part of a Crucifixion group, as is suggested by the direction of the gaze. The snug gown, revealing the anatomy of the indifferently

[87]

modeled body, recalls several works of sculpture of the Southern Netherlands in the second quarter and middle of the sixteenth century. Examples are some of the reliefs of Jan Mone on the retable in St. Gudule, Brussels, and more especially the work by assistants of Jacques Dubroeucq at Mons.[1] Thus the attribution to a South Netherlandish sculptor seems reasonable.

[1] Paul Saintenoy, *Le Statuaire Jan Mone. Jehan Money, maître artiste de Charles-Quint; sa vie, ses oeuvres*, Brussels and Paris, 1931, pls. X, XI; R. Hedicke, *Jacques Dubroeucq von Mons*, Strassburg, 1904, pl. XXV; Jan Steppe, *Het Koordoksaal in de Nederlanden*, Louvain, 1952, fig. 77.

41. Way to Calvary, South German (?), c. 1550–1575

Fogg Art Museum 1962.116; gift, Harry G. Friedman in memory of Francis L. Friedman. Gilded bronze relief; 3¾ × 2¾ in. (9.5 × 7 cm.)

Plate XXXIX

In the front plane Christ is shown falling beneath the weight of the Cross. Behind Him a soldier goads Him forward, while before Him kneels Saint Veronica holding the Sudarium. In the background, in lower relief, is a procession of soldiers and their mounts rounding the edge of a steep hill.

The surfaces have been slightly rubbed. The gilding is restored.

The flowing forms of the drapery and the costumes indicate that the plaquette probably dates from the third quarter of the sixteenth century. The composition may have been derived from a print, although no actual model has been found. The general disposition of the figures and the rather vague pictorial treatment of the landscape is comparable to that in several Netherlandish stone reliefs.[1] In style and scale, however, the work resembles a number of plaquettes that are usually considered to be of Augsburg origin.[2] Since Netherlandish influence was so prevalent in Southern Germany during the second half of the sixteenth century it is possible that the Way to Calvary was produced in that area rather than in the Netherlands.

[1] J. Warichez, "La Cathédrale de Tournai," *Ars Belgica*, vol. II, Brussels, 1935, p. 20, pl. LIX, fig. 94; Paul Saintenoy, *Le Statuaire Jan Mone. Jehan Money, maître artiste de Charles-Quint; sa vie, ses oeuvres*, Brussels and Paris, 1931, pl. XI.

[2] Rudolph Lepke's Kunst-Auctions-Haus, Berlin, *Münzen und Medaillen aus dem Besitz des Herren F. von Parpart, Englische Sammlung von Medaillen und Plaketten des 15. bis 17. Jahrhunderts*, sales catalogue no. 1678, April 23, 1913, nos. 703–721, pl. XVI.

42. Saint Martin and the Beggar, Lower German (?), late XVI century

Busch-Reisinger Museum 1959.29; gift, Mr. and Mrs. Donald Fenn. Oak relief; 19¾ × 14½ in. (50 × 37 cm.)

Plate XXXIX

COLLECTIONS
Mr. and Mrs. Donald Fenn, Watertown, Massachusetts

The composition is in high relief. Saint Martin wears a cape over his pseudo-classical armor. A pointed hat rests upon his head. He is astride his horse, his left hand holding a fold of his cape while his right hand (which originally held a sword) is raised to cut the garment in two. The bearded one-legged beggar is at the right of the composition and awaits expectantly the gift of the fragment of clothing. Framing the figure is an arched niche with suggestions of classical architectural ornament.

The loss of the sword and several splits in the relief are the only damages that the work has sustained.

The carving, crude in quality, is by a provincial sculptor. Indeed, one might consider it a piece of folk art except for the presence of Italianate Renaissance motives. The vertical grooves of the edge of the relief suggest fluted columns; the arch of the niche (which is not quite 180 degrees) rests upon an entablature. The round holes drilled in the spandrels either once held ornamental motives or were inspired by roundels. So pervasive was the influence of Italy in the late sixteenth and early seventeenth centuries that it was felt even in remote villages.

The use of oak does not help in localizing the relief since it probably adorned a piece of church furniture, which all over Central Europe was normally fashioned from oak. In general style, however, it is somewhat similar to the carvings on the pulpits of such North German churches as the Marienkirche and the Johanniskirche of Flensburg, dated 1579 and 1587 respectively.[1] This rather provincial style lasts into the seventeenth century in the pulpit of such a village church as that at Översee in Schleswig-Holstein.[2] It is possible, therefore, that the Saint Martin was carved by a Lower German craftsman at the end of the sixteenth century.

[1] Ludwig Rohling, *Die Kunstdenkmäler der Stadt Flensburg* (Die Kunstdenkmäler des Landes Schleswig-Holstein, vol. VII), Munich, 1955, pp. 101, 222–223, figs. 43, 104, 105.
[2] Dietrich Ellger, *Die Kunstdenkmäler des Landkreises Flensburg* (Die Kunstdenkmäler der Landes Schleswig-Holstein, vol. VI), Munich, 1952, pp. 264–265, fig. 150.

43–47. Series of Five Triumphs, Netherlandish, end XVI century

Fogg Art Museum 1934.85–1934.89; gifts, Grenville L. Winthrop.

Plate XXXVIII

COLLECTIONS
Bardini, Florence
Grenville L. Winthrop, New York

LITERATURE
Christie, London, *Catalogue des objets d'art . . . provenant de la collection Bardini de Florence* . . . sales catalogue, Paris ed., May 27, 1902, no. 279, pp. 46–47, pl. 10.

43. Triumph of Justice (1934.85)

Bronze relief with dark brown patina; 2⅞ × 5 in. (7.5 × 12.9 cm.)

Justice, a female figure with sword in one hand and balances in the other, is seated on a four-wheeled cart drawn toward the right by a pair of lions. She is accompanied by Peace bearing an olive branch and by Abundance with a cornucopia. A youth grasping a laurel branch and a goad is their driver.

The condition of the plaque is good except for the usual rubbing in the high parts of the relief.

For further comments, see Number 47.

44. Triumph of Folly (1934.86)

Bronze relief with brown patina; 2⅝ × 4⅛ in. (6.6 × 10.5 cm.)

A four-wheeled cart adorned with grotesque animal heads is hitched to a team of oxen. The cart is occupied by allegorical figures. Half-reclining at the back is a young woman holding a sprig of flowers, attended by a lad who offers her a single bloom. Behind them is a woman carrying a dish of fruit, a beldam with a full cornucopia, and a laurel-crowned female, holding several pieces of fruit. The driver of the wagon is a youth equipped with a staff and a two-tined fork. Behind him a bearded man in

monkish habit raises aloft a flaming dish. A distant landscape is suggested by a few clouds and a fortified building.

A small notch in the left edge of the relief may be due to faulty casting. Otherwise, the condition is good.

For further comments, see Number 47.

45. Triumph of the Church (1934.87)

Bronze relief with brown patina; 2⅞ × 5 in. (7.5 × 12.9 cm.)

Two unicorns, driven by a bearded man cracking a whip, pull a four-wheeled cart. Seated at the back of the cart, a female figure clutching the keys of Saint Peter represents the Church. Above her head flies the Dove of the Holy Spirit, and before her are three Virtues: Faith, her hands clasped, Chastity holding a dove and scepter, and Humility with a yoke.

The condition is fair. A hole in the rear has been drilled and tapped in relatively modern times.

This subject is sometimes referred to as the "Triumph of Wisdom." For further comments, see Number 47.

46. Triumph of Humility (1934.88)

Bronze relief with brown patina; 2⅝ × 5 in. (7.5 × 12.9 cm.)

Humility, an old woman with a staff in one hand and a piece of fruit (lemon?) in the other, is seated on a cart led by two horses, Temperance and Gentleness. Faith bearing a cross and chalice and Love with her three offspring accompany the vehicle on foot. Hope, identified by an anchor and a bird, assists the bearded driver, Fear, who holds a bundle of faggots.

The condition is good except for some rubbing. Two holes at the top and bottom of the relief were drilled through the bronze at an undetermined date.

The composition of the plaquette, except for the omission of Peace, is borrowed from a design by Martin van Heemskerk, engraved and published by Hieronymus Cock, where each figure is identified by an inscription.

For further comments, see Number 47.

[91]

47. Triumph of Poverty (1934.89)

Bronze relief with brown patina; 2⅝ × 5 in. (7.5 × 12.9 cm.)

Poverty (INOPIA), an emaciated woman, perches at the rear of a wicker, four-wheeled cart drawn by two asses. Her companions are Humility, VMI (LITAS), grasping a winnowing shovel, and Fear, TIM (OR), the driver of the cart, brandishing a whip. Walking beside the cart are the figures of Patience in chains, holding a piece of fruit, and Servitude, carrying an anvil on her shoulders. Alongside the asses is an old woman who represents Fragility. A few landscape elements in the middle distance include a walled cluster of buildings surmounted by a cross — probably a convent or monastery.

Some of the areas are badly rubbed. A notch in the lower edge toward the right is due to improper casting.

The composition of this relief, like that of the Triumph of Humility, copies a design by Heemskerk, engraved by Hieronymus Cock.

The series of five Triumphs exists in several casts. They were first published by Molinier, who regarded them as Italian works of poor quality.[1] Other scholars believed them to be German or Flemish.[2] They are now generally accepted as Netherlandish in origin partly for the reason that two of the series are derived from compositions of Heemskerk. Two unpublished oak reliefs of Triumphs in the Maison Boucherie in Antwerp are very similar in style and tend to support this attribution.

[1] Emile Molinier, *Les Bronzes de la Renaissance. Les Plaquettes. Catalogue raisonné*, Paris, 1886, pp. 150 ff., nos. 663–667.

[2] Edmund Wilhelm Braun, *Die Bronzen der Sammlung Guido von Rhò in Wien*, Vienna, 1908, p. 29, pl. XLVII b, and *Die Deutschen Renaissanceplaketten der Sammlung Alfred Walcher*, Vienna, 1918, pp. 47–50, no. 111, pl. XXIV. Braun believed that a sixth plaquette, depicting the Triumph of Patience, belonged to the series. F. F. Leitschuh, *Flötner-Studien. I*, Strassburg, 1904, attributed two of the series to Peter Floetner. See also E. F. Bange, *Die Bildwerke in Bronze und in anderen Metallen* (Staatliche Museen zu Berlin, Die Bildwerke des deutschen Museums, vol. II), Berlin and Leipzig, 1923, pp. 132–133, pl. 30.

48. Saint John the Evangelist, Netherlandish, c. 1575–1600

Fogg Art Museum 1949.90; purchase, Grace Nichols Strong Memorial Fund. Bronze; h. 11 in. (28 cm.)

Plate XLVI

COLLECTIONS
Henri Daguerre, Paris

LITERATURE
Parke-Bernet Galleries, New York, *The Notable Art Collection belonging to the estate of the late Joseph Brummer*, sales catalogue, pt. 2, May 11–14, 1949, no. 497.

The youthful Saint turns slightly to the left, raising his right hand in a gesture of emphasis. The left arm, pressed to his side and bent at the elbow, supports a voluminous cape. His undergarment is buttoned at the breast and held at the waist by a sash.

The yellow-brown patina has been covered in part by a darker paint or varnish that remains only in the deepest folds. The metal of the left knee, first finger of the left hand, and nose has been dented by a series of blows or falls. A hole in the base between the feet is probably the result of the casting.

The figure's slight axial twist, facial type, and classical stance, as well as the emphasis given by the artist to the mass of the curly hair and the drapery rather than to surface detail, are all characteristic of sculpture of the late sixteenth century. These elements are marked, for example, in the Apostle and Evangelist drawings by the Netherlandish artist, Frederik Sustris about 1589 as sketches for bronzes for the Church of Saint Michael, Munich.[1] A second series of drawings of apostles, one of which is dated 1608, once associated with the South German artist Georg Petel, is also related. These drawings are now believed to be by an Augsburg or Munich artist.[2] Both groups are in the Graphische Sammlung, Munich. Other stylistic parallels are the bronze Sorrowing Virgin in Dortmund, attributed to the Netherlander Hubert Gerhard and dated about 1588–1598,[3] and a large unpublished wooden figure of Saint Anne in the Church of Saint Andrew, Antwerp. Thus it seems likely that our Saint John is of Netherlandish origin and dates from the last quarter of the sixteenth century.

[1] Kurt Steinbart, "Die Niederländischen Hofmaler der Bairischen Herzöge," *Marburger Jahrbuch für Kunstwissenschaft*, vol. IV, 1928, pp. 124 ff., figs. 49–56.
[2] Theodor Müller and Alfred Schädler, *Georg Petel 1601–1634*, exhibition catalogue, Munich, 1964, no. 62, p. 39.
[3] Museum für Kunst und Kulturgeschichte, Dortmund, *Deutsche Bronzen des Mittelalters und der Renaissance*, exhibition catalogue, Schloss Cappenberg, 1960, no. 30.

49. Crocodile Sand Container, Nuremberg, c. 1575–1600

Fogg Art Museum 1956.206; gift, Stanley Marcus. Gilded silver; l. 12¾ in. (32.5 cm.)

Plate XLV

The creature is in a creeping position with its jaws open. The head is removable, and slightly recessed within the neck is an embossed screen.

The gilding, although somewhat rubbed, is in fair condition and appears to be original.

The use of animal forms as utilitarian objects has a long history. With the great prosperity of the goldsmith trade in Nuremberg and Augsburg in the sixteenth and seventeenth centuries came an increase in the quantity and variety of these zoomorphic utensils. Stimulated perhaps by the popularity of the bronze animals of Andrea Ricci and Giovanni Bologna, a taste for reptiles and birds as well as mammals manifested itself. These objects were handled with as great a naturalism as the skill of the artisan allowed. Rearing horses and running stags became drinking cups, stately birds were transformed into decorative goblets. Typical of this vogue is an inkwell, now in the Vienna Museum, by the Nuremberg goldsmith Wenzel Jamnitzer (1508–1585). This metal container is liberally sprinkled with insects, shells, lizards, toads, mice, modeled with complete fidelity to nature.[1]

Our crocodile, part of a desk set, was inspired by the same fashion as the inkwell. Two hallmarks are visible on the inside of the piece. One is known to have been used as the Nuremberg city mark from about 1550 to 1650.[2] The second, the initials R P in a circle, may be the stamp of the assayer. The sand container is probably contemporary or slightly later than the Jamnitzer inkwell and is surely the product of a Nuremberg goldsmith.

[1] Ernst Kris, "Der Stil 'Rustique,'" *Jahrbuch der kunsthistorischen Sammlungen in Wien*, new series, vol. I, 1926, pp. 137 ff.

[2] Marc Rosenberg, *Der Goldschmiede Merkzeichen*, 3rd ed., Frankfurt a.M., vol. III, 1923, no. 3758.

50. Coconut Goblet, Hans Müller of Breslau, c. 1600

Busch-Reisinger Museum 1961.58; purchase in memory of Eda K. Loeb. Gilded silver; h. 11¾ in. (30 cm.)

Plate XL

COLLECTIONS
Edward J. Berwind, New York

LITERATURE
Parke-Bernet Galleries, New York, *Valuable Objects of Art . . . from the Collection formed by the Late Edward J. Berwind*, sale no. 139, November 10, 1939, pp. 109–110, lot no. 393; Edward R. Lubin, New York, *Works of Art*, sales catalogue [1959]; *Art Quarterly*, vol. XX, no. 1, Spring 1962, p. 76.

The body of the goblet is a coconut shell with three scenes from the story of Samson carved in relief: Samson carrying the doors of Gaza, Samson and the lion, and Samson battling the Philistines. Three female herms, which form part of the gilded silver framework supporting the coconut, divide the scenes one from the other. A putto decked out as a warrior with armor, sword, and shield strikes a martial pose atop the goblet's cover. The lid is adorned also with a frieze on which three animal heads, depicted frontally against panels of scrollwork, alternate with three pairs of birds in opposing profile. The metal rim of the cup has two zones of decoration: the upper consists of scrollwork, the lower of broad leaves suggestive of acanthus. The teardrop stem, also of metal, is embellished with scroll and strap ornament and garlands that stream from four seashells. The base echoes the tripartite division of the coconut body and the cover. Scrollwork designs are the foil for three mask-like faces, separated from one another by pairs of pendant pomegranates.

The condition of the cup is good. The only repairs are replacements for the bottom pins holding two of the herms in position. Some of the more prominent details of the surface have been rubbed and the gilding has been renewed.

The great centers of the goldsmith's trade, Nuremberg and Augsburg, were among the first to embellish natural objects with carvings and frames of precious metal. The designs of these goldsmiths were soon imitated elsewhere, stimulating the production of nautilus and coconut goblets in many parts of Germany, the Low Countries, and England.

The Busch-Reisinger Coconut Goblet has no hallmark and thus must be localized on the basis of style. The carving of the scenes of the life of Samson on the shell itself is of no assistance in establishing the place of manufacture. While the execution is competent, the style is rather dry and mechanical, and the compositions appear to be based on models that date from the first half of the sixteenth century.[1]

Close connection exists between the style of decoration of the Cambridge cup and one in the collection of the city of Breslau. The Breslau goblet bears the hallmark of

[95]

Hans Müller, active there from 1588 to 1606.[2] A comparison of the Cambridge cup with a photograph of the Breslau goblet discloses that the herms of both are so alike they might have been cast from the same mold. The pattern of decoration of the Busch-Reisinger Museum cup also strongly resembles the Breslau example, both employing similar scrollwork, vegetable forms, and frontally-posed heads. Moreover, the two goblets are identical in size. Thus it seems probable that the Busch-Reisinger goblet was manufactured in Breslau about 1600, and may well have been produced in the shop of Hans Müller.

[1] A woodcut by Hans Weiditz of Samson with the Doors of Gaza suggests this composition (Campbell Dodgson, *Catalogue of Early German and Flemish Woodcuts . . . in the British Museum*, London, vol. II, 1911, pl. XI).

[2] Christian Gündel, *Die Goldschmiedekunst in Breslau*, Berlin, n.d., pl. 38.

51. Virgin in Glory, Augsburg, c. 1600

Busch-Reisinger Museum 1964.31; purchase, Antonia Paepcke DuBrul Fund. Partially gilded silver on wooden base; h. including base 13¾ in. (35 cm.); h. of Madonna alone 7⅞ in. (20 cm.)

Plates XLII, XLIII

The crowned Madonna stands on a sickle moon which is mounted on a sphere. She turns her head slightly toward the Christ Child, whom she holds with her left hand. In her right hand, which is slightly extended, is a scepter. The Child, with an orb in one hand, makes a gesture of benediction with the other. Attached to the back of the Virgin is the sun, a disk-shaped human face from which issue twenty rays. The base, of black painted wood, is heavily profiled. On each of the four corners is a small winged angel with arms outstretched. On the front and two sides of the base are silver decorations of scrollwork, foliate ornament, and rosettes. Gilding has been applied to the hair and parts of the garments of all the figures and to the sickle moon, sphere, sun, and rays.

The gilding, with the possible exception of that on the sphere, is original. The four angels once held objects in their hands, probably palm leaves, but these have been lost.

The glittering gold and silver of the figures and the silhouettes of the ornamental panels create an impression of overwhelming opulence and exquisiteness. The work was clearly intended for a patron of importance, either for private worship or as a display piece in a *Wunderkammer*.

[96]

The pose of the Madonna and Child and the main folds of the Virgin's costume are almost identical with those of the bronze Madonna and Child designed by Hubert Gerhard about 1595 for a column in the Marienplatz, Munich.[1] Gerhard's Madonna was widely influential in Southern Germany, and, indeed, its impact was felt as far away as Prague.[2] There can be little doubt that it served as a model for the goldsmith who cast our statuette and who altered it from the prototype only in minor details. The four angels on the corners closely resemble in face, hair, and costume the over life-size bronze angel standing by the baptismal font in the Church of Saint Michael, Munich, also a work by Hubert Gerhard, dated 1596.[3] The ornament on the base is similar to that commonly employed by Augsburg goldsmiths.[4] The Cambridge work, then, may surely be considered South German, and in all likelihood it was the product of an Augsburg goldsmith about 1600.

[1] Rudolf Artur Peltzer, "Der Bildhauer Hubert Gerhard in München und Innsbruck," *Kunst und Kunsthandwerk*, vol. XXI, 1918, pp. 145, 147 ff., figs. 35, 36.

[2] Hans R. Weihrauch, *Die Bildwerke in Bronze und in anderen Metallen* (Kataloge des Bayerischen Nationalmuseums München, vol. XIII, pt. 5), Munich, 1956, p. 155, no. 186; A. E. Brinckmann, *Süddeutsche Bronzebildhauer des Frühbarocks*, Munich, 1923, pls. 42, 52; V. V. Štech, *Baroque Sculpture*, trans. by R. F. Samsour, London, n.d., pl. 4.

[3] Brinckman, *Süddeutsche Bronzebildhauer*, pl. 24.

[4] Edwin Redslob, *Deutsche Goldschmiedeplastik*, Munich, 1922, pl. 42; Gustav E. Pazaurek, *Alte Goldschmiedearbeiten aus schwäbischen Kirchenschätzen*, Leipzig, 1912, pl. XLI.

52. Christ Crowned with Thorns, South German, c. 1600–1620

Busch-Reisinger Museum 1962.99; purchase, Museum Association Fund. Polychromed lindenwood; h. 22½ in. (57 cm.); w. 30¼ in. (77 cm.); d. 9 in. (23 cm.)

Plate XLVII

COLLECTIONS
Edouard Chappey, Paris

LITERATURE
Galerie Georges Petit, Paris, *Catalogue des objets d'art dépendant des collections de M. Edouard Chappey*, fourth sale, June 7, 1907.

A red-robed Christ, His hands tied before Him and a heavy crown of thorns on His head, is seated on a bench. He is flanked by two Roman soldiers in pseudo-classic

armor, the one on the left in red, the one on the right in dull yellow-brown. Each places a foot on the bench and raises his arms in a threatening gesture. The group is mounted on an irregularly shaped base.

The three figures have suffered greatly from damage and restoration. Much of the original polychromy has vanished and, in order to make the losses less apparent, a coat of tinted varnish has been applied. The arms and legs of both soldiers have been broken and repaired. The lower left arm of the Roman at the left is a restoration. Originally the soldiers must have held poles or tool handles with which they were pushing the crown of thorns, but these have disappeared.

The lively movement of the two soldiers is almost Late Gothic in feeling and contrasts sharply with the quiet resignation of the Saviour. His pose recalls the Dürer woodcut of the Man of Sorrows done for the Small Passion. The heavily muscled anatomy of the Christ and the costumes of His tormentors with their form-fitting breastplates, scalloped ornament, and grotesque shoulder masks all point to a date early in the seventeenth century.

A somewhat later and much smaller group of the Mocking of Christ, in a private collection, has been published as reflecting a lost work by Georg Petel.[1] Like our sculpture, this Mocking of Christ is full of movement, it has heavy musculature, and its Christ figure shows the influence of Dürer. The facial types and costumes, however, are quite different. The soldiers in our group have the round faces, spherical heads, and curly hair and beards that are consistently found in the works of such Weilheim artists as Hans Reichle, Hans Krumper, Hans Degler, and even ivory carver Christoph Angermair.[2] Like them, Georg Petel was born and trained in Weilheim, but he belonged to the next generation. The privately-owned Mocking of Christ might well be a reflection of an early seventeenth-century group, possibly belonging to a Passion series by the same master as our Crowning with Thorns. Some of the features of both of these works are present in Petel's small representation of Christ at the Column in the Bavarian National Museum, which may thus faintly echo the same series.[3] Whether or not this conjecture is correct, the Crowning with Thorns is probably by a Weilheim artist and was carved about 1600–1620.

[1] Erich Herzog, "Eine deutsche Verspottungsgruppe des 17. Jahrhunderts vom Mittelrhein," *Kunst in Hessen und am Mittelrhein*, vol. I–II, 1962, pp. 94 ff.

[2] Theodor Müller, *Deutsche Plastik der Renaissance*, Königstein, 1963, pp. 75, 85, 86.

[3] Theodor Müller and Alfred Schädler, *Georg Petel 1601–1634*, exhibition catalogue, Munich, 1964, no. 15, pls. 10–11.

53. Angel, South German, c. 1600–1620

Busch-Reisinger Museum 1964.34; purchase, Museum Association Fund. Polychromed lindenwood; h. 44½ in. (113 cm.); full round

Plate XLI

The angel, with both arms extended, stands on a rounded base carved to simulate a cloud. It wears a dress and an over-garment that resembles a short surcoat. A golden bodice, cut out at each breast and dipping below the waist, hugs the figure. A scarf is draped about the shoulders and knotted at the front. The dress, surcoat, and buskins are white trimmed with gold bands. The unruly hair is also gold. On the top of the head is a dowel hole, evidence of a missing halo.

Much of the original polychromy remains, although there have been a number of minor losses. The flesh tones have been repainted. Part of the drapery below the right knee has been lost and replaced. Small repairs have been made to the base.

The figure is probably an angel, in spite of the absence of wings. Similar wingless angels holding garlands were made by Hans Degler for the high altar of 1604 in the Church of Saints Ulrich and Afra at Augsburg.

The position of the arms and hands may derive from the engraving of Virtue Triumphing over Vice by Philippe Galle. It has been suggested that this same engraving served as a model for the bronze Virtus of about 1630, made for the Residence in Munich by Hans Krumper (c. 1570–1634) and now in the Bavarian National Museum.[1] Some of the details of our Angel, such as the knotted scarf and buskins, are even closer to the engraving than is the bronze. Krumper's sketch of the figure of Justice, dated about 1596, for the tomb of William V of Bavaria is marked by these same details as well as similarly-posed arms and hands.[2]

Although our Angel is less skillfully carved than the works of Krumper, it bears a stylistic relationship to several of them. Krumper's personifications of Painting and Sculpture, in wood painted to resemble bronze, dated about 1610, have the curly hair, plump cheeks, and slightly parted lips of our figure, and their drapery is carved in much the same manner. These traits also appear in Krumper's polychromed wood Madonna and Child of about 1620.[3] The visages of the bronze Spring and Summer figures from his series of the Four Seasons are further proofs of kinship with the Busch-Reisinger Museum Angel.[4]

The many common features of the Cambridge Angel and the works of Munich-Weilheim artists such as Krumper and Degler support an attribution to that area of Southern Germany and a date of about 1600 to 1620.

[1] Raimond van Marle, *Iconographie de l'art profane*, The Hague, vol. II, 1932, fig. 11; Hans R. Weihrauch, *Die Bildwerke in Bronze und in anderen Metallen* (Kata-

loge des Bayerischen Nationalmuseums München, vol. XIII, pt. 5), Munich, 1956, no. 179, pp. 148–150.

[2] Adolf Feulner, "Hans Krumpers Nachlass," *Münchner Jahrbuch der bildenden Kunst*, vol. XII, 1922, p. 72, fig. 8.

[3] These three figures are in the Bavarian National Museum, Munich: inventory nos. 27/168, 27/169, 7728.

[4] Weihrauch, *Die Bildwerke in Bronze*, no. 175, pp. 143–145.

54. Personification of Death, Upper Rhenish, c. 1600–1650

Busch-Reisinger Museum 1959.32; purchase, Museum Association Fund. Lindenwood; h. 10⅛ in. (25.5 cm.)

Plates XLVIII, XLIX

LITERATURE
Theodor Müller, "Frühe Beispiele der Retrospektive in der deutschen Plastik," *Bayerische Akademie der Wissenschaften, Philosophisch-Historische Klasse*, Munich, 1961, pp. 20–22.

Death is here personified as a partially decomposed cadaver, originally armed with bow and arrows. The idea of disintegration is conveyed by several cavities in the chest and abdomen. Bits of loose skin are designed to suggest such articles of clothing as boots, gloves, a hood. A sash diagonally across the breast originally supported a quiver which hung at the left hip, and the raised left hand once held a bow. Serpents emerge from many of the breaks in the surface of the body and a toad squats within the abdominal cavity. A second toad is on the base. The figure and base are a single piece of wood.

Although the figure has suffered several important losses, sufficient remains to give a clear indication of its original condition. The quiver of arrows and the bow once held in the left hand are missing. The right forearm, which at one time held an arrow or drew the bow-string taut, has also disappeared. The left hand has sustained minor damage: several fingers are missing.

For further comments, see Number 55.

55. Personification of Death, Upper Rhenish, c. 1600–1650

Busch-Reisinger Museum 1959.33; purchase, Museum Association Fund. Lindenwood; h. 10⅝ in. (27 cm.)

Plates L, LI

LITERATURE
See Number 54.

As in Number 54, Death is represented as a partly decomposed cadaver and once was equipped with bow and arrows. The right arm probably held a spade. In this piece, too, flaps of skin resemble clothing, and snakes crawl from various parts of the body. One serpent, holding an apple in its mouth, is twined around the advanced left leg. Figure and base are carved from a single piece of wood.

In general, the condition of the figure is not as good as Number 54. Quiver, bow, spade, and left forearm are gone. The lower jaw bone has been broken away, as have several of the fingers of the right hand and toes of the left foot.

The two statuettes, clearly the work of the same sculptor, belong to a long series of figurines of Death, beginning with the early sixteenth century. None is more refined in execution and more graceful of pose than the group carved by the master who created the Busch-Reisinger figures. The small scale and meticulous, detailed workmanship indicate that they were destined as cabinet pieces for the art collection of an aristocrat or a wealthy patrician.

The theme of Death as a skeleton or cadaver played an important role in art from the date of its first appearance in the thirteenth century. With time, the iconography of death became increasingly complex.[1] Death often holds an hourglass to show that he comes to all men as the sands of time run out. His most common attribute is a weapon — a scythe or, more frequently, a dart or bow and arrows, for arrows are symbolic of the three scourges of God, which are war, famine, and plague.

Armed Death is Death Triumphant, Death the Hunter, who tracks down and overpowers all mankind. Sometimes he is winged or mounted, for he must move swiftly in his work. Frequently his person is infested with snakes. The ambivalent serpent with its worm-like shape suggestive of putrefaction is here intimately bound up with the presence of Death; for it was the serpent who caused the Fall of Man, making him mortal and thus susceptible to the blandishments of both the Devil and Death. The snake with the apple in its mouth writhing about the foot of our statuette (Number 55) is an unmistakable reference to this relationship of sin and mortality.

The problem of dating the Death figurines is complicated by the absence of drapery and visages and by the artist's aim to achieve complete realism. The earliest of the Death statuettes designed as collectors' pieces can be dated in the first half of the six-

teenth century because of their similarity to figures of Death in the paintings, drawings, and graphic work of Albrecht Dürer, Hans Baldung, Nicholaus Manuel Deutsch, and Hans Holbein the Younger. These artists created Death personifications that have a "Renaissance" quality. The grisly cadavers usually stand quietly and calmly. Their surfaces, although exhibiting decay, are comparatively smooth and unbroken and are defined by sharp, continuous contours. Even where the artists used shreds of flesh to indulge their penchant for linear patterns, as in Baldung's painting of Death and a Woman of 1517 in Basel, there is no sacrifice of the continuous bodily contours.[2] The large stone statue of Death carved for the tomb of René de Châlons (d. 1544) in St. Pierre at Bar-le-Duc and attributed to Ligier Richier has these same smooth, flowing contours and surfaces.

The Death holding a thigh bone produced about 1574 for the famous clock of Strassburg after a grisaille sketch by Tobias Stimmer is a departure from this "Renaissance" mode.[3] Here, a mummy-like cadaver is portrayed in an active pose. The silhouette of the Stimmer grisaille is restless and broken by the fluttering shreds of the winding sheet and the serpents which twine about the legs. The proportions are more slender and attenuated than those of the "Renaissance" group.

The Busch-Reisinger figures retain the slenderness of the Stimmer figure, but their stance is more serene. Despite broken contours, a languid elegance has crept into their pose. Theodor Müller considers that they belong to a group of eight figures, all products of the same artist and all examples of a revival of interest in the Dürer period manifested in seventeenth-century German sculpture.[4] Two figures in this group so markedly resemble the Busch-Reisinger statuettes that they may be regarded as their twins. The Death figurine from the Landesmuseum of Passau, now on loan to the Bavarian National Museum in Munich, in stance, position of the arms, and in most details, seems almost a replica of our Number 54. The Death with Bow and Spade formerly in the Hommel Collection, Zurich, has an equally close correspondence with Number 55 of the Cambridge pair.[5] The Mounted Death in the Metropolitan Museum, New York, though it depicts a variant activity, seems to be of this same family.[6] The remaining figures mentioned by Müller have less affinity with the Busch-Reisinger group. In the Death with Bow and Arrow in the Victoria and Albert Museum the torso is disproportionately large and the anatomy is inaccurate. The quiver differs from those carried by the other figures and the statuette and base are separate. Death with a Banderolle in the Walters Art Gallery is carved of boxwood. It is slightly smaller in scale and its sturdier proportions are closer to the "Renaissance" group. The eighth statuette of Müller's group is an unpublished work in a French private collection.

On the underside of the Passau Death is crudely incised "A.D. 1673." Müller considers this the date of the creation of the work, and concludes that all the statuettes of the group belong to a seventeenth-century revival style which looks back to the art of the early sixteenth century for models.[7] The figures of the Busch-Reisinger group, although

obviously later than the Strassburg clock figure of 1574, have the willowy proportions and gracefulness of the late Renaissance — stylistic evidence that points to the end of the sixteenth century or the first years of the seventeenth as the time of their manufacture. The inscription on the base of the Passau statuette, if regarded as the date of the work, would of course conflict with this hypothesis. It may be, however, that the date is a later addition, scratched in perhaps to commemorate a death in the owner's family.

Localizing precisely the atelier that produced the five statuettes of the Busch-Reisinger group has not yet been possible. The intense and widespread interest in representations of Death in the upper Rhine region and the kinship of the Busch-Reisinger group with the Tobias Stimmer clock figure would lead one to place the shop tentatively somewhere between Strassburg and present-day Switzerland.

[1] Raimond van Marle, *Iconographie de l'art profane*, The Hague, vol. II, 1932, pp. 361 ff.; Alberto Tenenti, *La Vie et la mort à travers l'art du XVe siècle*, Paris, 1952; Hellmut Rosenfeld, *Der Mittelalterliche Totentanz*, Münster and Cologne, 1954, with bibliography.

[2] Hans Curjel, *Hans Baldung Grien*, Munich, 1923, pl. 59.

[3] Bassermann-Jordan, in *Münchner Jahrbuch der bildenden Kunst*, vol. VIII, 1913, p. 218; Friedrich Thöne, *Tobias Stimmer: Handzeichnungen*, Freiburg i.B., 1936, figs. 9, 10.

[4] Theodor Müller, "Frühe Beispiele der Retrospektive in der deutschen Plastik," p. 20.

[5] Kunst-Auktionshaus Math. Lempertz, Cologne, *Sammlung Adolf Hommel, Zürich*, August 1909, p. 205, no. 1462.

[6] E. F. Bange, *Die Kleinplastik der deutschen Renaissance in Holz und Stein*, Munich, 1928, fig. 71.

[7] Theodor Müller, in *Zeitschrift des deutschen Vereins für Kunstwissenschaft*, vol. X, 1943, p. 259, fig. 8; vol. IX, 1942, pp. 191 ff.; idem, "Frühe Beispiele der Retrospektive in der deutschen Plastik," pp. 20–22.

56. Knife Sheath, German, 1626

Busch-Reisinger Museum 1963.5479; purchase in memory of Eda K. Loeb. Boxwood with silver band; l. 7¾ in. (19.5 cm.)

Plate XLV

The top of the sheath is rimmed with silver; at the bottom is a small globe carved with a foliate pattern. The body of the object is divided into four vertical bands, wide and narrow alternating. The narrow bands are filled with representations of the Twelve Apostles, ending in the one case with the initials WGW and in the other with the date 1626. Each of the broader bands is divided into seven compartments containing scenes

[103]

or decoration. On one side are the Paying of the Thirty Pieces of Silver, the Last Supper, the Arrest of Jesus, Christ before Caiphas, Christ before Pilate, Pilate Washing his Hands. The compartment at the top of this band is decorated with an angel holding a shield, in relief high enough to have allowed a hole to be drilled behind it for a carrying thong. The opposite band has a series of genre scenes terminating at the bottom with a low-relief angel holding a shield. The subjects are gentlemen feasting, drinking, entering a bath house, preparing for the bath, bathing, departing from the bath house.

The sheath is in good condition except for some rubbed surfaces. At the base of the knob was once a metal ornament, slight traces of which are still visible.

The style of the tiny scenes shows them to be the work of a craftsman with sufficient skill to suggest contemporary costume and traces of architectural interiors.

Sheaths for eating utensils are common after the middle of the sixteenth century and are often of leather, precious metals, or, in the eighteenth century, porcelain. A surprising number of those made of boxwood bear the initials WGW, the Cambridge example being the latest. Nagler, who knew two of them dated 1589 and 1591, believed the initials to be the monogram of the maker.[1] Since the publication of his book a number of others have come to light; they are in the Bavarian National Museum, Munich (1587), the Rijksmuseum, Amsterdam (1590), the Musée des Arts Décoratifs, Paris (1593), the Landesmuseum Johanneum, Graz (1595), and the collection of Schloss Steyr (1592 and 1611).[2] The series are all marked WGW, range in date from 1587 to 1626, and vary greatly in style and quality. Thus the monogram can hardly be the signature of a single artist. It may be the mark of a workshop in existence for more than one generation, or it may stand for a motto. Prayers or mottoes were often used on weapons or bits of harness. One of them is *Wenn Gott Will, so ist mein Ziel* (As God wills, so is my aim).[3] This saying with its war-like association would have been equally appropriate for cutlery sheaths carried for outdoor feasts in connection with the hunt. It is possible, therefore, that the letters stand for the first three words of this couplet.

[1] G. K. Nagler, *Die Monogrammisten*, Munich, vol. V, 1879, p. 339, no. 1686.

[2] Hans Wühr, *Altes Essgerät: Löffel-Messer-Gabel*, Darmstadt, 1961, no. 17 (the author considers this example to be Greco-Dalmation); Alfred Walcher von Moltheim, "Die Bestecksammlung im Schloss Steyr," *Kunst und Kunsthandwerk*, vol. XV, 1912, p. 15, fig. 17.

[3] James G. Mann, *Wallace Collection Catalogue, European Arms and Armour*, London, pt. III, 1945, p. 495, no. 1211.

57. Bust of Christ, François du Quesnoy, c. 1630

Fogg Art Museum 1960.120; purchase, Alpheus Hyatt Fund. Bronze with dark brown patina; h. including base 9¼ in. (23.5 cm.); h. of bust alone 5¾ in. (14.5 cm.)

Plate LIV

LITERATURE
Fogg Art Museum, Cambridge, Mass., *Acquisitions 1959–1962*, 1963.

Christ is depicted as a bareheaded youth gazing sadly at the ground.
The surface of the neck shows damage and the base of the figure, once broken where it joins the head, has been repaired with lead solder.

For further comments, see Number 58.

58. Bust of the Madonna, François du Quesnoy, c. 1630

Fogg Art Museum 1960.119; purchase, Alpheus Hyatt Fund. Bronze with dark brown patina; h. including base 9¼ in. (23.5 cm.); h. of bust alone 5¾ in. (14.5 cm.)

Plate LV

LITERATURE
See Number 57.

The Madonna, a veil covering part of her hair, inclines her head slightly and turns it to the left. Her eyes are closed.
There are slight imperfections in the back of the veil and drapery.

The pair of busts, which exist in several casts, are attributed to François du Quesnoy (1597–1643) because of their similarity to his documented statue of Saint Susanna of 1633 in the Church of Santa Maria di Loreto, Rome. According to the biography of this artist by Gianpietro Bellori (published in 1672), du Quesnoy made terra cotta busts of the Madonna and the young Christ which were cast in silver and retouched by the artist himself.[1] A relatively newly-discovered terra cotta tends to substantiate Bellori's account.[2]

The silver casts have disappeared, but two bronzes in the Vienna collection are of excellent quality and were probably made in the seventeenth century from the original

mold.[3] They are superior to our bronzes, which reveal slight changes and imperfections. The Cambridge pair are probably later in date and may be eighteenth-century casts.

[1] Mariette Fransolet, *François Du Quesnoy, sculpteur d'Urbain VIII, 1597–1643* (Académie Royale de Belgique, Classe des Beaux-Arts, Mémoires, 2nd series, vol. IX), Brussels, 1942, p. 110, pl. XXIII.

[2] Elisabeth Dhanens, "Twee ongekende Werken van Frans Du Quesnoy te Rome," *Gentse Bijdragen tot de Kunstgeschiedenis*, vol. XIV, 1953, pp. 247 ff.

[3] Julius von Schlosser, *Werke der Kleinplastik in der Skulpturensammlung des A. H. Kaiserhauses*, Vienna, 1910, vol. I, p. 17.

59. Saint Sebastian, Erasmus Kern, c. 1625–1650

Busch-Reisinger Museum 1964.4; gift, H. Kevorkian. Polychromed lindenwood on a pine pedestal; h. including pedestal 49 in. (124.5 cm.); h. of figure alone 42¾ in. (108.5 cm.); full round

Plate LII

The figure of Saint Sebastian, clad in a gilded loincloth, stands against a tree. His right arm is raised as though lashed to one of the branches, the left arm is bent at the elbow and the hand reaches forward, making an emphatic gesture. Brown ringlets adorn the high forehead and tumble down to the neck. Gilded foliate ornament is applied to the sides of the pedestal and in front forms a frame for an inscription: "S. SEBASTI . . ."

The original polychromy is almost entirely concealed by repaint. Repair of numerous splits in the body necessitated the filling of all but one of the holes — that in the left leg — from which arrows once protruded. New holes were thereafter bored. A hole in the top of the head indicates that the halo at one time was differently attached. The present halo is a modern replacement, and the right arm is a restoration. Part of the first finger is missing from the left hand. Folds of flesh at the waist and on the legs just above the ankles indicate that originally ropes were employed at these positions to secure the martyr to the tree.

The Saint Sebastian has distinctive stylistic features that call for an attribution to Erasmus Kern (act. 1624–c. 1650), the leading sculptor of his generation in the Vorarlberg and the principality of Liechtenstein.[1] In all of Kern's works one finds brittle drapery, the painfully exact details of anatomy, and a facial type like that of our figure. At least three other statues of Saint Sebastian have been attributed to this sculptor. The Cambridge figure most closely resembles the earliest of the three, made about 1630 for an altarpiece in Feldkirch.[2] The slender proportions, handling of the hair, facial expres-

[106]

sion, and anatomy, even to the bands of swollen flesh suggesting constrictions made by ropes, are identical. The proportions of Kern's later figures are somewhat more ample, as in the altarpiece at Levis dated 1648 and in his last known documented work, a retable of about 1650 at Eschen.[3]

[1] Dagobert Frey, *Die Kunstdenkmäler des politischen Bezirkes Feldkirch* (Österreichische Kunsttopographie, vol. XXXII), Vienna, 1958, pp. 304, 357, 439, figs. 293, 366, 473; Erwin Poeschel, *Die Kunstdenkmäler des Fürstentums Liechtenstein* (Die Kunstdenkmäler der Schweiz, vol. XXIV), Basel, 1950, pp. 89 ff., 115 ff., 232, 251, figs. 92–93, 98–106, 223–225, 248–249.
[2] Frey, *Die Kunstdenkmäler des politischen Bezirkes Feldkirch*, p. 174, fig. 114.
[3] *Ibid.*, p. 304, fig. 293; Poeschel, *Die Kunstdenkmäler des Fürstentums Liechtenstein*, pp. 266 ff., figs. 222–224.

60. Model of a Nautilus Goblet, Nuremberg (?), c. 1650–1675

Busch-Reisinger Museum 1962.29; anonymous gift. Gilded silver; h. 2⅜ in. (6 cm.)

Plate XLIV

COLLECTIONS
Oskar Bondy, Vienna

The body of the goblet is a small shell, the lip of which is rimmed with silver. It is held in position by four hinged silver straps. On the top is a nude male figure astride a dolphin. A second dolphin forms the stem, the head of the animal resting on an oval base decorated with acanthus leaves and having a scalloped edge. Four holes for jewel settings are in the base.

The shell has been cracked and repaired and much of the gilding has been worn away. There are several dents in the metal rim of the lip. The base has been damaged on one side and a small section has been broken off. Only one of the original jewel settings remains.

Small-scale models of tankards and goblets were made by goldsmiths for display purposes and to demonstrate the designs to prospective buyers. Occasionally these minute works had hallmarks, but the Cambridge example lacks them. Localizing the work is difficult, especially since nautilus cups were manufactured throughout Europe during the seventeenth and later centuries.

The figure on the dolphin strikingly resembles the two bronze putti on similar mounts made by Georg Schweigger in Nuremberg about 1661–1665 for the Neptune

Fountain which adorned the Hauptplatz.[1] The ornament on the base of the cup is consistent with a date in the third quarter of the seventeenth century. Thus a Nuremberg goldsmith may have designed the work.

[1] Hans R. Weihrauch, "Georg Schweigger (1613–1690) und sein Neptunbrunnen für Nürnberg," *Anzeiger des Germanischen National-Museums 1940 bis 1953*, Nuremberg, 1954, pp. 87 ff., figs. 6, 18.

61. Rape of Proserpine, South German (?), c. 1625–1650

Fogg Art Museum 1949.66; purchase, Annie Swan Coburn Fund. Bronze with gray-green patina; h. 29½ in. (75 cm.)

Plate LIII

COLLECTIONS
Joseph Brummer, New York

LITERATURE
Parke-Bernet Galleries, New York, *The Notable Art Collection belonging to the estate of the late Joseph Brummer*, sales catalogue, pt. 1, April 20–23, 1949, no. 470, p. 118.

A long-haired and bearded Pluto grasps the struggling Proserpine with both hands. The victim tries to repel him by pushing his head with her left hand and disengaging his arm with her right. Her left foot touches the ground and her right leg is raised. Her head is thrown back and her face wears an expression of terror.

The condition is good. A green patina was artificially applied to the original gray finish at an undetermined date.

The rather large size of the Rape of Proserpine indicates that it may originally have been designed for a garden or fountain. Proserpine's expression and the oval shape of her head suggests that the sculptor was acquainted with the works of Peter Paul Rubens, whose influence was widespread in Central Europe.

The group has some features that make Southern Germany a possible place of origin. In spite of its inorganic figure construction and clumsy pose, the Cambridge bronze is related to the styles of Gerhard and de Vries.[1] A wax model by Adriaen de Vries may well be the direct artistic ancestor of our Pluto and Proserpine. The bozzetto by de Vries representing the Rape of a Sabine Woman no longer exists, but three views of it were engraved by Jan Müller. One of these engravings was copied in metal relief and is

in the Maximilian Museum in Augsburg.[2] Although there are slight differences in the position of the Sabine Woman's arms, she too pushes away her captor with her left hand, has her left foot on the ground, and her right leg raised. Pluto clutches Proserpine in the same manner as the Roman embraces the Sabine. Although Pluto and Proserpine have none of the grace and subtlety of de Vries, his composition appears to have inspired our statue.

These various stylistic connections with bronzes in Southern Germany suggest the possibility that the group was made in this general area during the second quarter of the seventeenth century.

[1] Adolf Feulner, *Die Deutsche Plastik des siebzehnten Jahrhunderts*, Munich, 1926, pls. 9, 16; A. E. Brinckmann, *Süddeutsche Bronzebildhauer des Frühbarocks*, Munich, 1923, pls. 64, 83, 85.
[2] Hans R. Weihrauch, "Notizen zum Kreis des Adriaen de Vries," *Zeitschrift des historischen Vereins für Schwaben*, vol. LIV, 1941, pp. 397 ff., figs. 30, 31.

62. Chandelier, South German or Austrian, c. 1675–1700

Fogg Art Museum 1957.185; gift, Milton I. D. Einstein. Polychromed lindenwood; h. of figure alone 17 in. (43 cm.); back hollowed out

Plate XXXVII

COLLECTIONS
William Randolph Hearst, San Simeon, California
Milton I. D. Einstein, New York

The figure is clad in a classical costume of gold. She extends both arms in front of her as though holding an object. A pair of elk horns protrude from her back. Behind them, the human body ends in a fish tail. Four wrought-iron candle holders are attached to her sides. She was suspended by three wrought-iron chains and a hook set in an iron rosette. Beneath the figure is a heraldic decoration in a rococo frame.

The original polychromy has almost entirely disappeared, or has been extensively repainted. All the wrought iron is relatively modern. The figure is carved of lindenwood and was hollowed out, but the hollow is now filled with a pine board to which the antlers are attached. The left arm has been broken and repaired. The fingers on both hands have suffered losses and some have been replaced with restorations. A hole at the top of the head may once have held the support of a halo. The heraldic device in its neo-rococo frame is relatively recent in manufacture.

[109]

The fragmentary figure, a work of indifferent quality, was converted at an undetermined time into a chandelier. The position of the arms and hands indicates that they may once have held a garland or a palm leaf suggesting that perhaps the creature was originally an angel. The general style of the work dates it late in the seventeenth century. It may have been carved in Southern Germany or Austria.

63. Abraham's Sacrifice of Isaac, South German, late XVII century

Busch-Reisinger Museum 1964.21; purchase, Museum Association Fund. Ivory; h. 14 in. (35.5 cm.)

Plate LVII

COLLECTIONS
The Barons von Rothschild, Vienna

LITERATURE
Franz Schestag, *Katalog der Kunstsammlung des Freiherrn Anselm von Rothschild in Wien*, Vienna, 1866, no. 112; Baltimore Museum of Art, *Age of Elegance: The Rococo and its Effect*, exhibition catalogue, April 25–June 14, 1959, no. 288, p. 66.

A tall, gaunt Abraham raises the sacrificial knife with his right hand and gazes upward at the angel who stays the blow. His left hand rests on the shoulder of his submissive but doleful son, Isaac, who, seated on a neat pile of faggots, bows his head. The base is carved to represent the ground. Between the feet of Abraham are a bit of vegetation and a lizard.

The tip of the angel's left wing is restored. A break in the base behind the group has been repaired.

The flowing unity of form combined with dramatic intensity is similar to the effect sought by Peter Paul Rubens when he painted the same subject in a sketch for the ceiling of the Jesuit Church in Antwerp. After about the middle of the seventeenth century, the influence of Rubens was strong in Southern Germany and Austria, where it sometimes fused with that of Bernini. These two currents came together in such ivory carvers as Matthias Rauchmiller (1645–1686) and Jakob Auer (d. 1710), some of whose works resemble the Cambridge piece in style. The Apollo and Daphne and the Bacchante ivories in the Vienna Museum, attributed to Rauchmiller, are sharper in carving and more detailed in surface treatment than the Sacrifice of Isaac, but they have the same tightly integrated composition and the same upward thrust.[1] Other kindred works are

to be found in the museums of Brunswick and Munich.[2] It is probable, therefore, that our piece is Austrian or South German in origin and dates from the end of the seventeenth century.

[1] Julius von Schlosser, *Werke der Kleinplastik in der Skulpturensammlung des A. H. Kaiserhauses*, Vienna, 1910, vol. II, pl. LIV, figs. 1, 2.

[2] Otto Pelka, *Elfenbein*, 2nd ed., Berlin, 1923, figs. 178, 179; Eugen von Philippowich, *Elfenbein*, Brunswick, 1961, fig. 133; Christian Scherer, *Die Braunschweiger Elfenbeinsammlung*, Leipzig, 1931, no. 110, p. 60, pl. 23; Rudolf Berliner, *Die Bildwerke in Elfenbein, Knochen, Hirsch- und Steinbockhorn* (Kataloge des Bayerischen Nationalmuseums München, vol. XIII, pt. 4), Augsburg, 1926, nos. 210, 211, 441, 442, pls. 163, 202, 203.

64. Return of the Holy Family from Egypt, Meinrad Guggenbichler, c. 1690

Busch-Reisinger Museum 1956.275; purchase, Museum Association Fund. Polychromed lindenwood; h. of Madonna 30¼ in. (77 cm.), Saint Joseph 30 in. (76 cm.), the Christ Child 19½ in. (49 cm.), God the Father 17½ in. (44.5 cm.); figures full round.

Plates LXII, LXV

LITERATURE
Heinrich Decker, *Meinrad Guggenbichler*, Vienna, 1949, p. 88, no. 81, fig. 114.

The figures from a small altarpiece show Mary and Joseph with the Infant Jesus between them returning on foot from Egypt after the death of Herod. Above them, on a bank of clouds, is the half-length figure of the Lord making a protective gesture. Mary holds one hand to her breast and extends the other toward the Child. The young Jesus raises His left hand as though to grasp the finger of Joseph. Saint Joseph, who probably once held a staff as he trudged along, regards the Child with great solemnity. All of the figures are clad in gold costumes that were lined with blue.

Most of the polychromy is original with the exception of the lining of the garments and certain areas of the flesh tones, which have been repainted. Many of the fingers have been broken and glued back into place. The little finger and the tip of the second finger of the left hand of God the Father have been lost. The staff of Saint Joseph has disappeared. The Dove of the Holy Spirit, normally represented in this scene, has also vanished.

The altar that our figures originally embellished was probably of the early Baroque type in which the central scene was flanked by pairs of spiral columns. Behind the Holy

[1 1 1]

Family may have been a painted landscape of the kind used occasionally in the sixteenth century and with some frequency in the seventeenth and eighteenth centuries.[1]

The work has been correctly attributed to Meinrad Guggenbichler, one of the most successful sculptors of his generation in the Salzburg area.[2] The credit for making the transition from the Late Renaissance to the Baroque styles in this section of Austria must go to Thomas Schwanthaler (1634–1707), who was some fifteen years older than Guggenbichler and exerted a profound influence upon him.[3] As far as is known, neither of these artists had been to Rome, but both show a certain understanding of the figure style of Bernini.

The Return of the Holy Family from Egypt is mentioned in the Gospel of Saint Matthew (II. 13–21). According to the Golden Legend, the event took place seven years after the birth of Christ. Prior to the seventeenth century the representation of the subject is rare, but it was popularized by Rubens, who depicted several versions of it. One of them, painted for the Chapel of Saint Joseph in the Church of the Jesuits at Antwerp, was very similar to the Guggenbichler in composition. The Rubens painting was engraved by Schelte Adam Bolswert (1586–1659), Martin van den Enden (act. 1636–1645), A. Voet (1613–1670), and others — graphic works that are the only pictorial record of the original, now lost. One or another of these engravings could well have inspired Guggenbichler.[4] They show the Virgin and Saint Joseph in much the same positions, and Rubens' Christ Child is almost a mirror image of Guggenbichler's. The scene was often portrayed in Austria and was the subject of an altarpiece by Schwanthaler at Saint Wolfgang, where Guggenbichler was to work a few years later.

Our sculpture was originally discovered at Zell am Moos, a village at the very center of Guggenbichler's activities. Almost all of his important documented works were made within a radius of thirty miles. According to a record of October 20, 1688,[5] the parish church of Zell am Moos once contained sculpture for a pulpit and an altarpiece by Guggenbichler. The statues were removed from the church about 1880, fell into the hands of local peasants, and eventually reached the art market.

The style of the Return of the Holy Family shows its kinship with Guggenbichler's work of the 1680's, as, for example, the V-shaped folds, particularly noticeable on the garments worn by Mary and the Child. Similar drapery treatment appears on the Apostles of the Mondsee pulpit, carved by Guggenbichler about 1682, and Saints Martin and Virgil of the Irrsdorf altarpiece, documented as 1682–1685. The Christ of the Resurrection at Mondsee, dated early in the 1680's, wears a winding sheet that makes a fluttering pattern identical with that of the Virgin in our composition. The gesture of the Mondsee Christ is strikingly like that of God the Father in the Cambridge group. Our Christ Child resembles the angels from the "Pestaltar" of Mondsee now in the Baroque Museum, Vienna.[6]

Decker is thus in error when he dates the Cambridge Holy Family about 1710. By the first decade of the eighteenth century Guggenbichler handled drapery in a far

more complex manner, abandoning his earlier style in favor of small folds which break the plastic surfaces. Moreover, his later compositions are better integrated with the surrounding space than is that of the Holy Family, which is rather frontal in conception. Thus all stylistic evidence points to an earlier dating and our group may well be part of the sculpture of Zell am Moos for which "Menrath Guggenpichl" was paid in 1688.

[1] Heinrich Decker, *Barock-Plastik in den Alpenländern*, Vienna, 1943, figs. 81, 153.

[2] Idem, *Meinrad Guggenbichler*, Vienna, 1949, p. 88.

[3] Rudolf Guby, "Der Bildhauer Thomas Schwanthaler und seine Zeit," *Kunst und Kunsthandwerk*, vol. XXII, 1919, pp. 228 ff.

[4] Max Rooses, *L'Oeuvre de P. P. Rubens*, vol. I, Antwerp, 1886, no. 183, pp. 246–247, pl. 65.

[5] Erich von Strohmer, "Verzeichnis der urkundlich gesicherten Werke Johann Meinrad Guggenbichlers," *Beiträge zur Kunstgeschichte Tirols. Festschrift zum 70. Geburtstag Josef Weingartner's* (Schlern-Schriften, 139), Innsbruck, 1955, pp. 157 ff.

[6] H. Decker, *Guggenbichler*, figs. 18–19, 24–25, pl. I.

65. Madonna and Child, German or Netherlandish, c. 1675–1700

Busch-Reisinger Museum 1954.105; gift, Mr. and Mrs. F. F. Beer. Boxwood; h. including base 5⅛ in. (13 cm.); h. of figure 4⅜ in. (11 cm.); full round

Plate LXVII

COLLECTIONS
Jacques Mühsam, Berlin
F. F. Beer, Berlin and New York

LITERATURE
Rudolph Lepke's Kunst-Auctions-Haus, Berlin, *Sammlung Kommerzienrat Jacques Mühsam, Berlin*, November 27–December 1, 1926, no. 78, p. 20, pl. 31.

The standing Madonna holds the Christ Child with her left arm. Her right hand is extended and may once have held a scepter. Long wavy hair falls down her back. She is clad in a dress and wide mantle. The nude Child, His head turned to the right, reaches for the breast of His Mother. The back of the statuette is carved with as much care and detail as the front. The base, although cut from a separate piece of wood, is original.

Except for the loss of the object held by the right hand of the Madonna and the slight rubbing of the face of the Child, the statuette is in excellent condition.

The Cambridge statuette somewhat resembles a group of seventeenth-century ivory carvings several of which are signed "FUX." A recent study of these works has proved

that they date in the last quarter of the seventeenth century and are thus somewhat *retardataire* in style.[1] Two of the ivories are particularly close to the Busch-Reisinger figure. One, a standing Madonna originally from a Crucifixion, is in the Bavarian National Museum of Munich.[2] On the bottom of the Munich figure is the artist's signature and the date, "J FUX 1683." In both the Cambridge and Munich Madonnas the drapery is arranged in long swinging folds which clearly reveal the organic structure of the body. The main rhythm of these folds is repeated by narrower arcs of drapery billowing at the hip and breaking the contours of the figure. Tiny restless motives formed by the mantle as it touches the ground play about the feet.

The second ivory of the group that resembles the Cambridge figure is a seated Madonna and Child, also signed by the artist and now in the Palazzo Pitti, Florence.[3] The drapery style is much the same as that of the Munich and Cambridge figures, and the facial type of the Madonna is very close to the Busch-Reisinger statuette. The faintly smiling mouth, the corners of which are accented with small drill holes, the flaring nostrils, and the rather heavily lidded eyes are identical in both figures. The gesture of the pudgy Christ Child of the Florence Madonna, with one arm behind His Mother's neck and the other reaching toward her breast, finds its counterpart in the Cambridge Child.

The folds of drapery of the Cambridge statuette are not as complex as those of Fux and their shape is less sharp. In this respect they recall ivory carvings made in Southern Germany in the mid-seventeenth century.[4] The realistic details of costume suggest some of the seventeenth-century Netherlandish boxwood figures.[5] Thus our sculpture may have been the work of a Netherlandish or German artist working in the last quarter of the seventeenth century.

[1] Hans R. Weihrauch, "Hans Georg Fux, Elfenbeinschnitzer und Holzbildhauer," *Festschrift für Erich Meyer zum sechzigsten Geburtstag*, Hamburg, 1957, pp. 228–236.

[2] Rudolf Berliner, *Die Bildwerke in Elfenbein, Knochen, Hirsch- und Steinbockhorn* (Kataloge des Bayerischen Nationalmuseums München, vol. XIII, pt. 4), Augsburg, 1926, no. 139, p. 44, pl. 254.

[3] Weihrauch, "Hans Georg Fux," p. 230, fig. 4.

[4] Berliner, *Die Bildwerke in Elfenbein*, no. 132, p. 42, pl. 75.

[5] E. F. Bange, *Die Bildwerke in Holz, Stein und Ton: Kleinplastik* (Staatliche Museen zu Berlin, Die Bildwerke des deutschen Museums, vol. IV), Berlin and Leipzig, 1930, nos. 7713–7715, pp. 109 ff.

66. Madonna, Michiel van der Voort, c. 1720

Busch-Reisinger Museum 1950.460; purchase, general funds. Oak; h. 37½ in. (95.2 cm.); back hollowed out

Plates LVIII, LIX

COLLECTIONS

Georg Schuster, Munich

LITERATURE

Charles L. Kuhn, "Recent Acquisitions, Busch-Reisinger Museum," *The American-German Review,* vol. XIX, December 1952, pp. 17–19, fig. 3.

The Madonna stands erect, her head thrown back and slightly to the left, the eyes partially closed. Her hands are pressed to her breast. A long veil covers her head, billows out at the left side, and hangs over her left arm, making a deeply-undercut fold at the right. Her gown reveals that the right knee is slightly bent.

The condition of the figure is good. Small losses to the veil and the drapery at the right have occurred. There is no restoration.

The Madonna, depicted as mourning the death of her Son, may once have formed part of a Crucifixion group. The strong plastic volume is emphasized by drapery that seems to embrace the surrounding space. All the folds as well as the position of the arms lead the eye to the dramatic face, framed by the deep shadow formed by the veil. The ample body is clearly articulated for the artist has suggested the mechanics of support and balance in an almost classical manner.

The closest parallels to our figure are to be found in the work of the Antwerp sculptor, Michiel van der Voort (1667–1737), sometimes known as Vervoort. Kuile has pointed out that many of his figures are tempered by a restrained academicism, but when he works in wood, Baroque emotionalism is pronounced.[1] A number of Van der Voort's statues have the same ample proportions as our Madonna. An example is the figure of Christ of 1709 from the Noli me Tangere in the churchyard of St. Paul's, Antwerp. The billowing, undercut drapery fold at the left and the lines converging toward the right also reappear in the figure of Christ. Van der Voort's allegory, Hope, on the silver monstrance in St. Andrew's, Antwerp, dated 1712, has an unusual interlaced fold of drapery, an element that is echoed in the twisted fold beneath the left arm of our Madonna. The marble mourning figure from the tomb of Jean François Cotten in the Church of St. Michael at Ghent, dated 1721, also has many points of resemblance with our statue. The head is tilted like that of the Madonna and the face is similarly framed by the irregular shadows of the veil. The drapery reveals the bend in the right leg and converges at the right in a manner identical with that of the Cambridge figure. The closest parallel in Van der Voort's *oeuvre* is the oak Madonna on the pulpit of Saint Rombout's,

[115]

Malines, dated 1723. Here, too, the proportions are more slender, but a violent Baroque pathos is expressed in both statues.[2] The tilt of the head, facial type, undercut veil, and deep shadow formed by the drapery beneath the left arm all find their counterpart in the Cambridge Madonna. On the basis of these analogies, the work can be attributed with confidence to the hand of Michiel van der Voort.

[1] H. Gerson and E. H. ter Kuile, *Art and Architecture in Belgium, 1600 to 1800*, trans. by O. Renier, Baltimore, Md., 1960, p. 43.

[2] Mark Edo Tralbaut, *De Antwerpse "meester constbeldthouwer" Michiel van der Voort de Oude*, Antwerp, 1950, pp. 81 ff., 114–115, 192, 203 ff., figs. 36, 45, 76–77, 84–91.

67. Bust of Democritus, Netherlandish, early XVIII century

Fogg Art Museum 1943.1294; Grenville L. Winthrop bequest. Painted lindenwood; h. not including marble base 9⅞ in. (25 cm.); head fully round, back flat

Plate L X

COLLECTIONS
Grenville L. Winthrop, New York

The smiling bearded philosopher turns his head slightly to the right. The profiled pedestal, mounted on a marble slab, carries the inscription: DEMOCRIET.

The surface shows damage from termites and the lowest part of the second "E" of the inscription is broken off. Subsequent to this break, the bust was stained and polished with wax which partially filled the termite holes. More recently, a split occurred in head and face and was repaired.

For further comments, see Number 68.

68. Bust of Heraclitus, Netherlandish, early XVIII century

Fogg Art Museum 1943.1293; Grenville L. Winthrop bequest. Painted lindenwood; h. not including marble base 9⅞ in. (25 cm.); head fully round, back flat

Plate L X I

COLLECTIONS
Grenville L. Winthrop, New York

[1 1 6]

The bearded man, weeping, turns his head slightly to the left. Classical drapery envelops his shoulders. On the front of the profiled pedestal, in raised Renaissance capitals, is the inscription: HERACLIET. The whole is mounted on a marble base.

The bust, a companion piece to Number 67, was stained and varnished in the same manner. There are signs of termite activity. Splits in the left cheek, drapery, and base have been repaired. The surface treatment of both figures is not original and must be fairly recent since the damages and termite holes have been filled and covered.

The laughing and weeping philosophers Democritus and Heraclitus derive ultimately from antique busts. In his youth Rubens painted the pair as full-length seated figures. The Antwerp painter made many drawings after antique busts, among them one of Democritus that is preserved in an engraving by Vorsterman (Le B. 49, H. 103); the head in the engraving faces in the opposite direction from our bust of Democritus but is otherwise very similar to it. The two busts might well have been inspired by engravings after Rubens or even original drawings by the master. The form of the proper names is Netherlandish, while that used in the Vorsterman engraving is Latin. The drapery style indicates that the figures were carved in the late seventeenth or early eighteenth century, while the linguistic evidence makes the attribution to a Netherlandish sculptor certain.

69. Saint Michael, South German, c. 1700–1710

Fogg Art Museum 1952.31; purchase, Alpheus Hyatt Fund. Gilded bronze on a stone base; h. of Saint Michael 4⅞ in. (12.5 cm.); h. of group not including base 5½ in. (14 cm.)

Plate LVI

Saint Michael, a winged, gilded bronze figure with drawn sword, has swooped down on his enemy. His drapery flutters out behind him. His left leg rests on the fallen figure of his foe and his left arm crosses his body as though it once held a shield. Satan is represented as a muscular bearded man sprawling on the rocky base. He is cast in bronze with a dark brown patina. The base is an irregular reddish stone.

Except for the loss of the shield, the Saint is well preserved. The gilding is not original and has suffered slight damage where the left foot is fastened (by welding?) to the fallen victim. Satan has been soldered to a metal pin driven into the stone base.

There can be little doubt that the group was assembled in relatively recent times. The style of the fallen nude resembles some Italian bronzes of the sixteenth century. It may originally have come from a group such as the Virtue Triumphing Over Vice at-

[117]

tributed to Benvenuto Cellini and formerly in the Berlin Museum. The irregular red stone employed as a base reflects Romantic taste and can hardly be earlier than the nineteenth century. Since the group is clearly a pastiche our concern is only with the gilded bronze Saint Michael. The graceful dancing pose of the archangel is suggestive of several South German statuettes of the early eighteenth century which were made under Italian influence. Typical of these are the bronze and silver Saint Michael Battling with Satan in the Germanic Museum in Nuremberg [1] and an unpublished polychromed wood group of the same subject, also in Nuremberg (inventory no. Pl.O.2428). Thus our bronze figure can be dated shortly after 1700 and localized in Southern Germany.

[1] Georg Biermann, *Deutsches Barock und Rokoko . . . Jahrhundert-Ausstellung deutscher Kunst, 1650–1800, Darmstadt, 1914*, Leipzig, 1914, vol. I, p. 357, fig. 604.

70. Beggar, Wilhelm Krüger, c. 1730

Busch-Reisinger Museum 1956.37; purchase in memory of Eda K. Loeb. Ivory; h. 4½ in. (11.5 cm.)

Plate LVII

LITERATURE

Charles L. Kuhn, "The Busch-Reisinger Museum: Three Years of Collecting," *The American-German Review*, vol. XXII, no. 6, August–September 1956, pp. 20–21.

The Beggar is clad in tattered shirt and trousers. He wears a hat, the brim of which is turned up in front and in back. A jacket is tied around his waist by a rope which also supports a gourd-shaped vessel. The left leg and foot are covered by a stout boot. The right leg is bare and the foot is thrust into a sandal. His left arm is a mere stump, cut off above the elbow. The right hand grasps a tool handle from which hangs a pack. He is in a striding position, his mouth is open as though panting, and his eyes are fixed on a distant goal.

The figure is in excellent condition with no restorations. It once was broken from the stand and glued back into position.

The extreme naturalism of the Beggar differentiates it from the eighteenth-century genre figures so frequently produced by the porcelain factories. It brings to mind the naturalism of many of the etchings of the seventeenth-century master, Jacques Callot, whose prints were freely copied by sculptors a century later. Callot's series of etchings of ragamuffins, *Les Gueux*, was especially popular and its frontispiece is strikingly like our figure.[1] Among the numerous ivory carvings influenced by Callot, the works of Wil-

helm Krüger most closely resemble the Cambridge Beggar. Krüger was one of several court artists employed by the Duke of Saxony, August the Strong. The documents mention him as working skillfully in ivory and in amber. His series of four ivory figures known as the "Beggars of Countess Königsmark," mistress of August the Strong, like the Cambridge ivory recall the realism of Callot.[2] Still closer in style to the Busch-Reisinger Museum figure are the two Krüger Beggars in the National Museum in Stockholm.[3] Even the shapes of the bases are the same, suggesting that all three may have belonged to the same series. Thus the Beggar is by Wilhelm Krüger and probably dates prior to the death of August the Strong in 1733.

[1] J. Lieure, *Jacques Callot*, Paris, 1927, vol. II, part 2, nos. 479–503.
[2] Jean Louis Sponsel, *Das Grüne Gewölbe zu Dresden*, vol. IV, *Gefässe und Bildwerke aus Elfenbein, Horn und anderen Werkstoffen*, Leipzig, 1932, p. 96, pl. 28.
[3] Arvid Julius, *Jean Cavalier och Några andra Elfenbenssnidare, Studier i elfenbensplastik i Sverige*, Uppsala, 1926.

71. Medal of Leopold I, Austrian, c. 1710–1740

Fogg Art Museum 1956.16; gift, Paul Gouray. Lead; diam. 5⅞ in. (15 cm.)

Plate LVI

Obverse: A bust-length portrait of a clean-shaven man wearing a plumed hat occupies the central area. He is dressed in a loose-fitting garment. A ruff frames his chin, and from his neck hang the chain and pendant of the Order of the Golden Fleece. The background consists of criss-crossed incised lines forming an allover diamond pattern. Around the edge of the medal, but within the rim, is the following inscription in Renaissance capitals:

LEOPOLD(US).D(EI). G(RATIA).ROMAN(ORUM).
I(MPERATOR).S(EMPER). A(UGUSTUS). G(ERMANIAE).
H(UNGARIAE).BOH(EMIAE). ZC(LAVONIAE). REX.

(Leopold elected Roman Emperor by the Grace of God. Forever Ruler of Germany, Hungary, Bohemia. King of Slavonia.)

Reverse: The entire medal within the unadorned border is filled with the following inscription, also in Renaissance capitals:

DIE STADT SO GOTT BEWACHT
ZERSTÖRT KEIN FEINDES MACHT
WIEN. MDCLXXXIII

(The city that God watches over, no enemy's power destroys. Vienna, 1683.)

Except for slight rubbing on the highest areas of the relief portrait and for a few minor scratches, the medal is in good condition.

[119]

The defeat of the Turks at the Battle of Kahlenberg was commemorated by the creation of many portraits of Leopold I in various media, among them the Fogg medal. A number of the official portrait medals of the Emperor cast during his reign depict a lean man wearing a luxuriant moustache, goatee, and ceremonial armor. None of them includes a hat. Indeed, imperial portraits after about 1560 are invariably bareheaded, or at most a laurel wreath or crown encircles the hair. The reverse of the medals of Leopold I customarily alludes to the power or exploits of the sitter by means of allegories, emblems, or coats of arms.[1]

The Cambridge medal with its rhyme on the reverse is mentioned several times in the literature of the nineteenth century, the earliest reference being in 1863.[2] Epigraphical evidence can be of some assistance in establishing the date. The dotting of the capital "I" in the words *kein* and *Feindes* is rare in the seventeenth century but occurs more frequently in the eighteenth.[3] The costume worn by the figure also throws some light on the possible date of the medal. Leopold's ruff, long out of date by the time of the Battle of Kahlenberg, was in fashion much earlier in the seventeenth century. It survived later as a badge of office among the bourgeoisie. The low-crowned hat with the rolled brim and decorative feathers was in vogue during the last quarter of the seventeenth and the early years of the eighteenth centuries.[4]

The clean-shaven gentleman with his plump cheeks has a strong resemblance to the portrait medals of the second son of Leopold I, who became the Emperor Charles VI in 1711 and reigned until his death in 1740. It seems likely, therefore, that our medalist worked far from court circles and, having never seen a portrait of the monarch whom he was honoring, used the likeness of the Emperor of his own day, Charles VI.[5] This deduction is strengthened by the naïve anachronisms of costume and the inconsistencies of the inscription on the reverse.

[1] Karl Domanig, *Porträtmedaillen des Erzhauses Österreich von Kaiser Friedrich III bis Kaiser Franz II, aus der Medaillensammlung des allerhöchsten Kaiserhauses,* Vienna, 1896, nos. 207–212, pls. XXIX and XXX; see especially no. 209, a contemporary medal commemorating the defeat of the Turks and dated 1683.

[2] *Katalog der historischen Ausstellung der Stadt Wien,* Vienna, 1873, p. 175, no. 68; Alexander Hirsch, *Die Medaillen auf den Entsatz Wiens, 1683,* Troppau, 1883; our medal is not recorded in the catalogue of imperial medals: Austria, Haupt-Münzamt in Wien, *Katalog der Münzen- und Medaillen-Stempel-Sammlung des k.k. Hauptmünzamtes in Wien,* Vienna, 1901–1906.

[3] I am grateful to Dr. John Welles for this information.

[4] Erika Thiel, *Geschichte des Kostüms,* Berlin, 1960, figs. 244, 245, 246.

[5] Domanig, *Porträtmedaillen,* nos. 237, 243, 245, 261, pls. XXXIV–XXXVII.

72. Crucifixion, Austrian, early XVIII century

Busch-Reisinger Museum 1959.128–1959.130; purchase, Museum Association Fund. Polychromed lindenwood; h. of Cross 11 ft. 6 in. (375 cm.), figure of Christ 6 ft. 10½ in. (209.5 cm.), Madonna 5 ft. 9 in. (176 cm.), Saint John 5 ft. 8½ in. (174 cm.); Christ full round, backs of Madonna and Saint John hollowed out

Plates LXIII, LXIV, LXV

LITERATURE
Art Quarterly, vol. XXVI, no. 3, Autumn 1963, pp. 356, 364–365.

Christ is held to the Cross by four nails. His head is erect and turned to the left as He gazes upward. The gold loincloth is drawn across His hips and flutters to either side. The Madonna raises her right arm and turns her head toward her Son. A loose and voluminous cape is draped over her head and envelops her body. Saint John, his hands clasped in a gesture of sorrow, turns slightly to regard the face of the Saviour. The drapery of both side figures is gold.

Only a few patches of the polychromy remain, and they are not original. The right side of the head of Christ above the crown of thorns is restored. Both legs have been broken and repaired. The Madonna has lost her left hand, and the fingers of the right hand are restored. The edges of the drapery at the lower right are chipped. Saint John's left foot is slightly damaged and the drapery just above it shows evidence of an old restoration that has been lost. Both the Virgin and Saint John originally wore halos.

The intense pathos of the three figures, their formal unity, and the relationship to the surrounding space which may be inferred by drapery style and position of the side figures are all characteristic of the High Baroque. The figures may originally have been placed before glazed windows or in a paneled niche flanked by Corinthian pilasters or twisted columns, settings that would have given them even greater unity.

In style close parallels are to be found in Styrian sculpture of the early eighteenth century. On the high altar of the Church of Saint Veit at Vorau, in a Death of the Virgin attributed to Jakob Seer (act. 1693–1727) and dated in the first decade of the eighteenth century, are several Apostles clad in garments similar to those worn by the Virgin and Saint John. The great swinging curves of the drapery, twisted and knotted, are almost identical. The Saint John of the Vorau altar has a visage that is strikingly like that of the Cambridge figure.[1] Other sculptural works in the same church also resemble the Cambridge statues: the four over life-size bishop saints placed against the piers of the crossing, the figures adorning the side altar of Saint Sebastian, and the personification of the Church on the pulpit. In the nearby monastic church at Pöllau and especially in the pilgrimage church at Berg Pöllau there are further examples of this drapery style and facial type.

[121]

The Crucifixion therefore appears to be an Austrian work of the opening years of the eighteenth century and is probably Styrian in origin.

[1] Rochus Kohlbach, *Steirische Bildhauer vom Römerstein zum Rokoko*, Graz, n.d., pp. 459 ff., 405–406, fig. 366, pl. 108.

73. Crucifixion, Upper Austrian, c. 1700–1725

Fogg Art Museum 1931.58; gift, W. B. Osgood Field. Pearwood (?); h. including base 33 in. (84 cm.); base 20½ × 9¾ in. (52 × 13 cm.); h. of Christ 9⅝ in. (24 cm.); figures full round

Plates LXVI, LXVII

COLLECTIONS
W. Osgood Field, Belmont, Massachusetts

LITERATURE
Charles L. Kuhn, "German Art of the Eighteenth Century," *Germanic Museum Bulletin*, vol. I, no. 2, March 1936.

Christ crucified between the two Thieves gazes heavenward. To His right, the Good Thief turns his head toward Him, while to His left the Wicked Thief squirms in the other direction. At the top of the Cross is a sign with the letters INRI, and attached to the upright beneath Christ's feet is a cloud formation with three angels. The Cross, thrust into a hole in the rocky ground, is held up by two wedges. At its foot a human skull and thigh bone rest on the mount. On the rock nearest the front edge the initials I.W.*f*[ecit] are carved. Four angels are disposed on the ground in varying postures. A basin is set at the foot of the Cross to the left, and an ornamental ewer to the right of the central Cross. Ground and crosses are mounted on a strongly profiled base, painted black. On the center front is a plaque framed by acanthus leaves and bearing the inscription: ET VOS CVM MORTVI ESSETIS IN DELICTIS, — CONVIVIFICAVIT CVM ILLO DONANS VOBIS OMNIA DELICTA: DELENS QVOD ADVERSVS NOS ERAT CHIROGRAPHVM DECRETI, QVOD ERAT CONTRARIVM NOBIS, ET IPSVM TVLIT DE MEDIO AFFIGENS ILLVD CRVCI: Ad Coloss. 2:13.

The work was received by the Fogg Museum in many pieces and fragments, which were assembled in 1934. Most of the figures have suffered losses of finger tips and bits of drapery. Many of the rays of the halo of Christ were missing and some were replaced by modern restorations. The crosses are not original.

The ornament on the base, the drapery of the three figures on the crosses, the tiny angels, and the multiplicity of detail indicate that the work dates from the

early years of the eighteenth century. Nevertheless the influence of the art of Georg Petel of a full century earlier is strongly marked. A number of ivory representations of Christ on the Cross by Petel resemble our figure — among the most striking the example in the Lodovico Pallavichino Collection, Genoa.[1] The Thieves also derive from Petel prototypes, such as the bronze Good and Wicked Thieves in the Berlin and Essen museums and the boxwood examples in the Victoria and Albert Museum, London. Thus it is clear that Petel's forms survived in Crucifixion scenes throughout the seventeenth century.[2]

The detailed treatment of the anatomy, the complex handling of the folds of the loincloth, the type of angels with their small wings find parallels in the work associated with the Schwanthaler family at Ried in Upper Austria.[3] Thus it appears that our master, who proudly signed his initials I.W. on the Crucifixion, was active in this area and produced the work during the first quarter of the eighteenth century.

[1] Theodor Müller and Alfred Schädler, *Georg Petel 1601–1634*, exhibition catalogue, Munich, 1964, no. 4, fig. 6; see also nos. 1, 2, 33, figs. 4, 5.

[2] *Ibid.*, nos. 17–19, 66, 67, fig. 20.

[3] *Kunst und Kunsthandwerk*, vol. XVIII, 1915, pp. 488–490, figs. 4, 5; Österreichische Galerie, Vienna, *Das Barockmuseum im Unteren Belvedere*, 2nd ed., Vienna, 1934, no. 119, pp. 43, 230; Florian Oberchristl, *Kefermarkt und sein gotischer Flügelaltar*, Linz, 1926, pp. 21, 56.

74. Angel Annunciate, Austrian, c. 1700–1725

Busch-Reisinger Museum 1962.23; purchase, Museum Association Fund. Polychromed lindenwood; h. including console 51¾ in. (131.5 cm.); w. 25½ in. (65 cm.); d. 19 in. (48 cm.); back hollowed out

Plate LXXIV

The kneeling figure faces to the right, its left hand pressed to the bosom and its right stretched sideward. The hair is light brown, the costume gold with a red lining. A blue band extends across the breast. The wooden console is painted to simulate red marble.

The polychromy is entirely restored. Damage to the right cheek has been repaired. All the fingers of the right hand were broken and repaired and the first finger is entirely restored. The left leg was cut off above the knee and a short piece of wood was added to it in order to fit the figure to the modern console. An old notch cut into the back below the right shoulder blade may have held the base of a wing. It is possible that the figure was once standing or hovering.

For further comments, see Number 75.

75. Virgin Annunciate, Austrian, c. 1700–1725

Busch-Reisinger Museum 1962.22; purchase, Museum Association Fund. Polychromed lindenwood; h. including console 54½ in. (138.5 cm.); w. 23¾ in. (60.5 cm.); d. 18½ in. (47 cm.); back hollowed out

Plate LXXV

The kneeling Madonna bows her head and folds her arms across her breast. Her hair is dark brown and she is clad in a golden costume lined with blue and edged with red at neck and sleeves. The console is painted to simulate red marble.

The polychromy is entirely restored. A piece of wood has been added to the right knee to allow the figure to rest on the modern console.

In mutilating the two figures the restorer probably failed to realize that they were the Angel and Virgin of an Annunciation and believed them to be two pendant angels. In spite of the brutal transformation, the style and scale of the statues indicate that they did in fact belong together.

Among the most distinctive aspects of their style are the wavy contours formed by the drapery and hair and the use of rather plump forms for the shoulders, arms, and hands, which are marked by the absence of anatomical detail. These mannerisms are often found in sculpture of the Salzburg area made during the first quarter of the eighteenth century. Examples are the bishop saints on the high altar of the parish church at Zell am Wallersee and on that of the little Church of Sankt Johann am Berg outside the village of Köstendorf. The latter is a dated work of 1711 by Paul Mödlhamer (act. until c. 1730). In the church of Köstendorf itself is a Baptism of Christ in which the Saviour assumes a position strikingly like that of our kneeling Virgin. This figure, too, has restless wavy contours and rather pudgy flesh undifferentiated by anatomical details. Still another example of the style is at Mattee in the side altars of the Stiftkirche, which date from the first decade of the eighteenth century.[1]

These same elements live on into the 1730's and 1740's in some of the works of Joseph Anton Thaddäus Stammel (1695–1765). Stammel's drapery style, however, is more advanced than that of our Annunciation.[2] Our two figures can therefore be dated about 1700–1725 and localized in Austria, possibly in the area north of Salzburg.

[1] Lothar Pretzell, *Salzburger Barockplastik*, Berlin, 1935, pls. 41a, 41b, 53a, 54b; Paul Buberl, *Die Denkmale des politischen Bezirkes Salzburg* (Österreichische Kunsttopographie, vol. X), Vienna, 1913, pp. 193, 280–283, figs. 194, 275, 276.

[2] Österreichische Galerie, Vienna, *Das Barockmuseum im Unteren Belvedere*, 2nd ed., Vienna, 1934, nos. 76, 105; Heinrich Decker, *Barock-Plastik in den Alpenländern*, Vienna, 1943, pls. 255, 258, 259.

76. Kneeling Magdalen, Franz Schwanthaler (?), c. 1730

Busch-Reisinger Museum 1964.36; purchase, Museum Association Fund. Pearwood; h. 6½ in. (16.5 cm.); back slightly hollowed out

Plate LXIV

The kneeling figure turns her head to gaze over her right shoulder. Her left arm is extended and her right hand rests on a covered vessel set upon a stone. The Magdalen is clad in a dress and bodice over which a cape is loosely flung. Jewels are inserted in the wood forming a clasp or brooch at the neck of the dress and decorating her forehead.

Beneath the stone on which the vessel rests is a small walnut supporting base that is relatively recent. The bare left arm and hand are restored. A small split on the right side of the neck ends in an imperfection in the wood at the breast. Very slight traces of gesso indicate that the figure may once have been polychromed.

Probably the Magdalen was originally part of a Crucifixion and knelt on an uneven crest of the Mount of Golgotha. The taut expression of grief on the thin face, the parted lips, and method of rendering the drapery are characteristic of a group of works carved in the second quarter of the eighteenth century and attributed to members of the Schwanthaler family.

A workshop of sculptors, first established at Ried in Upper Austria by Hans Schwanthaler in 1632, was maintained by his descendants for several generations. Biographical data on the family are fairly complete, but with few exceptions the artistic personalities of the individuals have not been well defined.

The statuette of the Magdalen can be dated in the second quarter of the eighteenth century, before the multiplicity of small folds of drapery and restless accents of the Rococo had developed. Two grandsons of the founder of the Ried workshop were active at this time: Johann Josef (1681–1743) and Franz Schwanthaler (1683–1762). Franz appears to have been the more talented of the two brothers for he was head of the workshop until 1759. Several statues attributed to him are related to our Magdalen. Two of them, a Sorrowing Madonna and a figure of God the Father, are in the Schloss Museum, Linz (inventory nos. S.142, S.652). A third piece, a Crucifixion in the Baroque Museum, Vienna, has a kneeling Magdalen that in pose, drapery style, and facial type is very similar to our statuette.[1] We may conclude, therefore, that the Cambridge figure was made by a member of the Schwanthaler family about 1730 and that it may be by the hand of Franz.

[1] Österreichische Galerie, Vienna, *Das Barockmuseum im Unteren Belvedere*, 2nd ed., Vienna, 1934, no. 119, p. 230.

[125]

77. Madonna Immaculata, Austrian, c. 1730–1750

Busch-Reisinger Museum 1962.12; purchase, Museum Association Fund. Polychromed wood; h. including base 8 in. (20.3 cm.); h. of figure alone 6½ in. (16.5 cm.); full round

Plate LXVII

COLLECTIONS
Oskar Bondy, Vienna

The Madonna, her head turned slightly to the right, clasps her hands before her. She is poised on a crescent moon surmounting a serpent coiled over a sphere. The flesh tones are pale, the hair light brown, the costume red. The serpent is painted in a greenish tonality.

The figure is well preserved except for the polychromy, which is original but badly worn.

The delicately carved little figure gives the impression of a weightless, soaring spirit. The tubular drapery swirls and flutters, its dynamic quality caught up by the twisted, flying tresses. The undulating line of hair and drapery is connected with the writhing serpent, which, although symbolic of evil, has a charming toy-like quality. The beauty of the Madonna's face and the exquisite modeling recall a cultural climate that produced the finest porcelains of Europe. Like the porcelains, the Madonna was designed for a private collector.

The facial type and light airy treatment of the drapery have stylistic parallels in a number of South German and Austrian examples of the Immaculata dating from about 1730 to 1750.[1] Thus our work was probably made in this area during the second quarter of the eighteenth century.

[1] Adolf Feulner, *Bayerisches Rokoko*, Munich, 1923, pl. 160, fig. 229; Otto Schmitt and Georg Swarzenski, *Meisterwerke der Bildhauerkunst in Frankfurter Privatbesitz*, Frankfurt a.M., vol. II, 1924, nos. 78, 85, 116; Hans Tietze, *Die Denkmale des politischen Bezirkes Melk* (Österreichische Kunsttopographie, vol. III), Vienna, 1909, p. 362, fig. 374; Dagobert Frey, *Die Denkmale des Stiftes Heiligenkreuz* (Österreichische Kunsttopographie, vol. XIX), Vienna, 1926, pp. 179, 182, fig. 128.

78. Reclining Nymph, Georg Raphael Donner, c. 1739

Busch-Reisinger Museum 1964.7; purchase, Museum Association Fund. Lead statuette on marble base; h. including base 11 in. (28 cm.); l. of figure alone 15⅞ in. (40.5 cm.); base 7½ × 15 in. (19 × 38 cm.)

Plate LXVIII

COLLECTIONS

Michael Grittner, Vienna
Anna Schwartz, Baden
Stephan von Auspitz, Vienna
Oskar Bondy, Vienna

LITERATURE

Albert Ilg, *Georg Raphael Donner; Gedenkschrift zum 200. Jahrestage der Geburt des grossen österreichischen Bildhauers, 24. Mai 1693–24. Mai 1893*, Vienna, 1893, no. 19; E. Tietze-Conrat, "Unbekannte Werke von Georg Raphael Donner," *Jahrbuch der k.k. Zentral-Kommission zur Erforschung und Erhaltung der Baudenkmale*, new series, vol. III, 1905; idem, *Österreichische Barockplastik*, Vienna, 1920, pp. 84, 139, fig. 48; Georg Lill, *Deutsche Plastik*, Berlin, 1925, p. 224; John Coolidge, "Donner Statue of a Resting Nymph," *Fogg Art Museum Annual Report*, 1951–1952, pp. 17–18, illustration on cover.

The nude figure reclines on a long cushion or mattress. She leans on her right elbow and fondles a dog with the other hand.

The surface of the figure has sustained a good many scratches, especially on the left shoulder and arm and on the legs. There is a small dent in the left shoulder. A minor break just above the left ankle appears to be an old one. A larger and comparatively recent break is on the back of the neck. The marble base, probably the original one, has suffered several losses and cracks.

The Reclining Nymph has long been associated with Donner's most famous work, the fountain for the Neuer Markt of Vienna. The central figure of the fountain, Prudentia, was completed by 1738. In that year Donner was commissioned to make personifications of the four rivers which flow into the Danube: the Emms, Traun, March, and Ybbs. They were finished in the fall of 1739, when the fountain was opened. The two female figures personifying the Rivers March and Ybbs are strikingly similar in pose and style to our statuette. Made of lead and exposed to the weather and to abuse by the public, the fountain figures suffered severely. The first recorded repair was in 1741, the year of Donner's death.[1] By 1774 the fountain was so damaged that the figures were removed. Extensive restoration was carried out at the end of the eighteenth century by Johann Martin Fischer and the figures were once more put in place in 1801. They were damaged again, and in 1873 they were replaced by bronze copies. The lead originals are now in the Baroque Museum of Vienna.

[127]

One other cast of the Reclining Nymph is known; like the fountain figures which it resembles, it is in the Baroque Museum.[2] As cabinet pieces these two statuettes were protected from the rigors of the elements and the depredations of the general public. Thus they are relatively well preserved and give a far better idea of the masterful modeling, languid elegance, and sly humor of the artist than do the river personifications completed at the same time.

[1] J. E. Schlager, *Georg Rafael Donner,* 2nd ed., Vienna, 1853, pp. 88 ff., 144–147.
[2] The example in the Baroque Museum is reproduced in most of the monographs on Donner; see particularly Kurt Blauensteiner, *Georg Raphael Donner,* Vienna, 1944, pls. 45–46.

79. Magdalen in the Desert, Viennese, c. 1740–1750

Busch-Reisinger Museum 1961.3; purchase, Museum Association Fund. Polychromed lindenwood; h. 8⅞ in. (22.5 cm.); l. 14½ in. (37 cm.); max. d. 6 in. (15.5 cm.); back unfinished

Plate LXIX

COLLECTIONS
Girou de Buzareingues, Paris

The Magdalen, facing to the left, reclines against a rocky background. Her head is slightly bowed. The right leg is extended and the left is bent. The arms are in a relaxed position, supported by the rocky ground. Her bodice and embossed dress are gilded and a golden ribbon holds her light brown hair. The rocks are painted a darker brown and are sprinkled with small bits of mica. On the back of the figure is a printed label reading "117 — Ariadne (Aba)ndonné." Beneath this, written in ink, is "Vente: Docteur Girou de Buzareingues — Paris le 26 février 1892."

The polychromy is original. The flesh tones have sustained minor losses and the gold of the bodice and dress is badly rubbed. The only loss to the figure is a toe of the right foot.

In seeking stylistic likenesses to the Magdalen one is struck by the similarity of its general conception to that of the figures of nymphs adorning fountains by Georg Raphael Donner in Vienna and to our Reclining Nymph (Number 78). A number of other smaller Viennese works are worth noting in this connection. In the Baroque Museum are two versions of a praying Magdalen, both attributed to Johann Baptist Hagenauer, a polychromed terra cotta group of Truth Unveiled by Time, and a bound Prometheus,

all resembling our figure.[1] Even closer to the Magdalen are two Viennese terra cottas in the Bavarian National Museum, Munich. One is a polychromed terra cotta Allegorical Figure of about 1740 which has the same facial type, handling of the hair, and treatment of the hands with the middle fingers pressed together.[2] The second figure, a River Goddess, also has these features and is considered to be a work of the Donner School.[3] The Magdalen can be assigned with confidence to the School of Vienna and dated about 1740 to 1750.

[1] August Schestag, "Die Neuaufstellung der Sammlung der Kleinplastik im Oesterreichischen Museum," *Kunst und Kunsthandwerk,* vol. XXII, 1919, pp. 130–131, figs. 27–28.
[2] No. Ker. 397.
[3] A. E. Brinckmann, *Barock-Bozzetti: Deutsche Bildhauer,* Frankfurt a.M., 1924, p. 46, pl. 14.

80. Judith with the Head of Holofernes, Würzburg (?), c. 1740–1750

Busch-Reisinger Museum 1963.5531; purchase, Antonia Paepcke DuBrul Fund. Alabaster; h. including base 14½ in. (37 cm.); full round

Plates LXX, LXXI

The figure sways a little to her left to support the head of Holofernes, which is held in the slightly extended right hand and toward which Judith looks. She assumes a walking position, her weight supported on the left leg while the right foot barely touches the ground. Her dress, suspended from a ribbon over the left shoulder, has slipped, baring one breast. Her loose outer garment flutters with her movement. Her hair is bound with a string of jewels, from which a larger ornamental gem is suspended and rests on her brow. As she turns her head, a tress of hair cascades down the left shoulder. A golden band encircles the left arm just above the elbow.

The sculpture has suffered the loss of the left arm below the elbow and a sheathed sword, probably also of metal, which was supported by a knob of stone on the left side below the waist. A long band of small holes in the stone, extending up the back of the figure beneath the lock of hair on the left shoulder and down the left side may originally have held in place a gold band which ended at the scabbard. There are minor losses at the sharp edges of the drapery, especially in the lower portions. The head of Judith was once broken at the neck and repaired. The lower two steps of the base are not original.

The style of the figure is a curious blend of Netherlandish and German elements, and combines the forms of the Late Renaissance with the Rococo. The similarity to a

[129]

drawing by Hendrick Goltzius for an engraving by Jacob Matham is so striking that it is possible to reconstruct from it the lost portions of the statue. The left arm of Judith in the Goltzius drawing is sharply bent and the hand rests on the hilt of a sword hanging in a scabbard at her side.[1] In all likelihood this was exactly the position of the arm and hand in the statuette. Like so much Rococo art in Germany, the canon of proportions is derived from the Late Renaissance as well.

The facial type is identical with that of an unpublished ivory statue of the Madonna Immaculata, carved in Antwerp about 1700 and now in the Rijksmuseum, Amsterdam.[2] The drapery of our Judith differs from that of the ivory, however; in the Cambridge figure, the sharp, angular folds of the cape and the linear creases of the clinging dress beneath resemble some Würzburg sculpture of the first half of the eighteenth century.

There is a long tradition of Netherlandish influence in the sculpture of that city. The use of graphic works designed by Goltzius, Spranger, and others as models for sculpture in the seventeenth century has been noted by Bruhns.[3] In the eighteenth century, when a great building program was initiated by the prince-bishops, a native of Malines, Jacob van der Auvera (1672–1760), was called to establish a shop for sculptural decoration. His son, Johann Wolfgang van der Auvera (1708–1756), succeeded his father as workshop leader in 1736. He was apparently a close friend of the architect of the palace, Balthasar Neumann, for the two men visited the Netherlands together in 1740. Auvera's wife was the daughter of Oswald Onghers, a painter at Würzburg, who, like Jacob van der Auvera, was a native of Malines. Johann Wolfgang Auvera had finished his training in Vienna in the tradition of Raphael Donner, but he soon developed a restless, agitated drapery style that was in harmony with the complex palace ornament and was a radical departure from Donner's classicism. Auvera's drapery is not unlike that of the Judith. The wholesale destruction of works of art in Würzburg in the spring of 1945 makes it necessary to rely heavily on photographs and reproductions. Some of the funerary sculpture carved by Auvera for the Schönborn prince-bishops and originally in Bamberg is now in the Mainfränkisches Museum at Würzburg; thus a few of his marble figures can still be seen. Their proportions are sturdier than those of the Judith but they are clad in somewhat similar sharp-edged linear garments. Their heads are larger in proportion to the bodies than that of the Judith, but Auvera's drawings in proportions are very close to our statuette and some of them even suggest a relationship with Goltzius.[4]

Other stylistic parallels can be found in some of the statues of the second quarter of the eighteenth century in the Lower Franconian area. Even as late as about 1760, the restless drapery is still retained in the work of Johann Peter Wagner at Maria-Limbach.[5] The combination of Netherlandish influence and playful linear drapery which resembles so much of the work of the Würzburg area shortly before the middle of the eighteenth century makes it reasonable to assign the Judith to this region.

[1] E. K. J. Reznicek, *Die Zeichnungen von Hendrick Goltzius*, Utrecht, 1961, vol. I, p. 242, no. 19.

[2] Inventory no. 1962.5; negative nos. 6359–6361.

[3] Leo Bruhns, *Würzburger Bildhauer der Renaissance und des wendenden Barock, 1540–1650*, Munich, 1923, pp. 279, 389, 437, figs. 78, 79.

[4] Richard Sedlmaier and Rudolf Pfister, *Die fürstbischöfliche Residenz zu Würzburg*, Munich, 1923, pl. 34; Rudolf Edwin Kuhn, *Würzburger Madonnen des Barock und Rokoko*, Aschaffenburg, 1947, figs. 26–30, 40, 41, 43; Richard Sedlmaier, *Wolfgang v.d. Auveras Schönborn-Grabmäler im Mainfränkischen Museum und die Grabmalkunst der Schönborn-Bischöfe*, Würzburg, 1955; Max Hermann von Freeden, "Die Neuerwerbungen des Mainfränkischen Museums, 1946–1956," *Mainfränkisches Jahrbuch für Geschichte und Kunst*, vol. VIII, 1956, pp. 33–34, pls. 30–31.

[5] *Die Kunstdenkmäler des Königreichs Bayern: Unterfranken und Aschaffenburg*, vol. III, *Bezirksamt Würzburg*, Munich, 1911, p. 86, fig. 58; vol. X, p. 217, fig. 183; Otto Schmitt, *Barock-Plastik*, Frankfurt a.M., 1924, pl. 75; Hans Reuther, "Balthasar Neumanns Wallfahrtskirche Maria-Limbach," *Mainfränkisches Jahrbuch für Geschichte und Kunst*, vol. V, 1953, p. 208 ff., pls. 4, 5; Liebieghaus, Frankfurt a.M., *Bildwerke der Barockzeit aus dem Liebieghaus*, catalogue, 1963, pl. 63.

81. Saint Ambrose (?), Austrian, c. 1725–1750

Busch-Reisinger Museum 1959.127; purchase, Museum Association Fund. Polychromed lindenwood; h. 7 ft. 3¼ in. (221.5 cm.); back hollowed out

Plate LXXII

The Saint turns his head slightly to the right. In his gloved left hand he holds a book, while the right is raised waist-high, probably to hold a crosier. His mitre and cope with its elaborately decorated border have traces of gilding. The lining of the cope is silver over which a blue glaze is applied. Beneath the cope is a white cassock with an intricately carved border simulating lace. The end of a gilded stole hangs down his right side. The hair and short beard are black.

Only a few traces of the original polychromy are visible. The entire figure has been repainted. The cope, mitre, and stole were given a yellow-brown color to approximate the original gilding. There have been some losses to the edges of the drapery and to the fingers of the right hand. The crosier no longer exists. A severe split in the wood runs vertically through the right arm and the drapery beneath it. The front of the base is restored.

For further comments, see Number 82.

82. Saint Augustine, Austrian, c. 1725–1750

Busch-Reisinger Museum 1959.126; purchase, Museum Association Fund. Polychromed lindenwood; h. 7 ft. 6¼ in. (229 cm.); back hollowed out

Plate LXXIII

The Saint, holding a flaming heart in his right hand, turns his head to regard it. His left hand is extended to grasp a crosier. His mitre and cope with its decorated border have traces of gold. The lining of the cope is silver, over which a blue glaze has been applied. A white surplice is worn beneath the cope and over a dark brown cassock. The hair and long beard are black.

The original polychromy has largely vanished or is covered by repaint. The little finger of the left hand is missing and all of the other fingers of that hand are damaged. The crosier, too, has disappeared. Disintegration of the wood and mechanical damage have marred the drapery above the left foot. The rounded front section of the base is restored.

The two Saints probably flanked the central section of an altarpiece. Bishop saints were frequently placed in this position on the retables of Southern Germany and Austria during the seventeenth and eighteenth centuries. The identification of Saint Augustine is certain because of his attribute, the flaming heart. The other figure, without a distinguishing attribute, is more difficult to recognize. It may be Saint Ambrose, who along with Augustine was one of the two bishops among the Church Fathers. There are instances, however, when Saint Augustine is paired with some other bishop saint.

The Saints are rather calm and tranquil, and their slender proportions seem to look forward to the Rococo. Their garments are sharply creased to create the appearance of a linear network over the surface. The bodily forms beneath the costumes are not revealed, yet the spectator is aware of the logical construction of an organic being implicit in the arrangement of the clothing. This type of drapery is not unusual in Austria, especially in the area near Lambach, where it makes its appearance as early as the late seventeenth century and continues into the second half of the eighteenth.[1] The elongated figures of our two Bishops and their classicistic bearded faces recall the figures of Saint Francis and Saint Anthony of Padua flanking the high altar of the parish church at Steinerkirchen, dated about 1750.[2] The Saint Ambrose and Saint Augustine may be considered Austrian works of the second quarter of the eighteenth century and possibly were made in the general area of Lambach, south of Linz.

[1] Heinrich Decker, *Barock-Plastik in den Alpenländern*, Vienna, 1943, fig. 194; Erwin Hainisch, *Die Kunstdenkmäler des Gerichtsbezirkes Lambach* (Österreichische Kunsttopographie, vol. XXXIV), Vienna, 1959, p. 107, fig. 86; *Bulletin of the Cleveland Museum of Art*, January 1964, back cover.
[2] Hainisch, *Die Kunstdenkmäler des Gerichtsbezirkes Lambach*, p. 494, fig. 570.

83. Hovering Angel, Bavarian, c. 1750–1760

Busch-Reisinger Museum 1964.19; purchase, Museum Association Fund. Polychromed lindenwood; h. 25½ in. (65 cm.); full round

Plate LXXVI

The angel, with arms outstretched, seems to be moving slowly to the right, although it looks to the left as if to attract the spectator's attention. A bit of fluttering pink drapery is suspended from a diagonal strap across the shoulder.

Most of the original polychromy has been preserved, although there has been some repainting. A finger and thumb have been lost from the right hand and two fingers from the left. A break just below the left hand has been repaired.

For further comments, see Number 84.

84. Hovering Angel, Bavarian, c. 1750–1760

Busch-Reisinger Museum 1964.20; purchase, Museum Association Fund. Polychromed lindenwood; h. 24½ in. (62 cm.); full round

Plate LXXVI

Like its companion piece (Number 83), the angel is looking at the spectator and pointing toward the object it flanks. Blue drapery is similarly supported by a strap.

Losses to the original polychromy are greater than in the case of the left angel. Much of the blue of the drapery has flaked away. The little finger of the left hand has been lost. A split in the left foot has been repaired.

The infant anatomy of the angels has been given rather detailed treatment and the folds of flesh and dimples have been accentuated. The fat cheeks, rather flat noses, almond eyes, and wide mouths are encountered in the angels of Joseph Deutschmann (1717–1787).[1] Even closer in style is a South German angel of about mid-century, now in an Austrian private collection.[2] Thus our pair can be considered South German, probably Bavarian, about 1750–1760.

[1] Adolf Feulner, *Die Sammlung Hofrat Sigmund Röhrer im Besitze der Stadt Augsburg*, Augsburg, 1926, section II, no. 12, fig. 49; idem, *Bayerisches Rokoko*, Munich, 1923, figs. 211–212; Julius Böhler, Munich, *Sammlung Georg Schuster, München*, sales catalogue, March 17–18, 1938, no. 227, pl. 48.
[2] Rupert Feuchtmüller, *Die Sammlung S., Wien*, Überreuter, 1962, pl. 57.

85. Head of an Angel, Bavarian, c. 1760

Busch-Reisinger Museum 1934.138; anonymous gift. Polychromed lindenwood; h. 8½ in. (21.5 cm.); w. 8 in. (20.3 cm.); full round

Plate **LXXVI**

A child's head with locks of hair at the top and left side of its head looks downward. Its lips are slightly parted. Small golden wings encircle the neck.

Most of the original polychromy has been preserved. There is a scattering of repainted losses, especially on the hair and wings.

The little putto, like the pair of Hovering Angels (Numbers 83–84), was originally a minor detail of the decoration of a Rococo church interior or a bit of church furniture. The soft forms of the cheeks, treatment of the hair, and "cupid's-bow" mouth recall the many putti produced by Ignaz Günther (1725–1775) and his workshop. Those carved for the churches at München-Thalkirchen, Rott am Inn, Weyarn, and München-Bogenhausen, decorated by the Günther atelier between about 1759 and 1773, are especially close to our example.[1] Thus the head must have been made in the Munich area about 1760–1770.

[1] Arno Schönberger, *Ignaz Günther*, Munich, 1954, figs. 10, 11, 23–25, 31, 59, 62, 144, 146.

86. Madonna, after Ignaz Günther, c. 1760

Busch-Reisinger Museum 1964.35; purchase, Museum Association Fund. Painted plaster; h. 6⅞ in. (17.5 cm.); back flat

Plate **XLIV**

The standing Madonna turns her body vigorously to her left and gazes over her right shoulder. Her hands are clasped at her breast, a cape falling with a fluttering movement over the left arm. The statuette is painted brown to simulate wood.

A few minor losses have occurred at the edges of the folds of drapery in relatively recent times. One such loss is earlier and has been repainted to hide the white of the plaster. The brown paint may date from the eighteenth century. Its surface has developed a fine network of crackle.

The Madonna is almost identical to a small lindenwood statuette in the Berlin Museum, attributed to Josef Götsch (1729–1793). Götsch employed it as a model for

[134]

a polychromed wood statue of a female saint formerly on the art market.[1] He had been a pupil and assistant of Ignaz Günther (1725–1775), the leading Rococo sculptor in Bavaria. Günther made models of both wood and terra cotta. Those of wood are very similar to the Berlin figure in their breadth of handling and almost crystalline forms. Götsch probably followed the normal workshop practice of collecting or copying his master's bozzetti.[2] The Berlin and Cambridge figures are closely related to such works of Günther as the Sorrowing Madonnas from Weyarn and Vierkirchen, the Virgin as the Apocalyptic Woman formerly in a private collection, and the Madonna Immaculata from Attel, all dating from the 1760's.[3] Thus the two statuettes probably reproduce a Günther bozzetto no longer extant.

There are minor differences between the two figurines, to judge from photographs of the Berlin piece. The Cambridge Madonna is slightly larger and the surfaces appear to be somewhat more detailed. These differences pose the question as to whether our plaster Madonna was cast from the Götsch copy of Günther's bozzetto or from that by Günther himself. The question cannot be definitely resolved until it is possible to place the two originals side by side for careful comparison.

[1] E. F. Bange, *Die Bildwerke in Holz, Stein und Ton: Kleinplastik* (Staatliche Museen zu Berlin, Die Bildwerke des deutschen Museums, vol. IV), Berlin and Leipzig, 1930, no. 7705, p. 126; Adolf Feulner, *Bayerisches Rokoko*, Munich, 1923, pl. 153, figs. 207, 208.
[2] A. E. Brinckmann, *Barock-Bozzetti: Deutsche Bildhauer*, Frankfurt a.M., 1924, pp. 7–8, pls. 37–43; E. Neeb, "Beiträge zur Kenntnis des Bildhauers Johann Sebastian Barnabas Pfaff," *Mainzer Zeitschrift*, vol. II, 1907, pp. 57 ff.
[3] Arno Schönberger and Gerhard Woeckel, *Ignaz Günther*, exhibition catalogue, Bavarian National Museum, Munich, Summer 1951, nos. 13, 32, 38, 42; Arno Schönberger, *Ignaz Günther*, Munich, 1954, pls. 72, 73, 102, 103.

87. Female Figure, Ferdinand Dietz, c. 1755–1765

Busch-Reisinger Museum 1962.33; purchase, Museum Association Fund. Polychromed lindenwood; h. 44⅞ in. (114 cm.); full round

Plate LXXVII

LITERATURE
Connoisseur, August 1962, p. XLIII.

The figure has a restless pose, the left leg sharply bent and the foot barely touching the ground, while the weight is carried by the right leg. She clutches a fold of her cape with her left hand and her right, waist high, is poised as though she once held

an object loosely in her fingers. A mantle flutters about her tight-fitting bodice, cinched with belt and buckle, and her dress. There are traces of red, blue, green, and gold polychromy on the costume.

The base has suffered from damp rot and several pieces are missing. The right foot was once partially restored, but the replacement has disappeared. Similarly, a restored section of the right sleeve is now gone. The thumb and tips of the last two fingers of the right hand are lost. There are a few small areas of flesh tones on the face and neck that are original. The rest of the patches of polychromy on the costume are restored.

The absence of attributes and of any indication of a halo has made it impossible to identify the statue. It may represent a saint, an allegorical figure, a goddess or a muse. The style clearly announces one of the most personal and genial of Rococo sculptors, Adam Ferdinand Dietz or Tietz (1708–1777).

Time has not been kind to the works of Dietz. Most of his *oeuvre* has been lost and that which remains is largely sandstone garden sculpture from the latter part of his career. We know that he was a skillful wood carver, however, for in addition to statues from a polychromed wood altarpiece done in 1743, numerous small finely-wrought polychromed wood models for his stone garden statues have survived.[1]

Dietz's chief patrons were the prince-bishops of Würzburg and members of their family, the Schönborns, who employed him on the decoration of their palaces and gardens at Bamberg, Seehof, Trier, Würzburg, and Veitschöchheim. The Bamberg Residence and the nearby Seehof gardens were adorned by Dietz during two periods: 1748–1753 and 1760–1765. Between 1755 and 1760 he was active at Trier as court sculptor to the Prince Elector. Only a few figures and reliefs from these years are extant, the most important being in the museums of Munich and Nuremberg and the Palace and Museum at Trier.[2] The vast undertaking for the gardens at Veitschöchheim, 1765–1770, is well represented by the figures still in their original setting and by those which have been removed from the outdoors and placed in the Mainfränkisches Museum at Würzburg.[3] The drapery of the Cambridge figure is closer to the few remaining figures from Seehof and Trier than to the later work for Veitschöchheim. After about 1765 the drapery folds become smaller and sharper than those of earlier years. The facial type preferred by Dietz remains unchanged, however. Our statue appears to have been carved prior to 1765.

[1] A. E. Brinckmann, *Barock-Bozzetti: Deutsche Bildhauer*, Frankfurt a.M., 1924, pp. 60–68, pls. 22–27; Max H. von Freeden, *Kleinplastik des Barock*, Stuttgart, 1951, figs. 24–29, 31; Victoria and Albert Museum, London, *Rococo Art from Bavaria*, catalogue of an exhibition organized by the Bayerisches Nationalmuseum, Munich, November–December 1954, pls. 16–26; Xaver Schaffer, *Leidenschaftliches Rokoko: Die Plastik des Ferdinand Tietz*, Augsburg, 1958, pp. 38–45.
[2] Adolf Feulner, *Skulptur und Malerei des 18. Jahrhunderts in Deutschland*, Potsdam, 1929, p. 106, fig. 105; *Münchner Jahrbuch der bildenden Kunst*, 3rd series, vol. XIV, 1963, pp. 249–251.

⁸ *Die Kunstdenkmäler des Königreichs Bayern: Unterfranken und Aschaffenburg,* vol. III, *Bezirksamt Würzburg,* Munich, 1911, pp. 173 ff.; Heinrich Kreisel, *Der Rokokogarten zu Veitshöchheim,* Munich, 1953.

88–91. The Four Seasons, Johann Joachim Günther (?), c. 1760–1765

Fogg Art Museum 1952.11a–d; purchase, Alpheus Hyatt Fund. Sandstone; h. including pedestals 10 ft. 10 in. (330 cm.); h. of figures alone 7 ft. 9 in. (236 cm.); full round

Plates LXXVIII–LXXXIII

COLLECTIONS

Prince-Bishops of Speyer, Bruchsal, Palace Gardens
Counts of Bismarck, Gut Lilienhof near Ihringen
T. Morris Murray, Abington, Connecticut

LITERATURE (selected)

Fritz Ziegler, "Die vier Gartenfiguren auf Gut Lilienhof bei Ihringen," *Schau-in's-Land!,* vol. XLVI, 1919, pp. 29–30; Anton Wetterer, *Das Bruchsaler Schloss, seine Baugeschichte und seine Kunst,* 2nd ed., Karlsruhe, 1927, pp. 100, 101, 106; Adolf Feulner, "Zum Werk Paul Egells," *Zeitschrift des deutschen Vereins für Kunstwissenschaft,* vol. I, 1934, pp. 134–146; Jakob Rosenberg, "The Four Seasons," *Bulletin of the Fogg Museum of Art,* December 1945, pp. 129–142 (with bibliography); Otto B. Roegele, *Bruchsal wie es war,* Karlsruhe, 1955, pp. 65, 157.

Spring, represented as a young woman, is in a slightly contraposto position, her hips resting against a flowering tree stump and her head turned to the right. Her scant drapery is held by a strap over her shoulder that is partially concealed by a garland of flowers. She holds up her right hand, while her left arm is thrust to the side. At her feet a putto is playing marbles. Three sides of the pedestal are decorated with sprays or bouquets of flowers within a *rocaille* frame.

Summer, even more lightly clad, looks to the left as she leans against a tree stump. She wears a straw hat with rolled brim and ribbons tied beneath the chin. Her drapery, like Spring's, is loosely suspended from a strap over her shoulder. Her left arm is bent at the elbow and upraised, her right encircles a sheaf of wheat. At her right a putto, also in a straw hat, helps her hold the wheat. On the top surface of the base are stalks of wheat and fruit. Three sides of the pedestal are decorated with the tools and fruits of harvest.

Autumn, a bacchanalian youth, has a completely relaxed stance, his left hand resting on his hip, his right holding a basket of grapes. His leering face is turned to the right. A goatskin hangs over his left shoulder and a bit of drapery is held by a strap at the waist. His head, slightly inclined, is wreathed with grape leaves. His left foot is implanted on a stone slab, part of the rock formation against which he is braced. Between his feet a baby satyr devours grapes. The pedestal, enframed like the others, is decorated with grapes and bits of vine.

[137]

Winter is a bearded old man, whose peaked hat is placed low on his forehead and whose nakedness is largely covered by heavy fur-lined drapery. Both hands are thrust into a fur-trimmed muff. He turns vigorously, looking over his right shoulder as though to avert his face from the cold. At his feet, seeking warmth beneath a fold of his drapery, is a putto blowing on a brazier of coals. On the top of the base, by the old man's left leg, are faggots of wood. Three sides of the pedestal are adorned with burning logs or leafless trees.

The four figures and their pedestals have suffered greatly from weathering and breakage. Old photographs show that the pedestals were originally much higher. They apparently rested on stone plinths, and the figures were separated from the low relief decoration by strongly profiled architectural blocks. The undecorated sides of the pedestals must have been at the rear, but when the figures, removed from their original setting, were reinstated on the pedestals, the least weathered sides were turned to the front. The surfaces of all of the figures are damaged by weathering, cracks, and repairs. All show a number of pointer drillmarks and all have faint traces of white paint. The left arm of Spring is broken off at the wrist and has been lost. The right hand is partially broken away and the object it held, perhaps a spray of flowers, is gone. Edges of the drapery and the putto's feet and nose are lost. Summer's drapery and the edges of her hat and that worn by the putto are chipped. The left hand, which probably held a sickle, is broken off. Her right cheek is seriously damaged by cracks and discoloration. The nose and lips of the putto are broken. Autumn is the best preserved of the four figures. The left hand shows evidence of repairs and the tip of the nose and a few edges of the drapery are lost, as is the big toe of the left foot. The young satyr's nose and some of his grapes are lost. Winter's legs and the lower parts of the drapery are severely cracked. Many edges of the drapery, the nose, and the ends of the bundles of firewood on the base are lost. The tips of the toes of his left foot, the nose of the putto, and both of his feet have disappeared.

The Four Seasons have long been recognized as among the most important examples of Rococo garden sculpture. The iconographic motive of personifying the Four Seasons dates back to classical antiquity. During the Middle Ages it survived in a few works of art and in a strong literary tradition. In European art of the Renaissance the Seasons were given the attributes of classical gods and goddesses — attributes which they never had in ancient times. This classical revival combined, in the course of the seventeenth century, with the painter's romantic perception of nature's varying moods to produce figures of the Seasons for use as garden sculpture.[1]

In the Cambridge examples, the personifications have lost the attributes of deities. Though Spring recalls Flora, a genre note is added by the putto who plays the season's typical game, marbles. Summer's bonnet robs her of any resemblance to Ceres. Winter has a heroic muscular physique, but turning, steels himself against the cold — hardly creating an impression of Olympian imperturbability. Only Autumn has the true character of a god, Bacchus.

The Four Seasons were part of the garden decoration of the Palace of Bruchsal, but in contrast to the documents for the palace building and garden design, the records concerning the garden sculpture are scant and inconclusive. The plan for the park was

made in 1724 by the Viennese landscape architect, Johann Franz Scheer, who enlarged it in 1725–1735. In 1754 Johann Joachim Günther was given the title of court sculptor and the following year was commissioned to design four halberdiers. Because of difficulties in obtaining material and assistance they were not completed until 1761. A record of 1806 mentions the Halberdiers as part of a group of twelve large figures which were sorely in need of repair. The others were the Four Elements and the Four Seasons. The last group was removed and eventually sold to the Counts of Bismarck, while the other eight have remained at Bruchsal.[2] Three of the Four Seasons — Summer, Autumn, and Winter — served as inspiration for a porcelain series of Seasons modeled by Konrad Link for the factory at Frankenthal. Link was employed at Frankenthal between 1763 and 1766, during the directorship of Adam Bergdolf.[3] We must assume, therefore, that at least three of the Bruchsal Seasons must have been completed by 1766.

The Four Halberdiers are documented as having been made from life-size clay models by Günther, but the attribution of the Four Elements and the Four Seasons to that artist has not been unanimously accepted by scholars. Among the bozzetti in the estate of Johann Sebastian Pfaff at Mainz, Brinckmann discovered a terra cotta almost identical to the Bruchsal Winter. He attributed the little figure to Johann Peter Wagner on stylistic grounds and believed that Wagner was the designer of all of the Seasons.[4] Feulner and Rosenberg, recognizing many stylistic parallels between the Seasons and some of the works of the Mannheim sculptor, Paul Egell, considered the Seasons to have been created by that artist.[5] Later Feulner, impressed by the fact that Egell died in 1752, several years before the commissioning of the large Bruchsal Halberdiers, changed his opinion and attributed the Seasons to Günther working under Egell's influence.[6]

Johann Sebastian Pfaff, an assistant to Günther until 1777, in that year moved to Mainz, taking with him many terra cottas by different hands.[7] Among them was the Winter, attributed by Brinckmann to Wagner because of its affinity to his figures for the altar of the Augustinerkirche at Mainz, a work that can be no earlier than 1771, five years later than the latest possible date of the Bruchsal Seasons. The terra cottas done during the early 1760's and signed by Wagner are quite different from the figure of Winter from the Pfaff estate.[8] Moreover, there is no documentary or stylistic proof that Wagner ever worked at Bruchsal. Egell was briefly in that city when engaged in making sculptures for the Hofkirche.

The resemblance of the Four Elements and the Four Seasons to many of Egell's pieces, as pointed out by Feulner and Rosenberg, is striking.[9] Several sculptures actually documented as by Günther are close to Egell as well. The pair of angels for the Stadtkirche at Bruchsal, dated 1759, show a comparable handling of the drapery, especially in the parting of the folds by the leg — a mannerism that occurs in Egell and in the Seasons.[10] The relief busts of the Evangelists for Waghäusel (now destroyed) had physiognomies like those of the Seasons and of Egell's kneeling angels from the Mannheim Altar. The subject matter and in particular the uniforms of the Halberdiers make

comparisons difficult in this instance. However, they have the same slightly contraposto positions as the Seasons, and, like several of the Seasons and Elements, rest one hip against a support. Günther's many stucco reliefs in the Palace at Bruchsal make use of the typical *rocaille* ornament that frames the sides of the Seasons' pedestals. In the section of the palace known as the "Saline," Günther used as part of the decoration symbols of the Four Seasons with the same motives as those appearing on the garden-figure pedestals.[11] The Seasons, like the Halberdiers, were carved from full-scale models, as the marks of the pointer drill demonstrate. Their unusually high quality must in part be attributed to the training, skill, and sensitivity of the stone cutters employed in the master's shop. In the absence of documentary and stylistic evidence to the contrary, it is reasonable to suppose that this master was the court sculptor, Johann Joachim Günther, and that he supervised the creation of the Seasons, along with the Four Elements, during the years immediately preceding 1766, that is, about 1760–1765.

[1] George M. A. Hanfmann, *The Season Sarcophagus in Dumbarton Oaks*, Cambridge, Mass., 1951, vol. I, pp. 278–279, vol. II, no. 543, fig. 147; Hans R. Weihrauch, *Die Bildwerke in Bronze und in anderen Metallen* (Katalog des Bayerischen Nationalmuseums München, vol. XIII, pt. 5), Munich, 1956, nos. 175–178, pp. 143–148.

[2] Hans Rott, *Die Kunstdenkmäler des Amtsbezirks Bruchsal* (Die Kunstdenkmäler des Grossherzogtums Baden, vol. IX, pt. 2), Tübingen, 1913, pp. 185 ff.

[3] Friedrich H. Hofmann, *Frankenthaler Porzellan*, Munich, 1911, vol. I, pl. 85.

[4] A. E. Brinckmann, *Barock-Bozzetti: Deutsche Bildhauer*, Frankfurt a.M., 1924, pl. 54.

[5] Adolf Feulner, *Skulptur und Malerei des 18. Jahrhunderts in Deutschland*, Potsdam, 1929, pp. 104–105; Jakob Rosenberg, "The Four Seasons," pp. 129–142.

[6] Adolf Feulner, "Zum Werk Paul Egells," pp. 145–146.

[7] E. Neeb, "Beiträge zur Kenntnis des Bildhauers Johann Sebastian Barnabas Pfaff," *Mainzer Zeitschrift*, vol. II, 1907, pp. 57 ff.

[8] Brinckmann, *Barock-Bozzetti*, pl. 52, pp. 106–107.

[9] Theodor Demmler, in *Jahrbuch der preussischen Kunstsammlungen*, vol. XLIII, 1922, pl. facing p. 142, fig. 151; Klaus Lankheit, *Die Zeichnungen des kurpfälzischen Hofbildhauers Paul Egell, 1691–1752*, Karlsruhe, 1954, pls. 17, 21, 24, 26, 27, 30, 31; Wolfgang Medding, in *Das Münster*, vol. XII, 1959, pp. 346, 347.

[10] Alois Siegel, "Johann Joachim Günther," *Oberrheinische Kunst*, vol. VII, 1936, pp. 197 ff., figs. 6, 7; Roegele, *Bruchsal wie es war*, p. 170.

[11] Rott, *Die Kunstdenkmäler des Amtsbezirks Bruchsal*, pp. 73 ff., fig. 35.

92. Bust of a Man, Johann Gottfried Schadow (?), c. 1797

Fogg Art Museum 1943.1083; Grenville L. Winthrop bequest. Painted terra cotta on marble base; h. including base 16 in. (40.5 cm.); h. of figure 10¾ in. (27.3 cm.); head and shoulders full round, back hollowed out

Plate LXXXIV

COLLECTIONS

Grenville L. Winthrop, New York

The face is that of a young man. The long hair is gathered at the back by a ribbon, and short curly sideburns reach almost to the chin. The sitter wears a jacket with high collar and wide revers and a ruffled stock. On the back of the jacket collar is incised the date 1797 within a rough oval. The terra cotta is painted yellow to harmonize with the yellow marble base.

A few small repairs have been made to the surface of the jacket.

For further comments, see Number 93.

93. Bust of a Woman, Johann Gottfried Schadow (?), c. 1797

Fogg Art Museum 1943.1084; Grenville L. Winthrop bequest. Painted terra cotta on marble base; h. including base 16⅛ in. (41 cm.); h. of figure 10⅞ in. (27.5 cm.); head and shoulders full round, back hollowed out

Plate LXXXV

COLLECTIONS

Grenville L. Winthrop, New York

The face is that of a mature woman. The figure wears a low-cut blouse with decorated border. Long wavy hair hangs loosely down the back. Encircling the head is a band with a metallic quality, decorated with a series of incised circles. Strands of hair descend on the forehead, forming casual bangs.

There is evidence of damage and repair to the surface of the right cheek and breast. The terra cotta is painted yellow to harmonize with the yellow marble base.

The busts were originally attributed to the French sculptor Chinard. The female portrait has been variously identified as Josephine Bonaparte and Madame Roland, while the male was believed to represent François-Nicolas-Léonard Buzot. The vivid

sense of the living presence indicates that the busts were made from the sitters. Since the male bust is dated 1797 the traditional identifications must be incorrect. Madame Roland died in 1793 and Buzot in 1794. Moreover, the earliest known portrait of Josephine Bonaparte by Chinard is dated 1805, the year following Napoleon's coronation.[1]

Stylistically the portraits differ from those of Chinard, which tend to be more complex in the handling of hair and details of costume. The Cambridge busts are much closer to the extant works of the Prussian court sculptor, Johann Gottfried Schadow (1764–1850). The date 1797 places them in the most productive decade of Schadow's career, when he created portrait busts, tombs, monuments, and his most admired work, the full-length double portrait group of the Princesses Luise and Friederike, completed in 1797. The clay portraits were usually life-size, but during this period many of them were copied on a smaller scale for use of the Royal Porcelain Factory of Berlin, and others were cast in plaster and terra cotta, or even reproduced in papier-mâché.[2] Our pair of portraits may have been designed as models for porcelain. The hand that incised the numerals 1797 in the damp clay was not Schadow's, for the method of rendering them differs from that on his extant clay models and in his drawings.[3] Thus the date could refer to the year in which Schadow made the originals from the sitters, or the year when they were copied by an assistant. In style they are very close to Schadow's portraiture of the 1790's; and their construction, too, with head and shoulders fully round and backs hollowed for the sake of lightness, is that of many documented works by Schadow.[4]

[1] Willy Günther Schwark, *Die Porträtwerke Chinards*, dissertation, Berlin, 1937, p. 74, no. 92.

[2] Georg Lenz, "Johann Gottfried Schadow und die Berliner Porzellanmanufaktur," *Kunst und Kunsthandwerk*, vol. XXII, 1919, pp. 65 ff. The bust of Friedrich Wilhelm II exists in marble, a plaster cast, and smaller versions in porcelain and iron, according to Hans Mackowsky, *Die Bildwerke Gottfried Schadows*, Berlin, 1951, no. 26, pp. 54–55.

[3] *Ibid.*, no. 35, pp. 68–69, figs. 46–48; Ferdinand Laban, "Johann Gottfried Schadows Thonbüste der Prinzessin Louis (Friederike) von Preussen in der Königlichen National-Galerie," *Jahrbuch der königlich preussischen Kunstsammlungen*, vol. XXIV, 1903, p. 23.

[4] Mackowsky, *Die Bildwerke Schadows*, nos. 49, 54, 60, 63, 75, 78.

Index of Sculptors

Index of Sculptors

Alamanno, Pietro, 55–56, Pl. XI
Angermair, Christoph, 98
Auer, Jakob, 110
Auvera, Jacob van der, 130
Auvera, Johann Wolfgang van der, 130, 131 n.4

Backhoffen, Hans, 77
Beauneveu, André, 9
Bernini, Lorenzo, 1, 25, 26, 110, 112
Bologna, Giovanni, 1, 23, 25, 26, 94

Cellini, Benvenuto, 118
Chinard, Josef, 141, 142

Daucher, Hans, 21
Degler, Hans, 24, 25, 98, 99
Derricks, Jakob, 78
Deutschmann, Joseph, 133
Dietz, Ferdinand, 32, 135–136, Pl. LXXVII
Donner, Georg Raphael, 31, 127–128, 129, 130, Pl. LXVIII
Douvermann, Heinrich, 20, 77–79, Pl. XXXI
Douvermann, Johann, 78
Dubroeucq, Jacques, 88

Egell, Paul, 139–140
Erhart, Gregor, 13

Fischer, Johann Martin, 127
Floetner, Peter, 22, 79–80, 92 n.2, Pl. XXXIV
Floris, Cornelis, 1, 23
Fux, Hans Georg, 113–114

Gerhaert van Leyden, Nikolaus, 1, 16
Gerhard, Hubert, 1, 23–24, 25, 93, 97, 108
Götsch, Josef, 134–135
Grasser, Erasmus, 13
Günther, Ignaz, 134–135, Pl. XLIV
Günther, Johann Joachim, 32–33, 137–140, Pls. LXXVIII–LXXXIII
Guggenbichler, Meinrad, 27, 29, 111–113, Pls. LXII, LXV

Hagenauer, Johann Baptist, 128

Jamnitzer, Wenzel, 94
Judenburg, Hans von, 52

Keldermans, Jan, 50
Kern, Erasmus, 26, 106–107, Pl. LII
Kraft, Adam, 13
Krüger, Wilhelm, 30, 118–119, Pl. LVII
Krumper, Hans, 24, 98, 99–100

Labenwolf, Pankraz, 84

Leinberger, Hans, 13, 17, 21, 24, 70–71, 77, Pl. XXVIII
Link, Konrad, 139

Master Bertram, 9
Master H.L., 20
Master Hartmann, 55
Master of Dingolfing, 71
Master of Grosslobming, 51–52
Master of the Beautiful Madonnas, 12, 53, 54 n.2
Master of the Dangolsheim Madonna, 57
Master of the Kefermarkt Altar, 58
Master of the Strassburg Ecclesia, 5
Mauch, Daniel, 74
Meit, Konrad, 83
Michelangelo, 31, 33
Mödlhamer, Paul, 124
Mone, Jan, 88
Müller, Hans, of Breslau, 95–96, Pl. XL

Nicholas of Verdun, 1, 2–3

Olmütz, Hans, 66

Pacher, Michael, 13
Parler, Peter, 9–10
Petel, Georg, 24, 25, 93, 98, 123
Pfaff, Johann Sebastian, 139, 140 n.7

Quellinus, Artus, 26
Quesnoy, François du, 26, 105–106, Pls. LIV, LV

Rauch, Christian Daniel, 33

Rauchmiller, Matthias, 110
Reichle, Hans, 23–24, 25, 98
Reinhart, Hans, 22, 80–82, Pl. XXXIV
Ricci, Andrea, 24, 94
Richier, Ligier, 102
Riemenschneider, Tilman, 13

Schadow, Johann Gottfried, 33, 141–142, Pls. LXXXIV, LXXXV
Schwanthaler Family, 30, 123, 125
Schwanthaler, Franz, 125, Pl. XLIV
Schwanthaler, Hans, 125
Schwanthaler, Johann Josef, 125
Schwanthaler, Thomas, 27, 112, 113 n.3
Schweigger, Georg, 107–108
Seer, Jakob, 121
Seyfer, Hans, 59, 60 n.4
Sifer, Conrad, 59, 60 n.4
Sluter, Claus, 1, 11–12, 49 nn. 1 and 2, 50
Stammel, Joseph Anton Thaddäus, 124
Stoss, Veit, 13, 17, 20, 65, Pl. XVIII
Sustris, Frederik, 25, 93

Tietz, Ferdinand, see Dietz

Vischer the Elder, Peter, 13, 21
Voort, Michiel van der, 29, 115–116, Pls. LVIII, LIX
Vredis, Jodocus, 62 n.3
Vries, Adriaen de, 1, 23–24, 25, 108–109
Vries, Jan Vredeman de, 23

Wagner, Johann Peter, 130, 139
Wydyz, Hans, 63

Plates

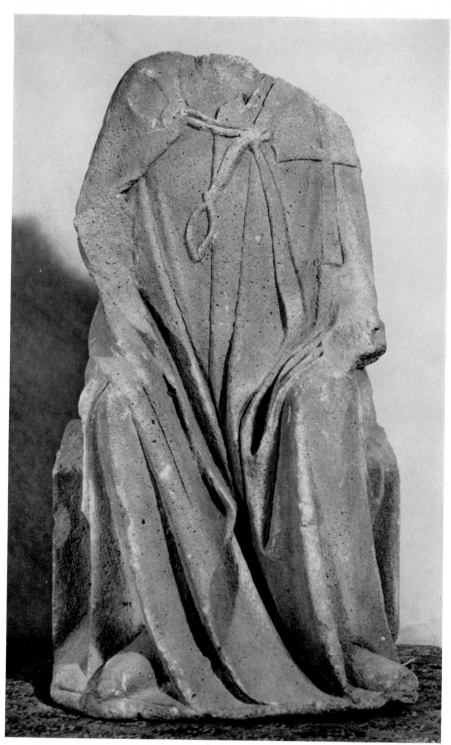

Seated Monk, Upper Rhenish, c. 1280–90
(Cat. no. 1)

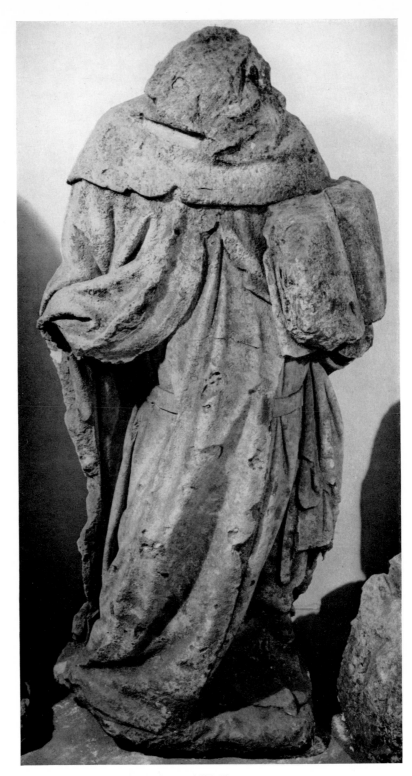

Prophet or Saint, Burgundian, c. 1425–50
(Cat. no. 5)

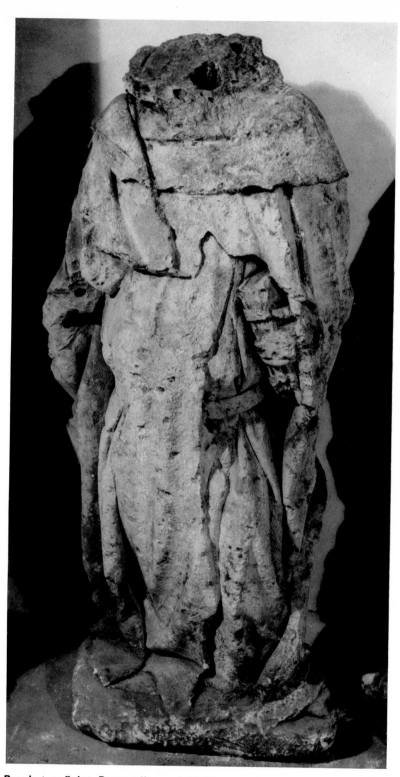

Prophet or Saint, Burgundian, c. 1425–50
(Cat. no. 6)

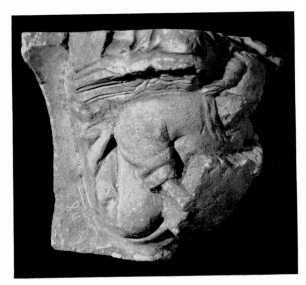 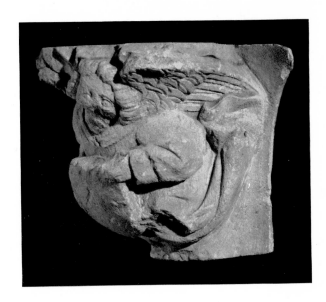

Console, Netherlandish, c. 1425–50
(Cat. no. 7)

Fragment from a Resurrection, Netherlandish, c. 1550
(Cat. no. 38)

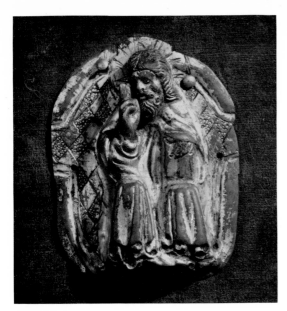

God the Father, Rhenish, c. 1325–50
(Cat. no. 2)

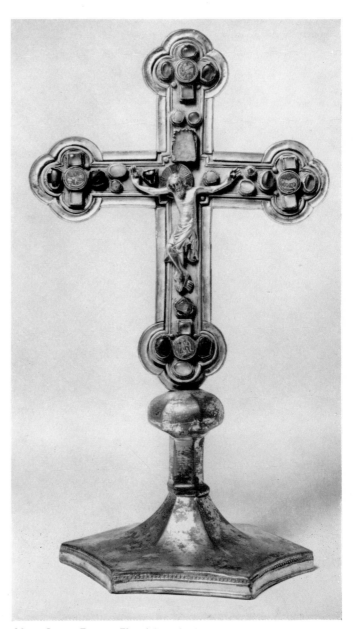

Altar Cross, Franco-Flemish, c. 1350
(Cat. no. 4)

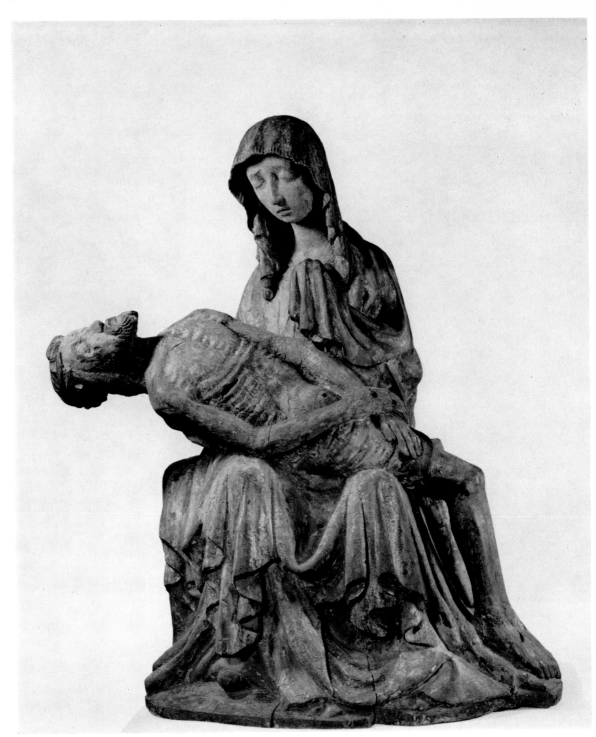

Pietà, Austrian, c. 1420
(Cat. no. 8)

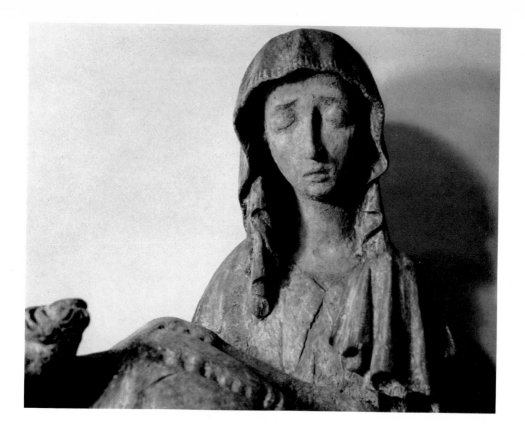

Pietà, details
(Cat. no. 8)

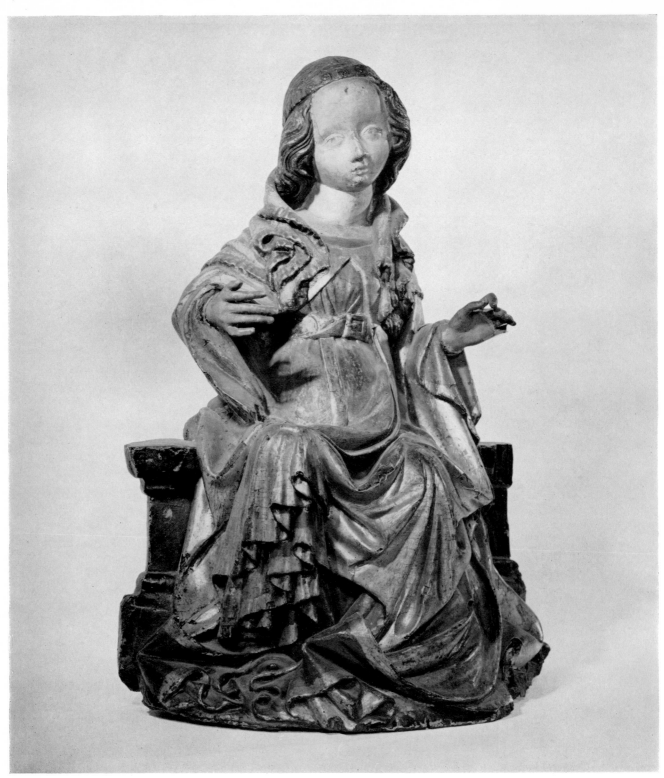

Madonna, Swabian, c. 1430
(Cat. no. 10)

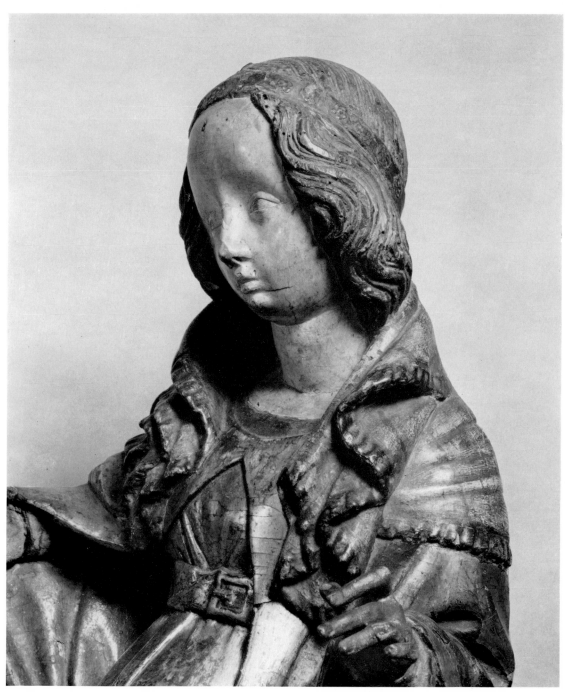

Madonna, detail
(Cat. no. 10)

Madonna and Child, Tyrolese, c. 1430
(Cat. no. 9)

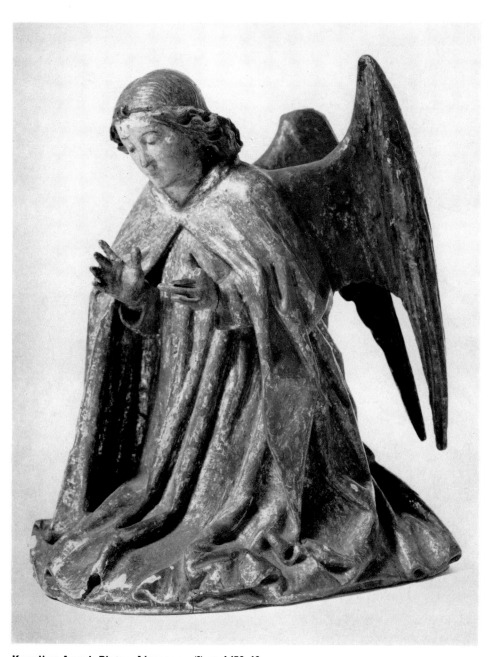

Kneeling Angel, Pietro Alamanno (?), c. 1450–60
(Cat. no. 11)

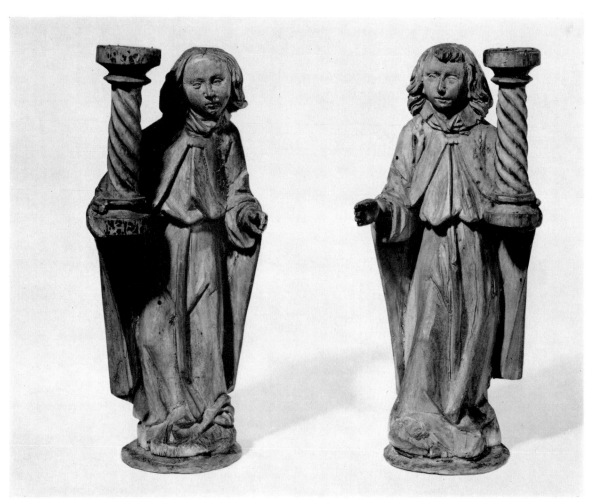

Pair of Angels, Austrian, c. 1490
(Cat. nos. 13–14)

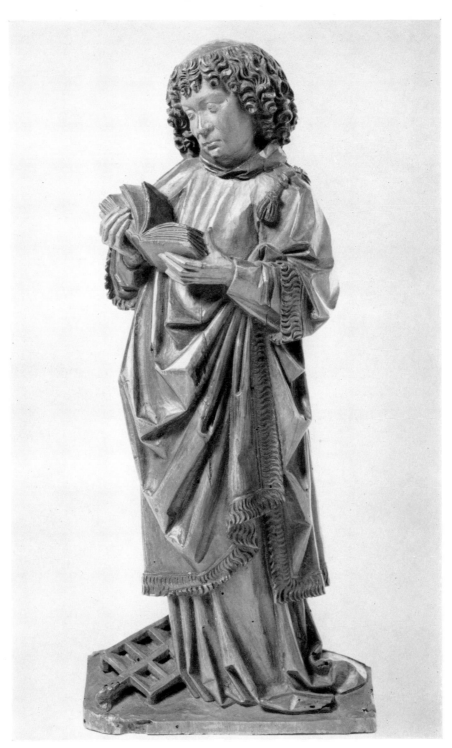

Saint Lawrence, Upper Rhenish, c. 1490
(Cat. no. 12)

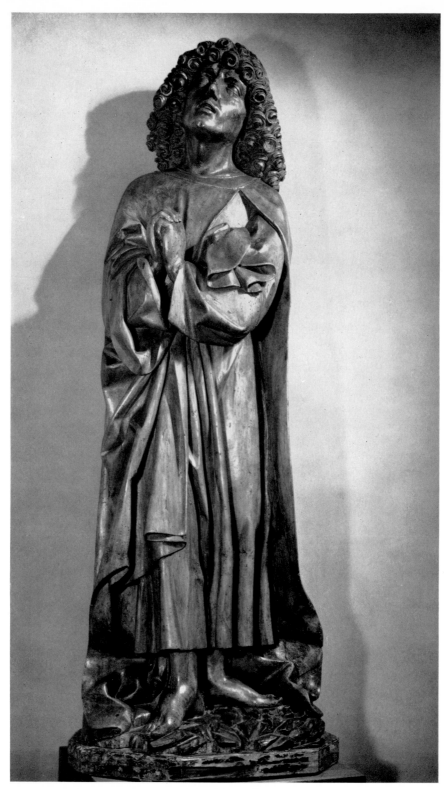

Saint John the Evangelist, Lower Swabian, c. 1490–1500
(Cat. no. 16)

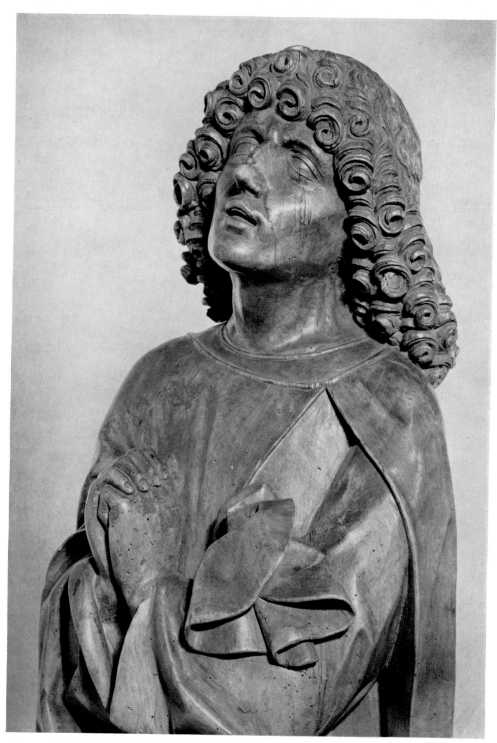

Saint John the Evangelist, detail
(Cat. no. 16)

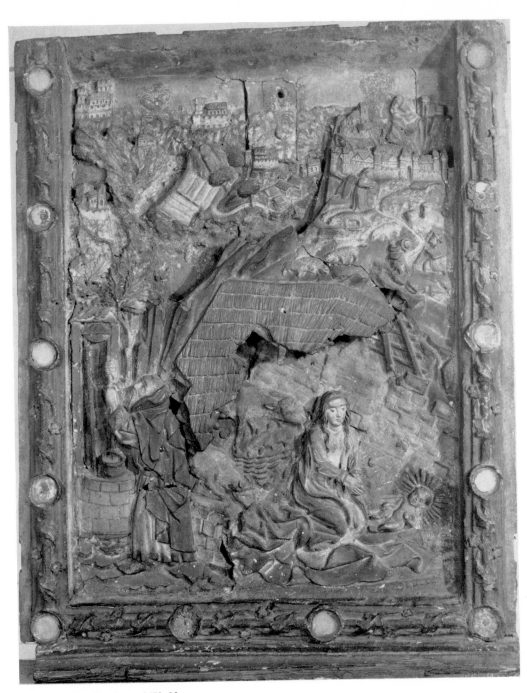

Nativity, Rhenish (?), c. 1470–80
(Cat. no. 18)

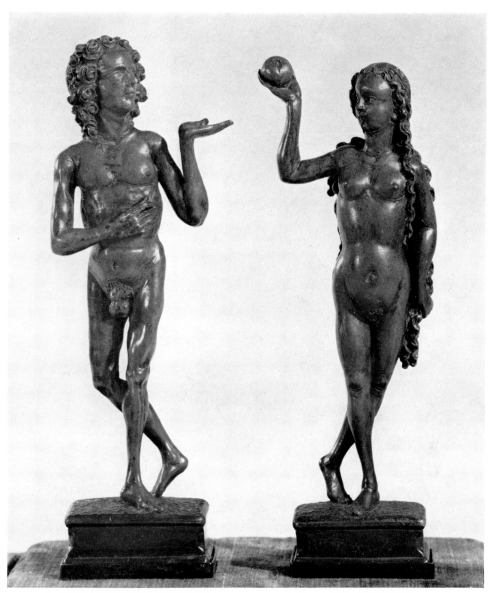

Adam and Eve, Upper Rhenish, c. 1490–1500
(Cat. no. 19)

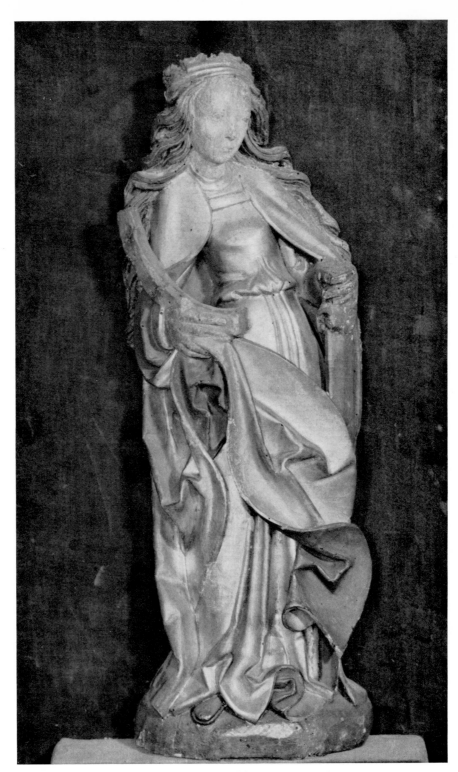

Saint Catherine, Circle of Veit Stoss, c. 1500
(Cat. no. 21)

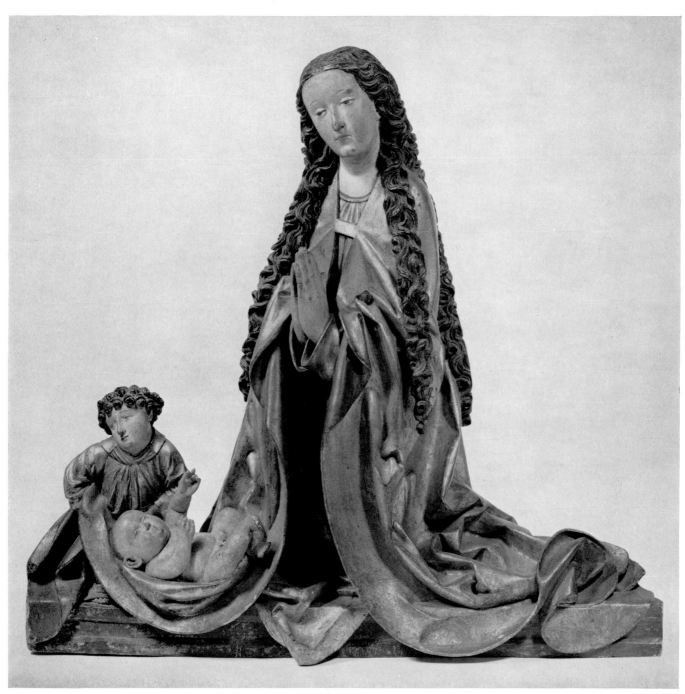

Nativity, Upper Rhenish, c. 1500
(Cat. no. 22)

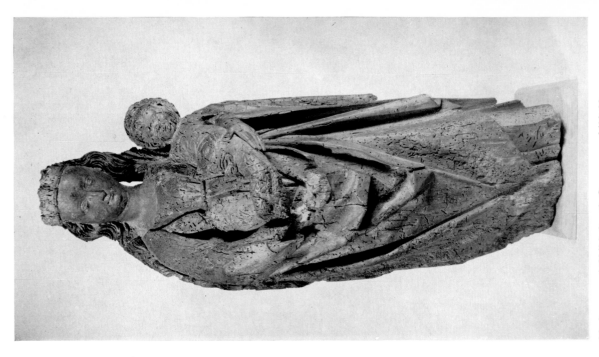

Madonna and Child, South German, c. 1480–90
(Cat. no. 15)

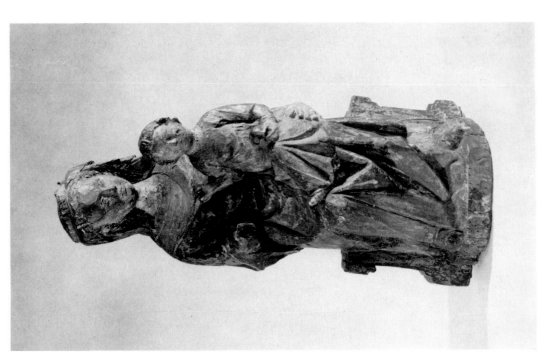

Madonna and Child, German, c. 1325–50
(Cat. no. 3)

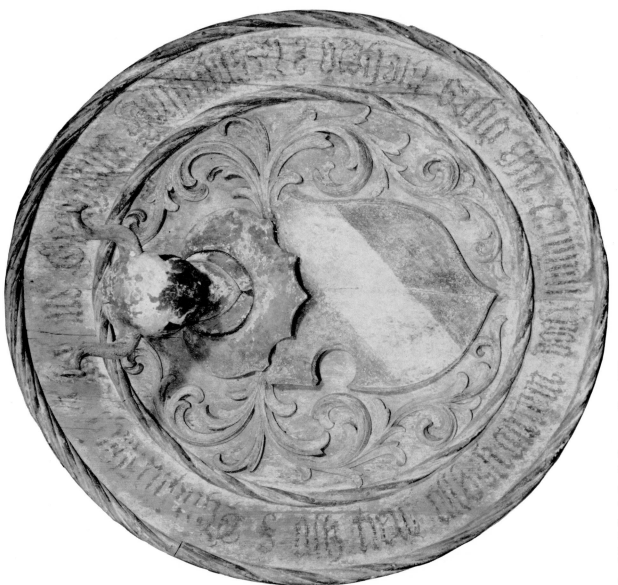

Heraldic Epitaph, South German (?), c. 1500
(Cat. no. 20)

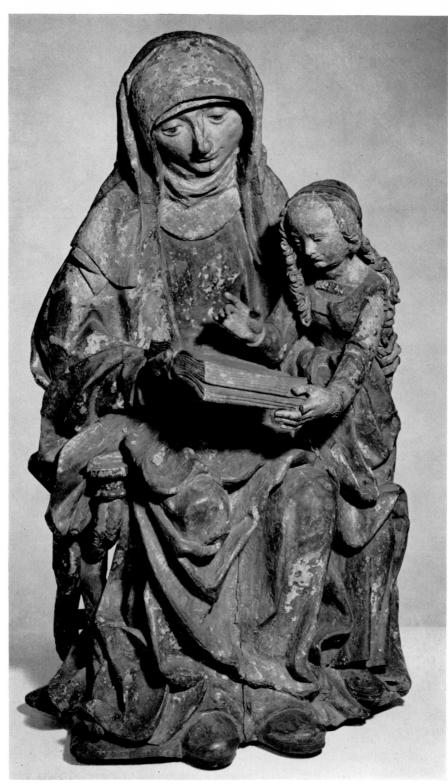

Education of the Virgin, Franconian, c. 1510–20
(Cat. no. 25)

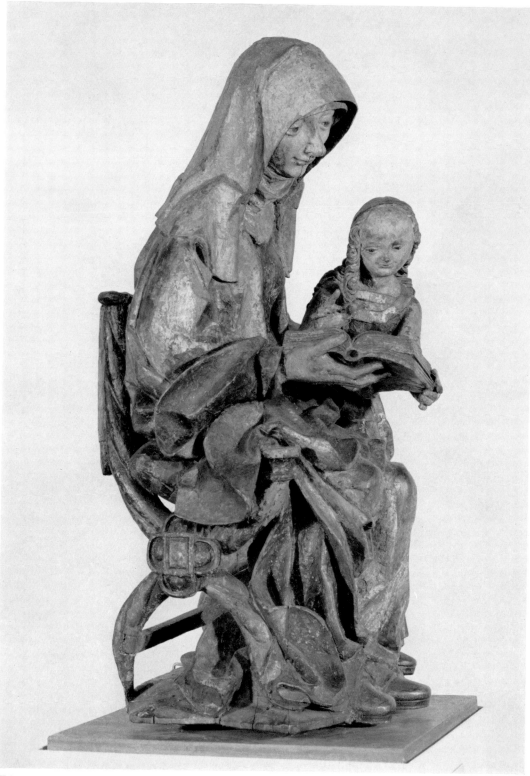

Education of the Virgin, side view
(Cat. no. 25)

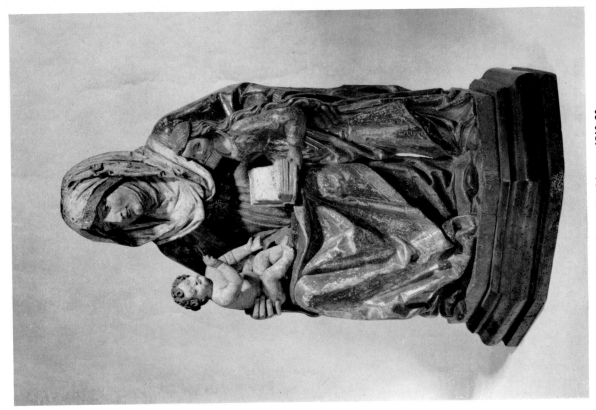

Madonna and Child and Saint Anne, Swabian, c. 1510–20
(Cat. no. 29)

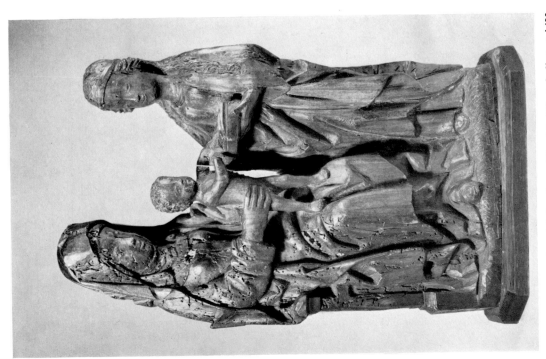

Madonna and Child and Saint Anne, Rhenish–Westphalian, c. 1490
(Cat. no. 17)

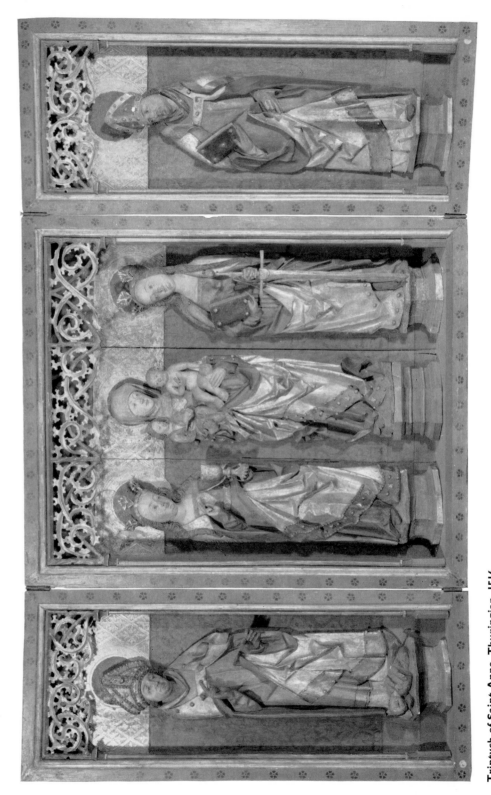

Triptych of Saint Anne, Thuringian, 1516
(Cat. no. 28)

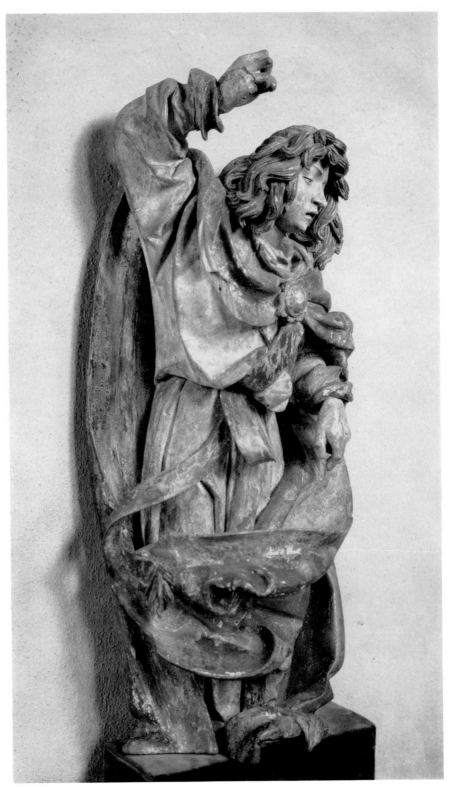

Saint Michael, Danube School, c. 1510–20
(Cat. no. 27)

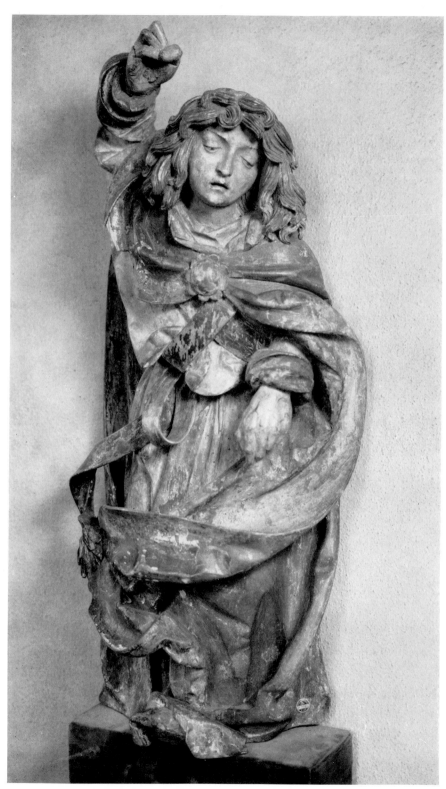

Saint Michael, front view
(Cat. no. 27)

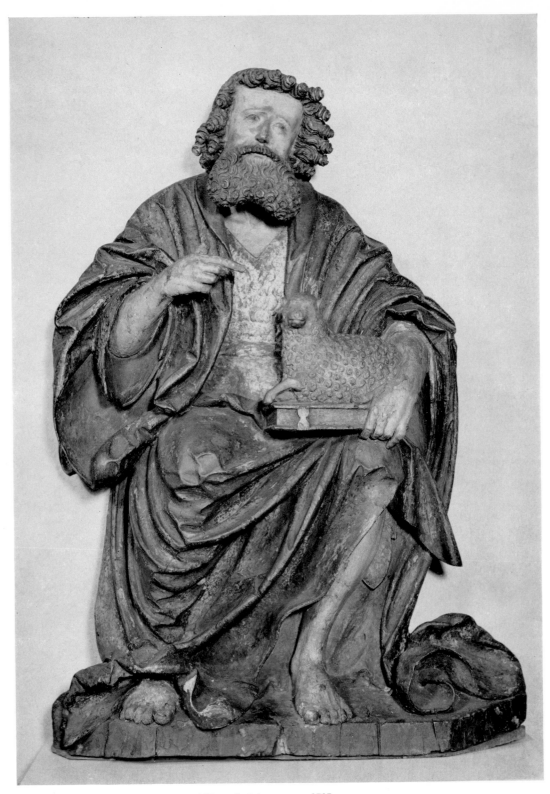

Saint John the Baptist, Follower of Hans Leinberger, c. 1515
(Cat. no. 26)

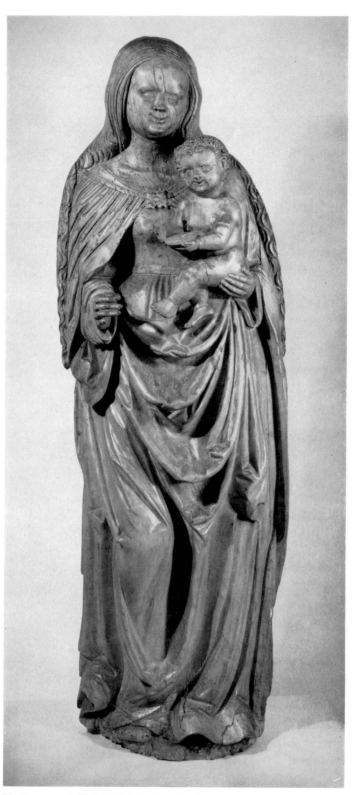

Madonna and Child, Middle Rhenish (?), c. 1520
(Cat. no. 31)

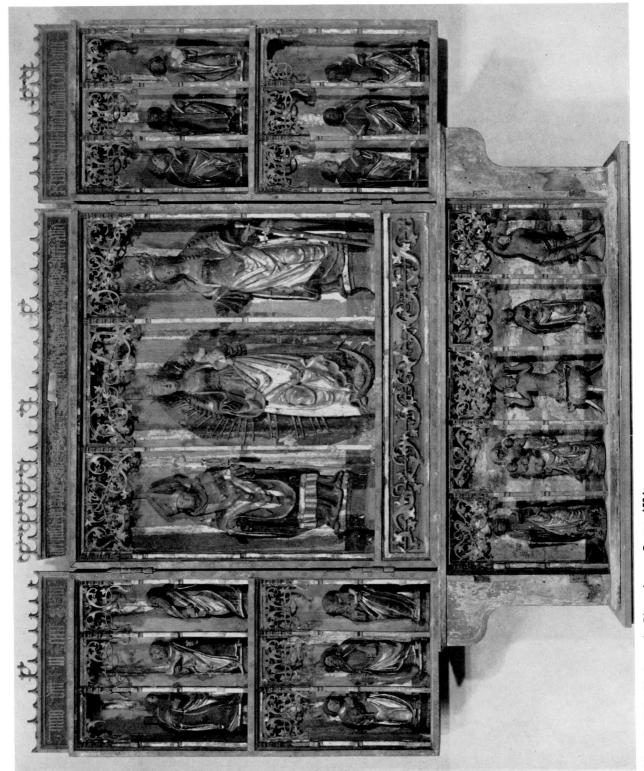

Triptych of the Madonna in Glory, Lower Saxon, 1524
(Cat. no. 30)

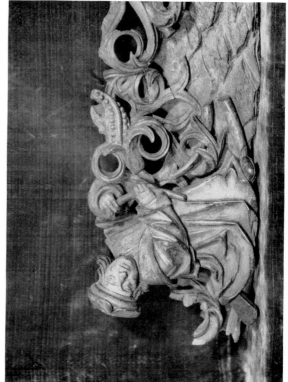

Jesse Tree, Circle of Heinrich Douvermann, c. 1520–30
(Cat. no. 32)

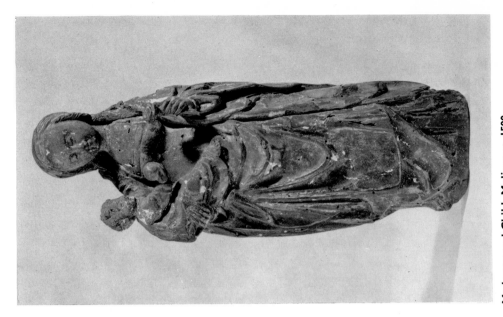

Madonna and Child, Malines, c. 1500
(Cat. no. 23)

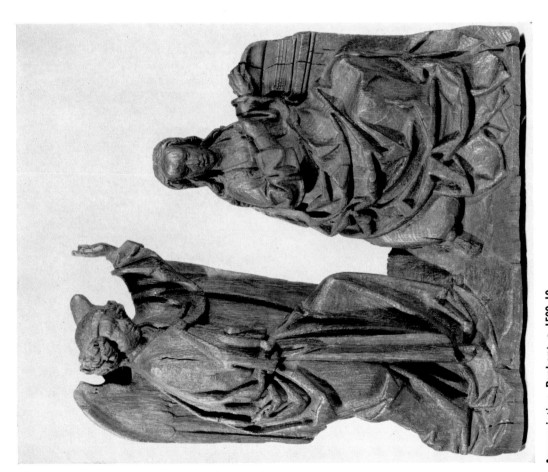

Annunciation, Brabant, c. 1500–10
(Cat. no. 24)

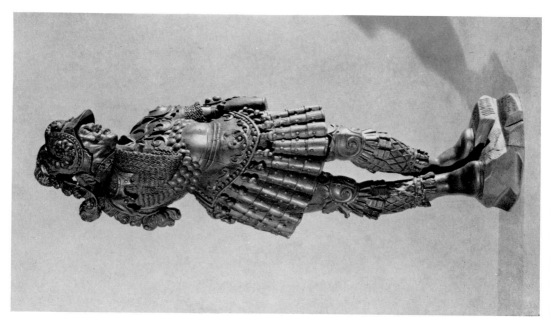

Standing Warrior, Netherlandish, c. 1530
(Cat. no. 35)

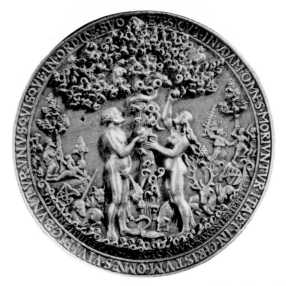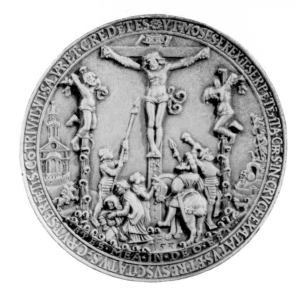

**Medal of the Fall and Redemption of Man, Hans Reinhart, 1536,
obverse and reverse**
(Cat. no. 34)

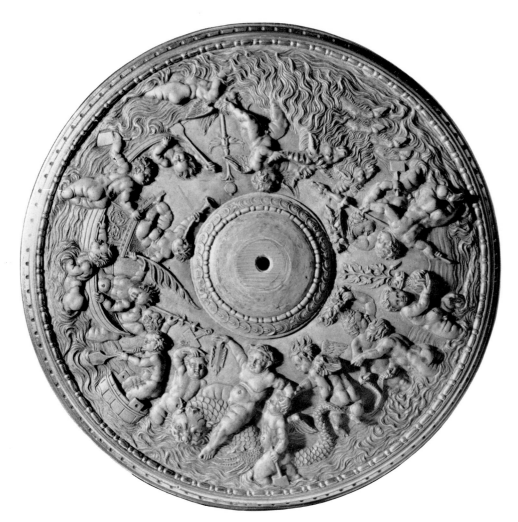

Triumph of a Sea-Goddess, Peter Floetner, c. 1530
(Cat. no. 33)

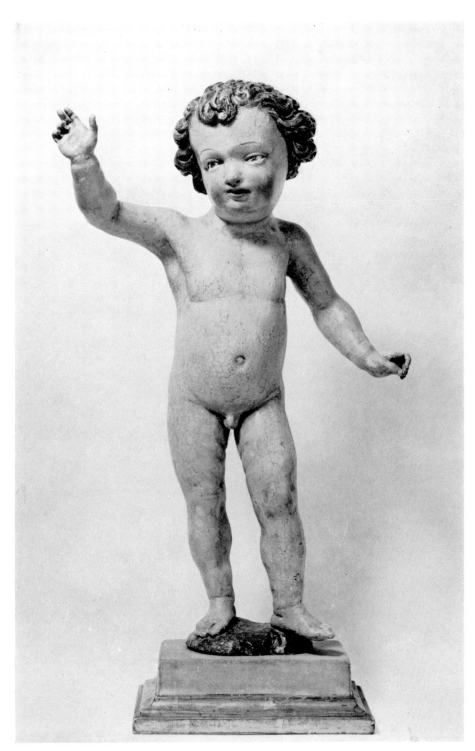

Christ Child, Swabian, c. 1530–40
(Cat. no. 36)

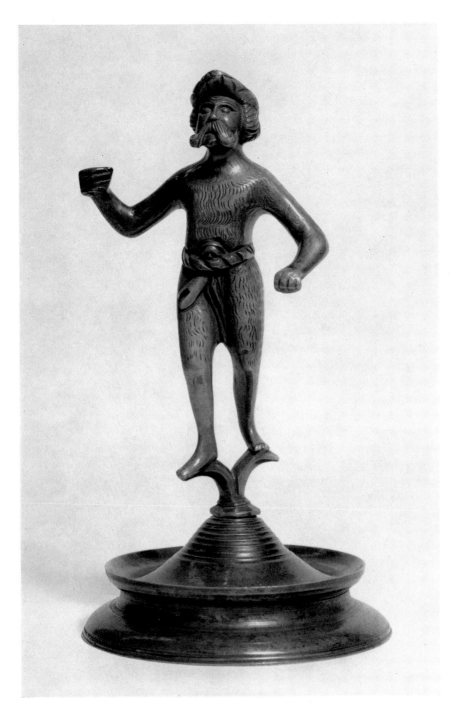

Wild-Man Candle Holder, Nuremberg (?), c. 1525–50
(Cat. no. 37)

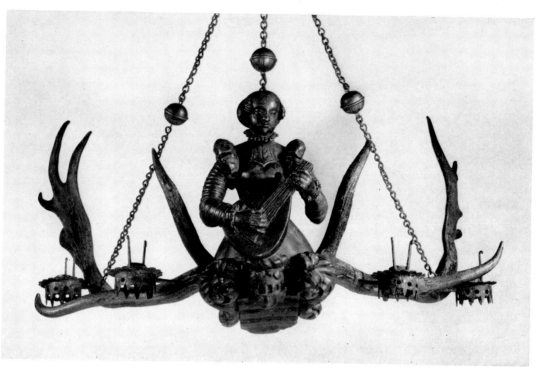

Chandelier, South German or Swiss, c. 1550–75
(Cat. no. 39)

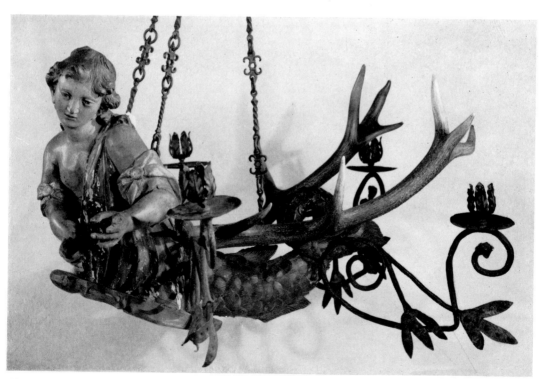

Chandelier, South German or Austrian, c. 1675–1700
(Cat. no. 62)

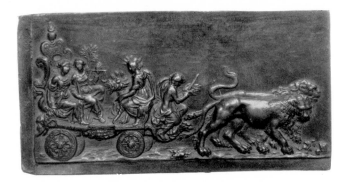

43. Justice

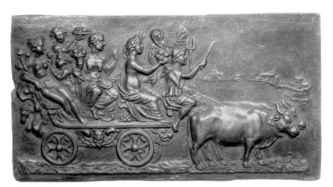

44. Folly

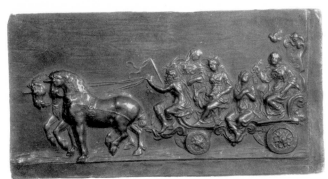

45. Church

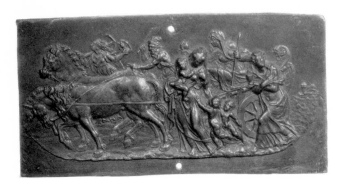

46. Humility

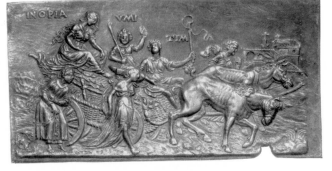

47. Poverty

Series of Five Triumphs, Netherlandish, end XVI century
(Cat. nos. 43–47)

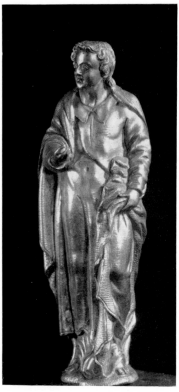

**Saint John the Evangelist,
Netherlandish, c. 1550**
(Cat. no. 40)

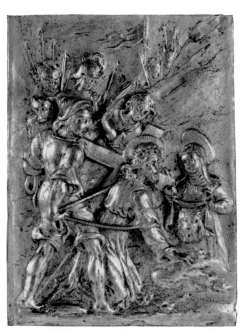

Way to Calvary, South German (?), c. 1550–75
(Cat. no. 41)

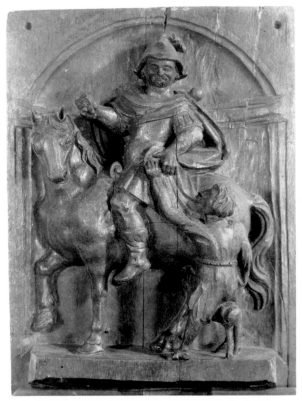

**Saint Martin and the Beggar, Lower German (?),
late XVI century**
(Cat. no. 42)

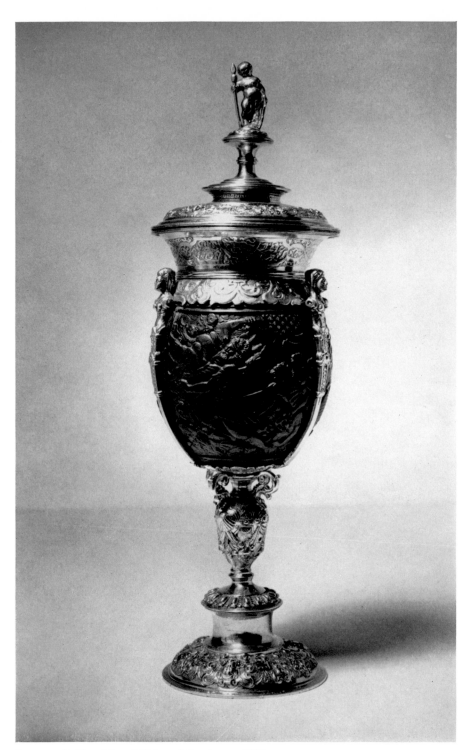

Coconut Goblet, Hans Müller of Breslau, c. 1600
(Cat. no. 50)

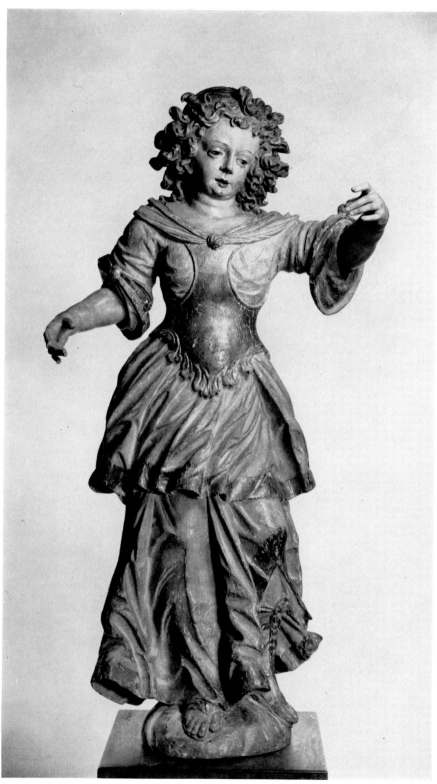

Angel, South German, c. 1600–20
(Cat. no. 53)

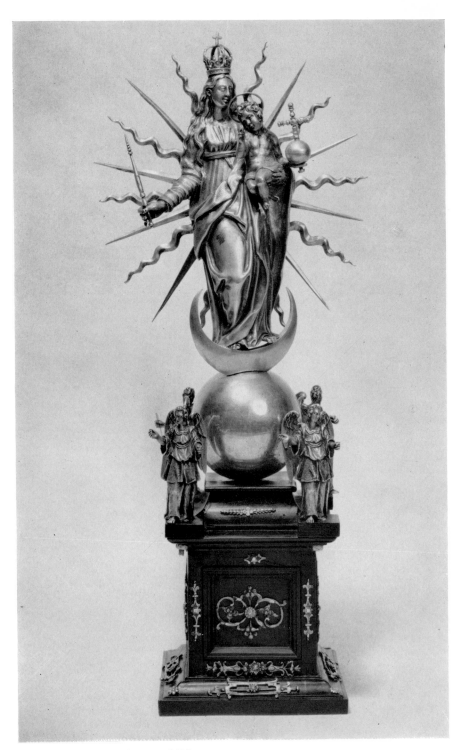

Virgin in Glory, Augsburg, c. 1600
(Cat. no. 51)

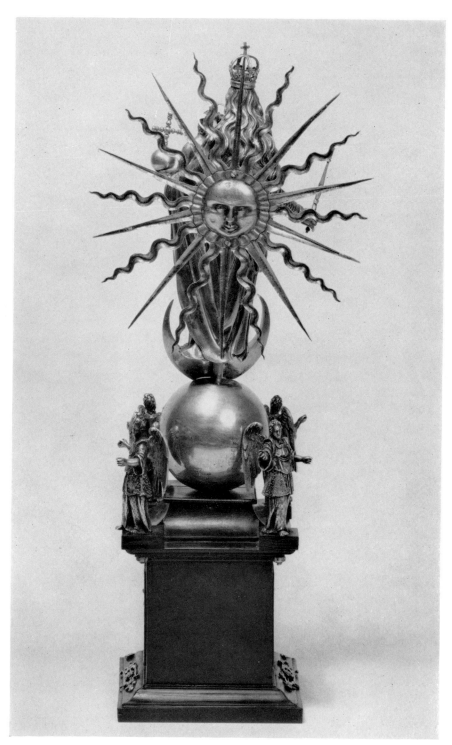

Virgin in Glory, rear view
(Cat. no. 51)

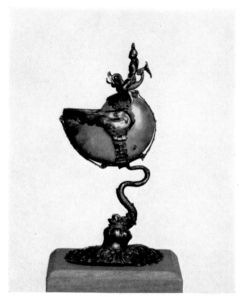

**Model of a Nautilus Goblet, Nuremberg (?),
c. 1650–75**
(Cat. no. 60)

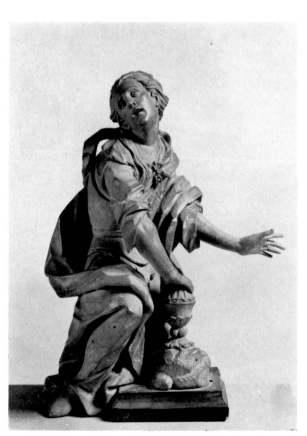

Kneeling Magdalen, Franz Schwanthaler (?), c. 1730
(Cat. no. 76)

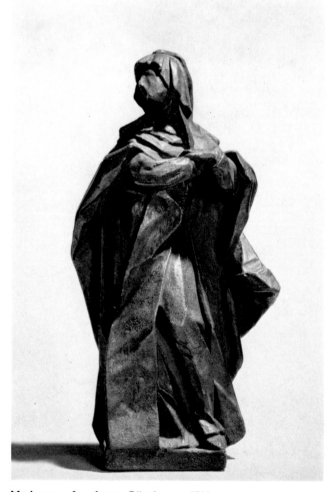

Madonna, after Ignaz Günther, c. 1760
(Cat. no. 86)

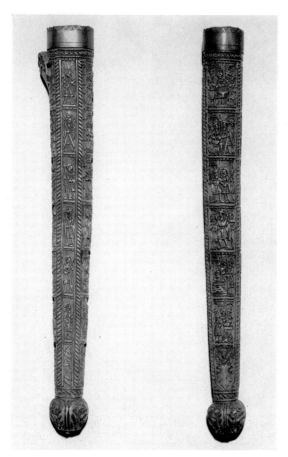
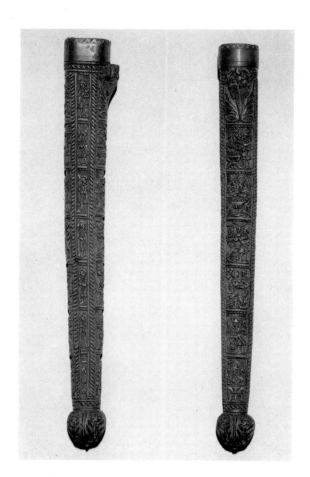

Knife Sheath, German, 1626
(Cat. no. 56)

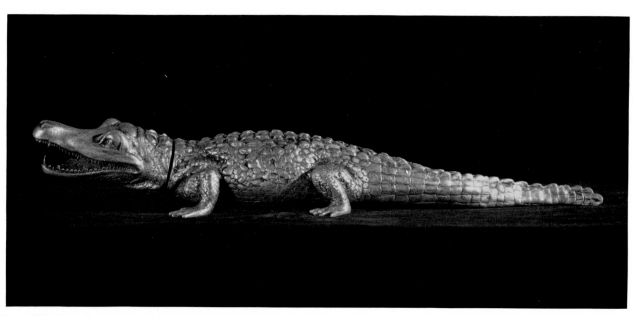

Crocodile Sand Container, Nuremberg, c. 1575–1600
(Cat. no. 49)

Saint John the Evangelist, Netherlandish, c. 1575–1600
(Cat. no. 48)

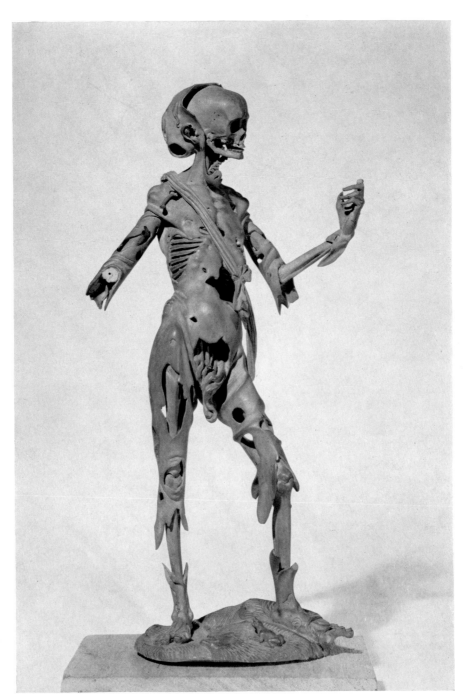

Personification of Death, Upper Rhenish, c. 1600–50
(Cat. no. 54)

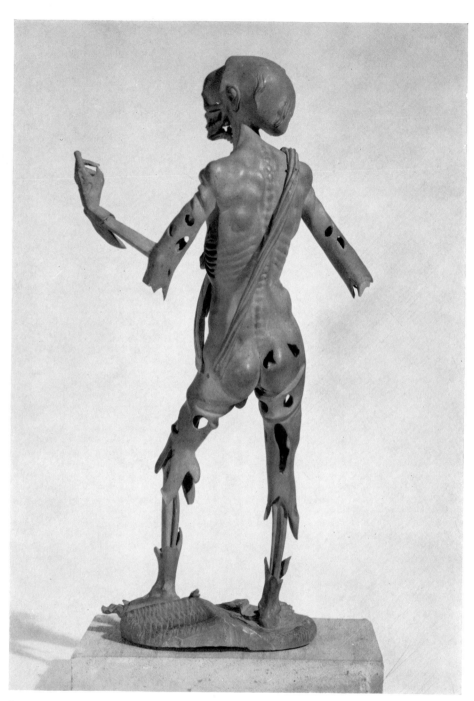

Personification of Death, rear view
(Cat. no. 54)

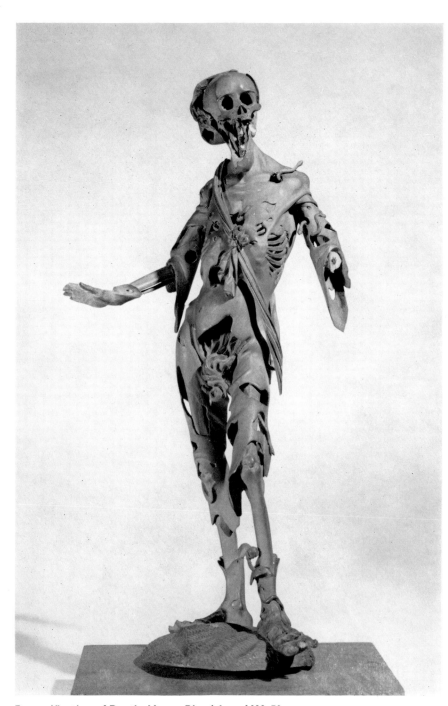

Personification of Death, Upper Rhenish, c. 1600–50
(Cat. no. 55)

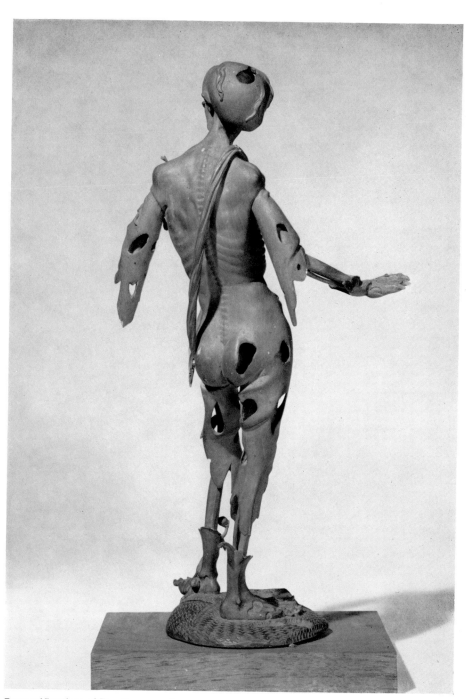

Personification of Death, rear view
(Cat. no. 55)

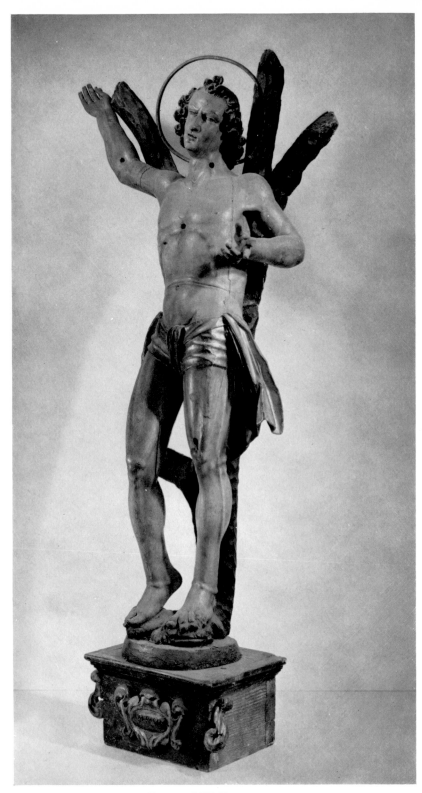

Saint Sebastian, Erasmus Kern, c. 1625–50
(Cat. no. 59)

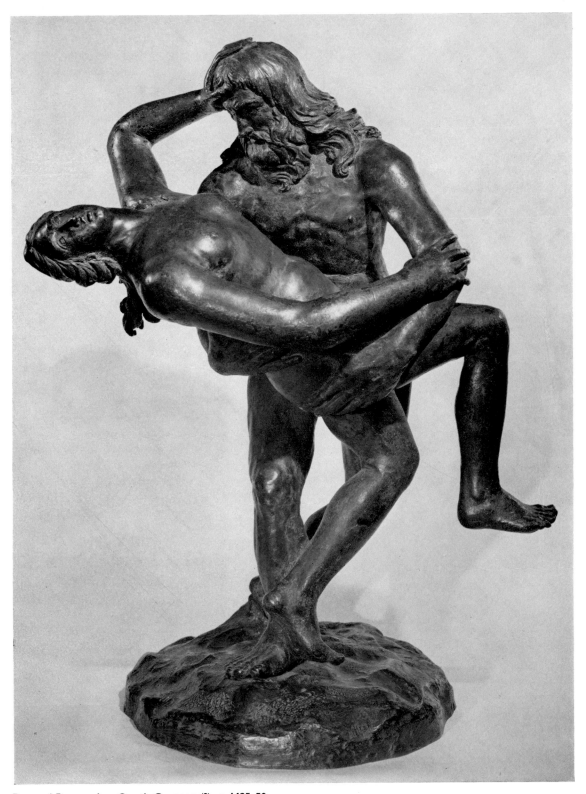

Rape of Proserpine, South German (?), c. 1625–50
(Cat. no. 61)

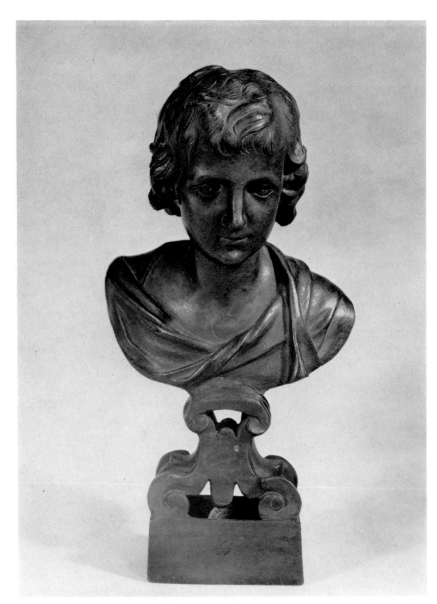

Bust of Christ, François du Quesnoy, c. 1630
(Cat. no. 57)

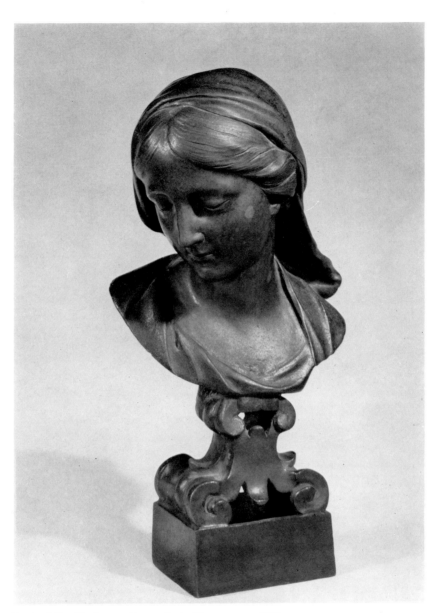

Bust of the Madonna, François du Quesnoy, c. 1630
(Cat. no. 58)

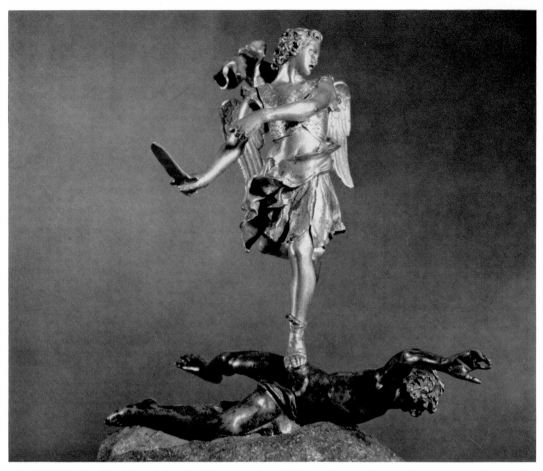

Saint Michael, South German, c. 1700–10
(Cat. no. 69)

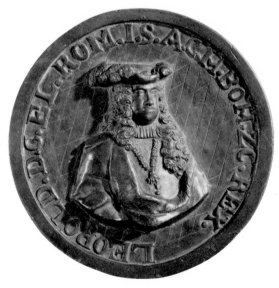
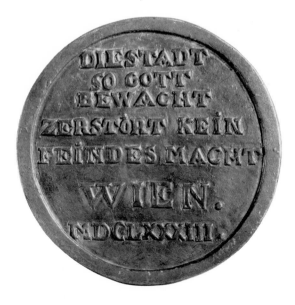

Medal of Leopold I, Austrian, c. 1710–40, obverse and reverse
(Cat. no. 71)

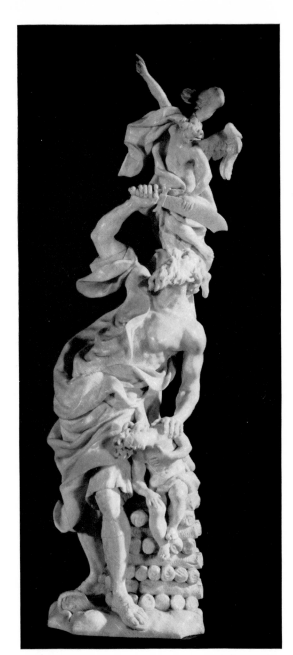

Sacrifice of Isaac, South German, late **XVII** century
(Cat. no. 63)

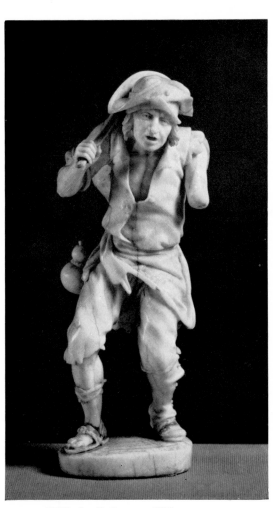

Beggar, Wilhelm Krüger, c. 1730
(Cat. no. 70)

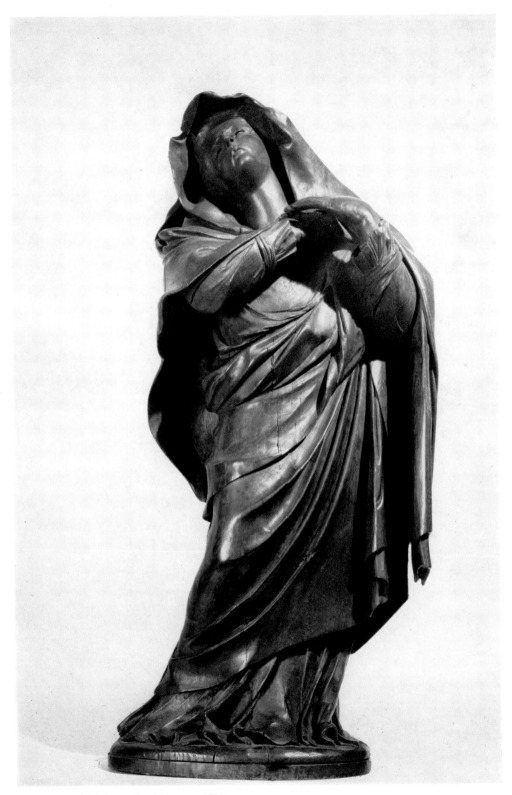

Madonna, Michiel van der Voort, c. 1720
(Cat. no. 66)

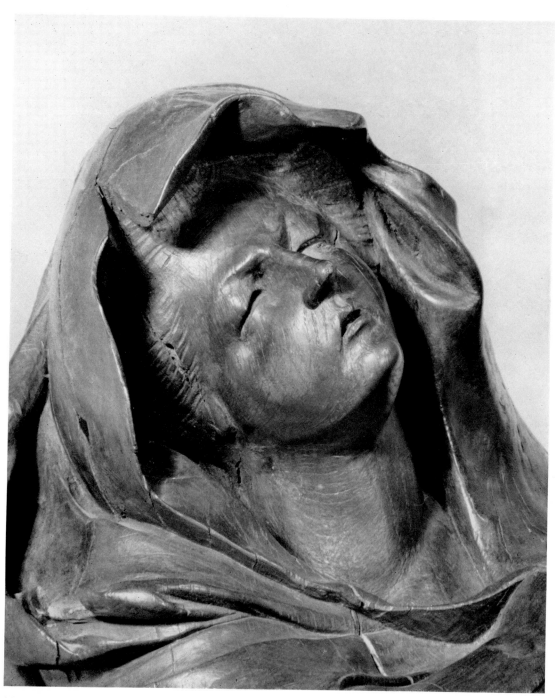

Madonna, detail
(Cat. no. 66)

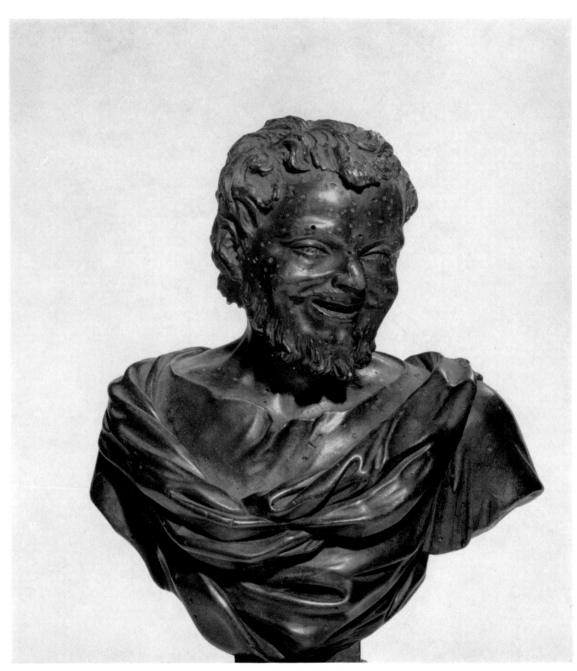

Bust of Democritus, Netherlandish, early XVIII century
(Cat. no. 67)

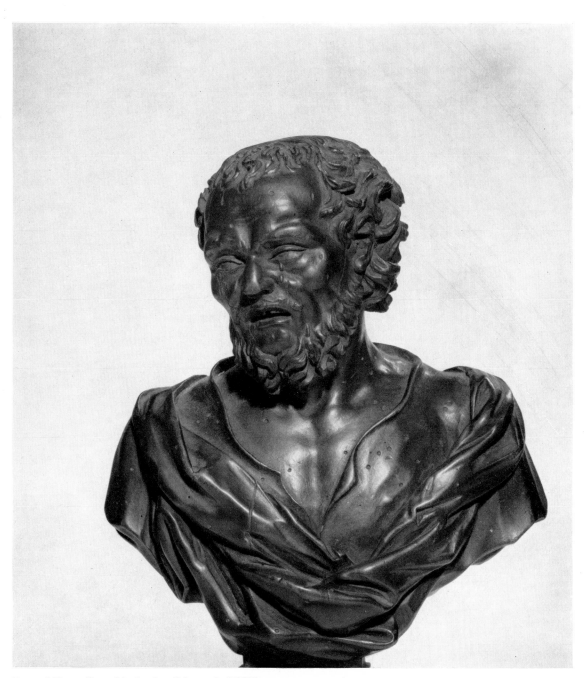

Bust of Heraclitus, Netherlandish, early XVIII century
(Cat. no. 68)

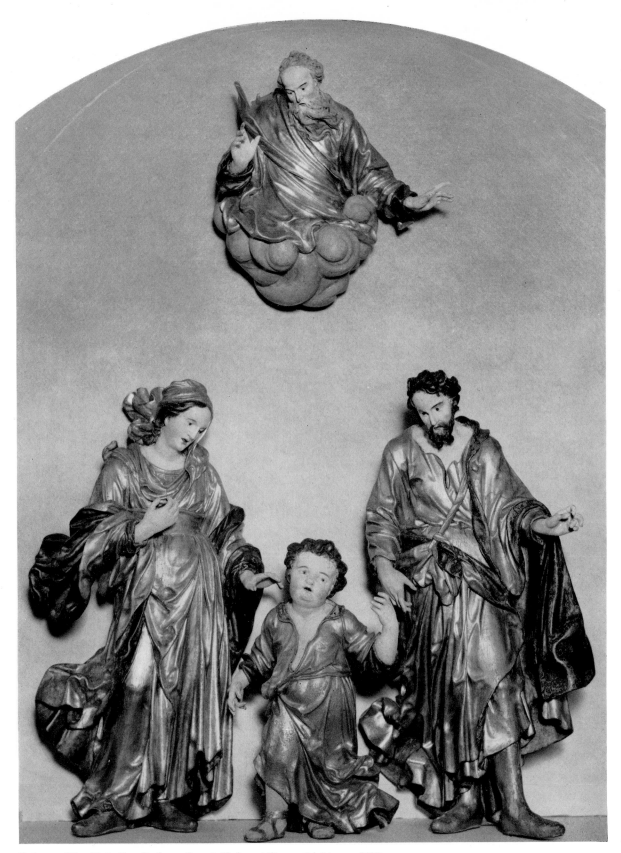

Return of the Holy Family from Egypt, Meinrad Guggenbichler, c. 1690
(Cat. no. 64)

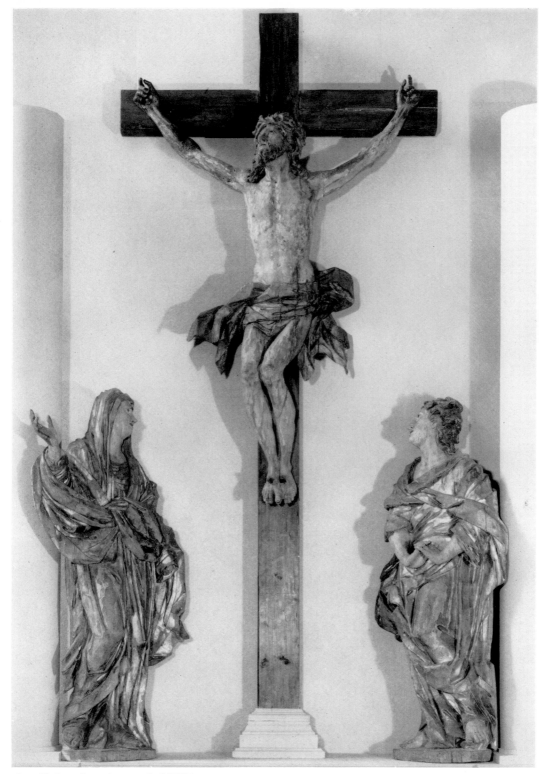

Crucifixion, Austrian, early XVIII century
(Cat. no. 72)

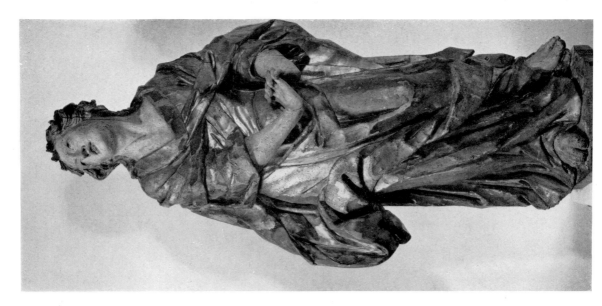

Saint John, detail of Crucifixion
(Cat. no. 72), Plate LXIII

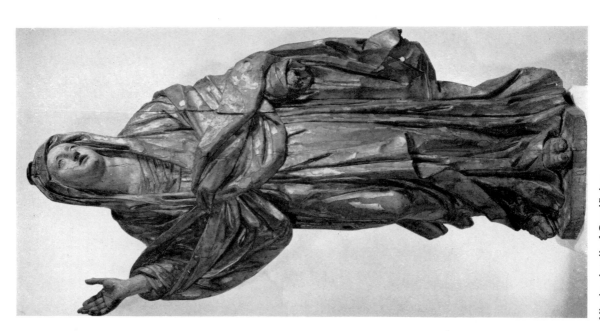

Virgin, detail of Crucifixion
(Cat. no. 72), Plate LXIII

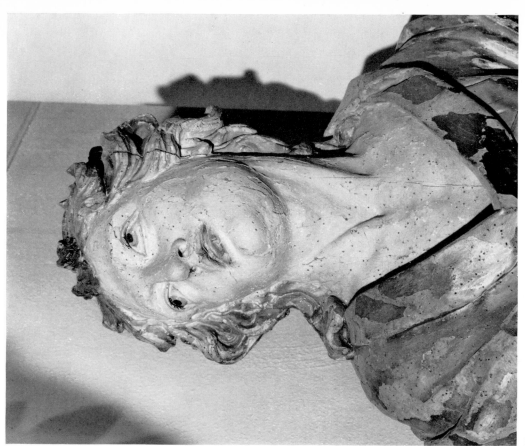

Head of Saint John, detail of **Crucifixion**
(Cat. no. 72), Plate LXIII

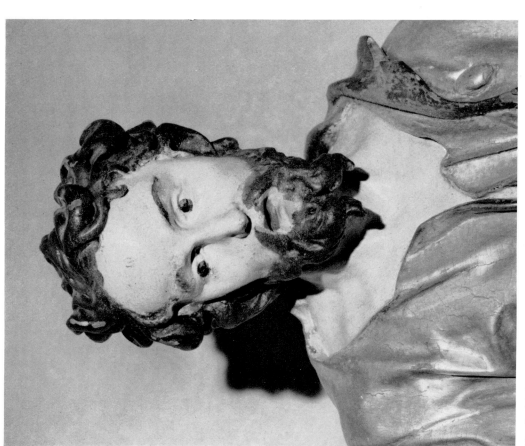

Head of Saint Joseph, detail of **Return of the Holy Family**
(Cat. no. 64), Plate LXII

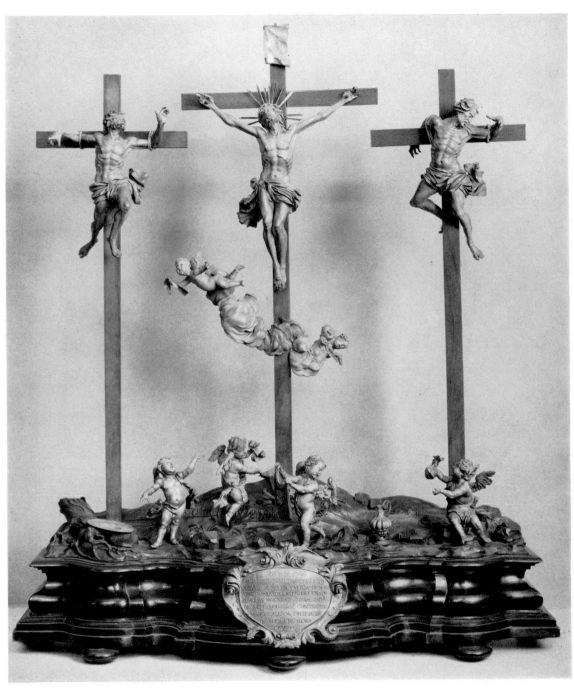

Crucifixion, Upper Austrian, c. 1700–25
(Cat. no. 73)

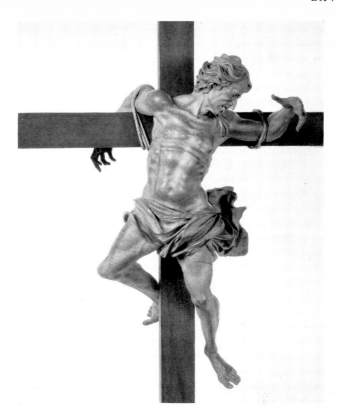

Crucifixion, details
(Cat. no. 73)

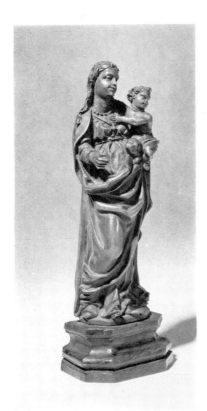

Madonna and Child, German or Netherlandish, c. 1675–1700
(Cat. no. 65)

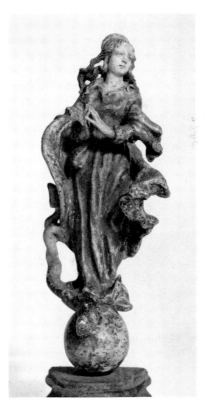

Madonna Immaculata, Austrian, c. 1730–50
(Cat. no. 77)

LXVIII

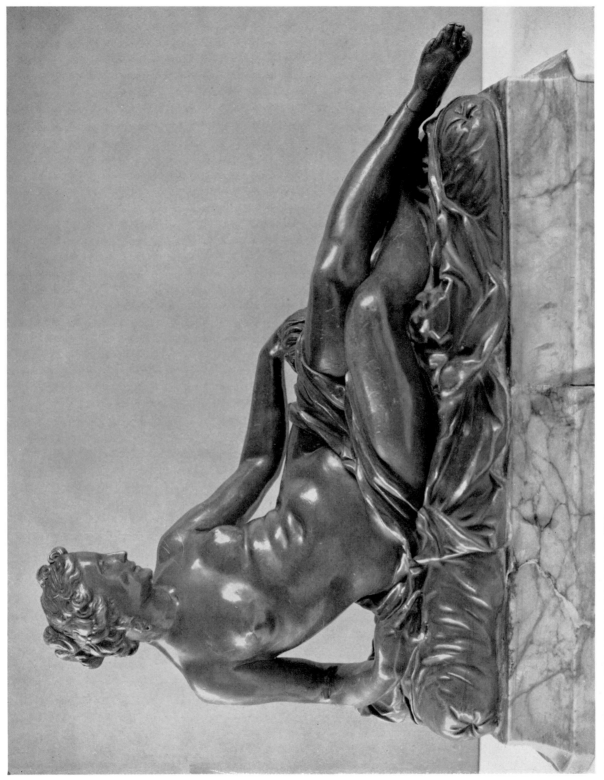

Reclining Nymph, Georg Raphael Donner, c. 1739
(Cat. no. 78)

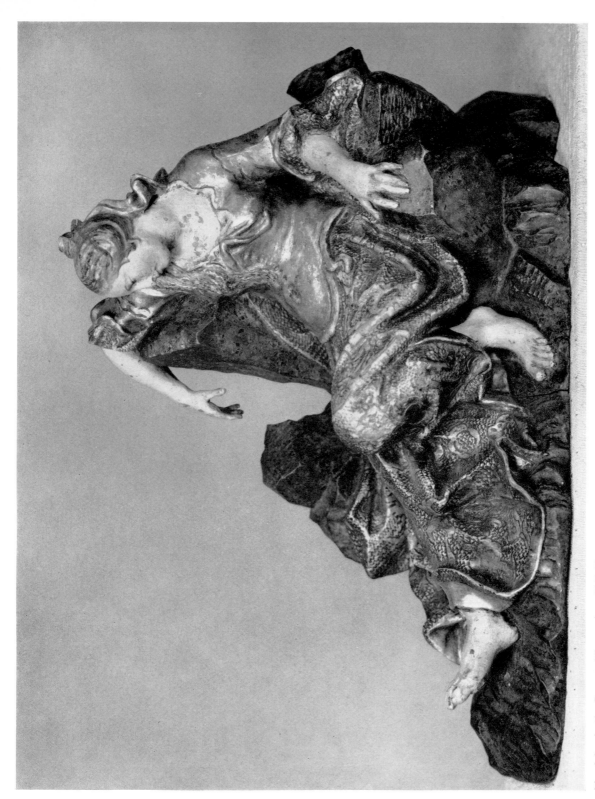

Magdalen in the Desert, Viennese, c. 1740–50
(Cat. no. 79)

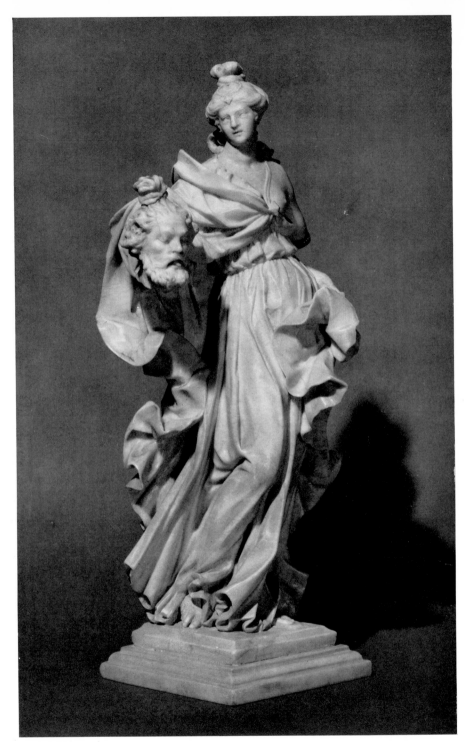

Judith with the Head of Holofernes, Würzburg (?), c. 1740–50, three-quarter view
(Cat. no. 80)

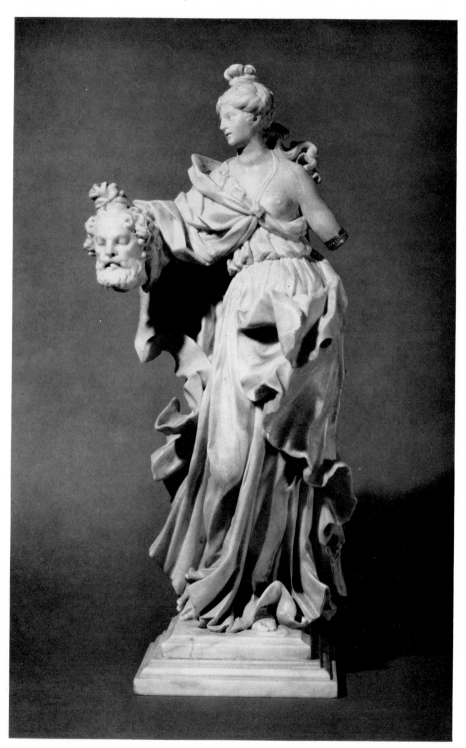

Judith with the Head of Holofernes, front view
(Cat. no. 80)

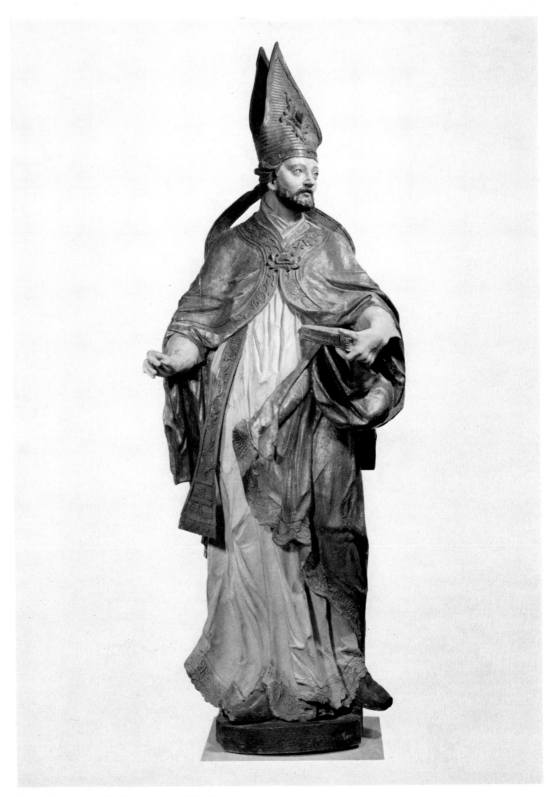

Saint Ambrose (?), Austrian, c. 1725–50
(Cat. no. 81)

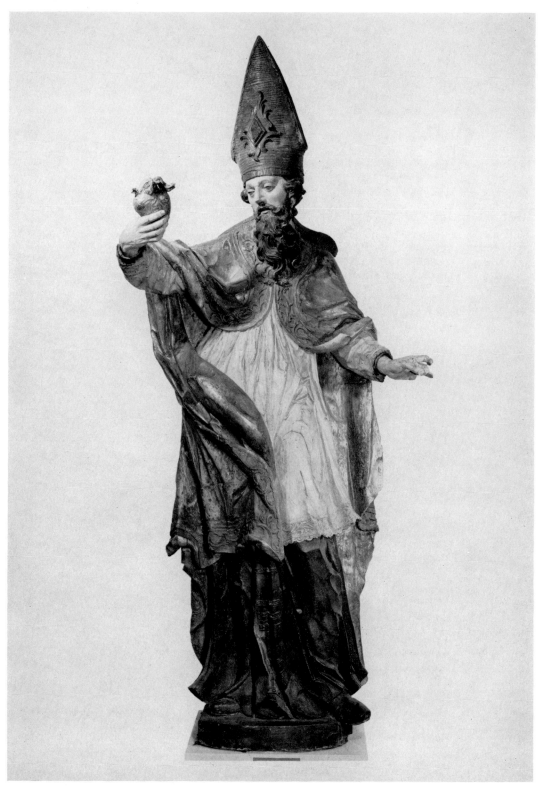

Saint Augustine, Austrian, c. 1725–50
(Cat. no. 82)

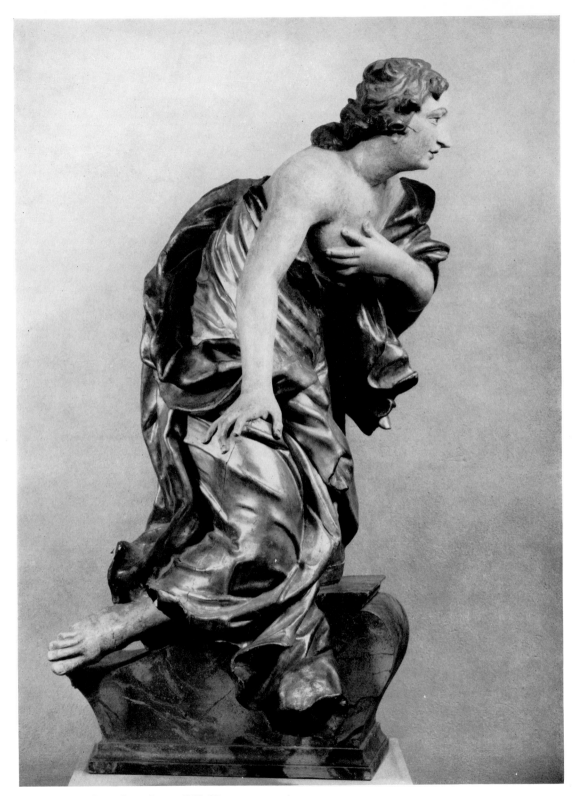

Angel Annunciate, Austrian, c. 1700–25
(Cat. no. 74)

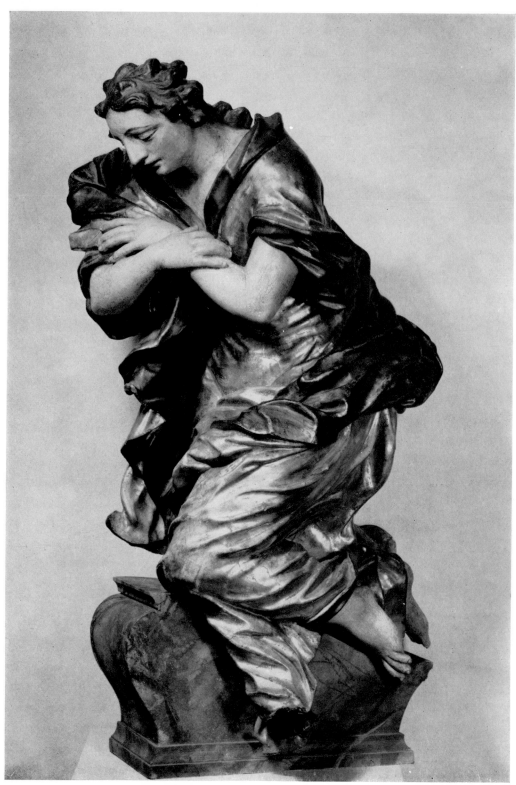

Virgin Annunciate, Austrian, c. 1700–25
(Cat. no. 75)

Head of an Angel, Bavarian, c. 1760
(Cat. no. 85)

Pair of Hovering Angels, Bavarian, c. 1750–60
(Cat. nos. 83–84)

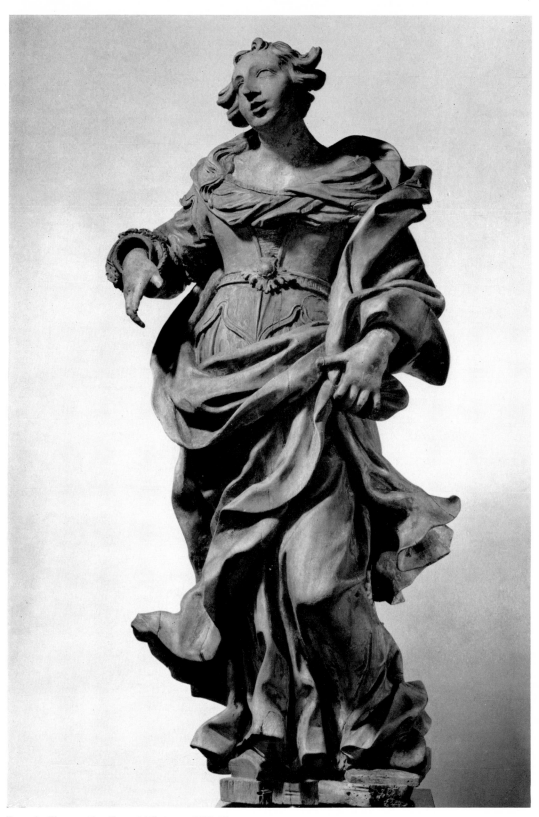

Female Figure, Ferdinand Dietz, c. 1755–65
(Cat. no. 87)

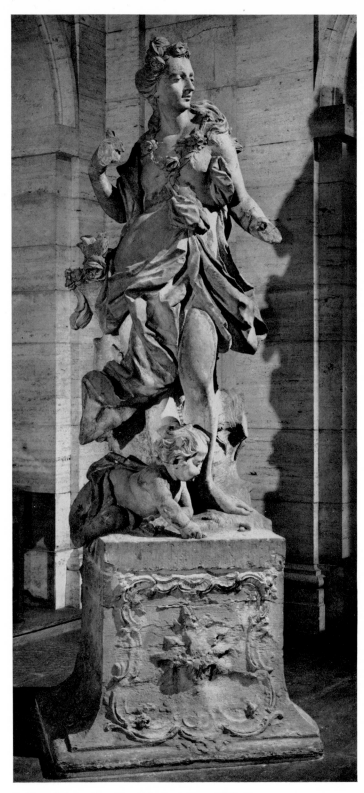

Spring, Johann Joachim Günther (?), c. 1760–65
(Cat. no. 88)

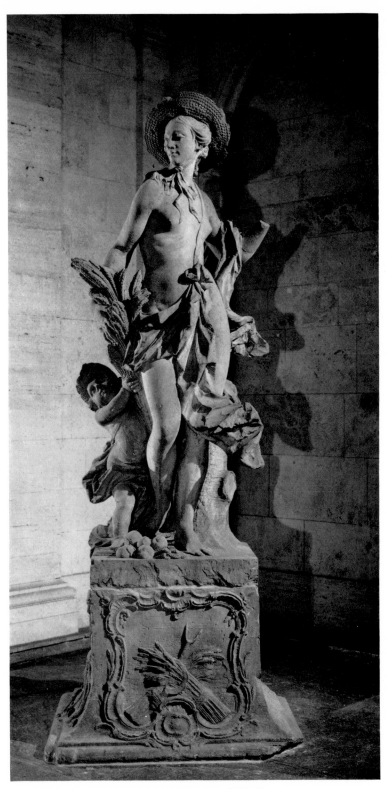

Summer, Johann Joachim Günther (?), c. 1760–65
(Cat. no. 89)

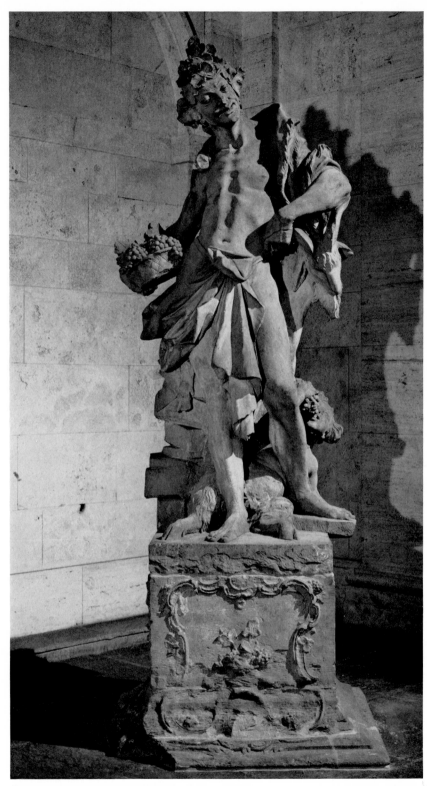

Autumn, Johann Joachim Günther (?), c. 1760–65
(Cat. no. 90)

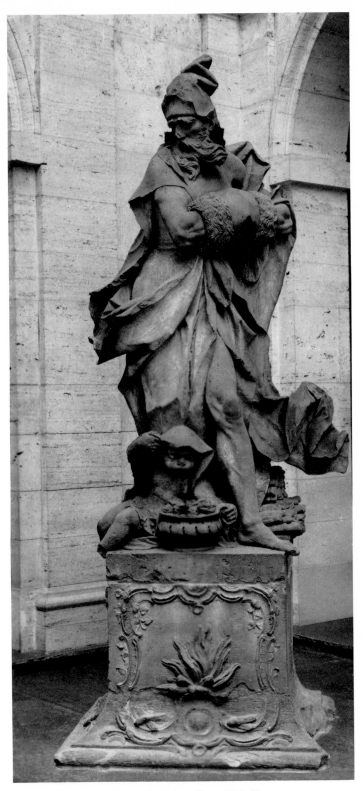

Winter, Johann Joachim Günther (?), c. 1760–65
(Cat. no. 91)

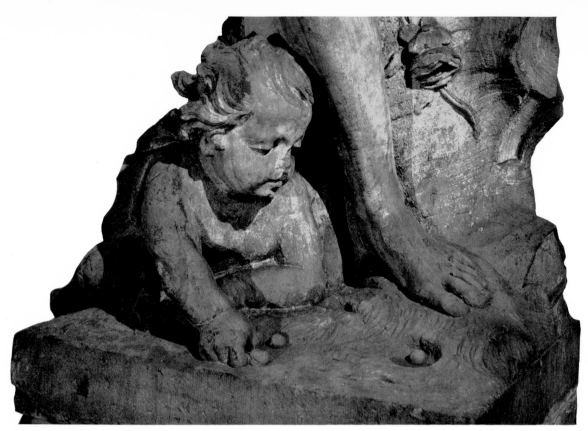

Spring, detail
(Cat. no. 88), Plate LXXVIII

Winter, detail
(Cat. no. 91), Plate LXXXI

Summer, detail
(Cat. no. 89), Plate LXXIX

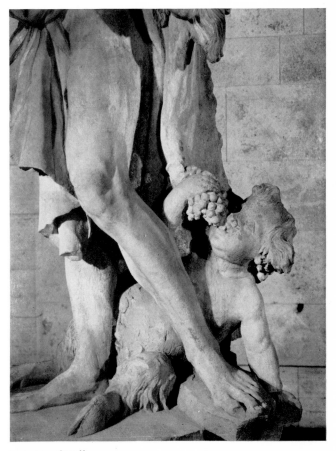

Autumn, detail
(Cat. no. 90), Plate LXXX

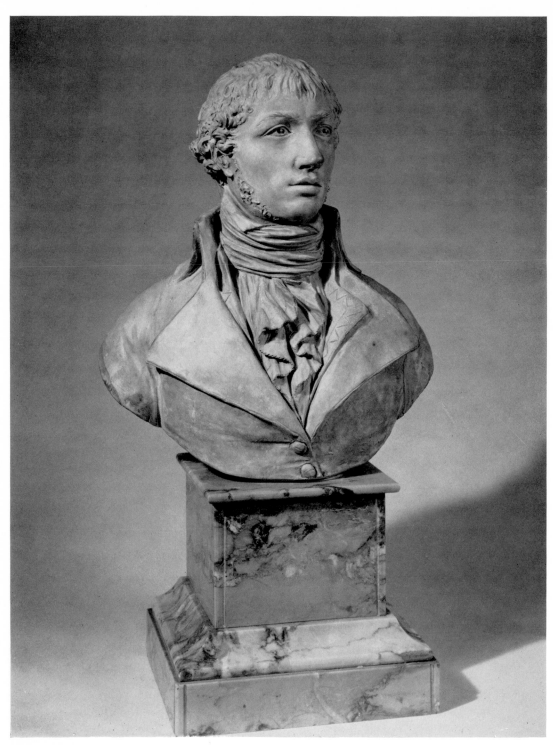

Bust of a Man, Johann Gottfried Schadow (?), 1797
(Cat. no. 92)

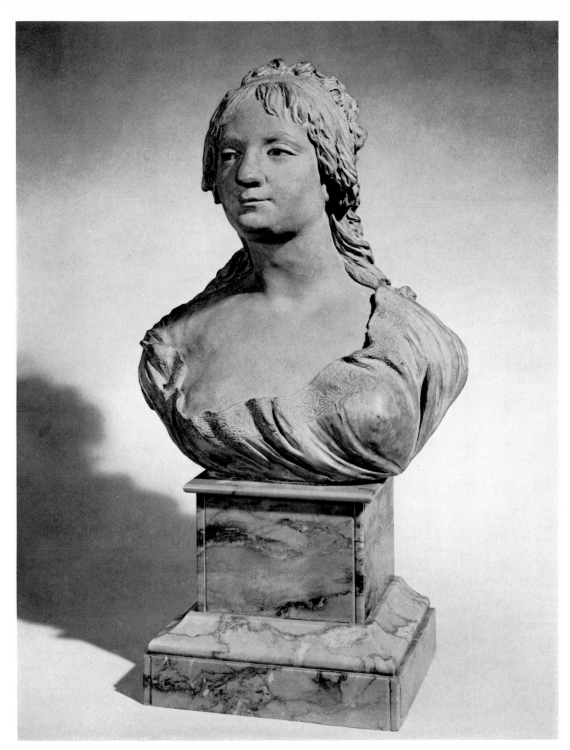

Bust of a Woman, Johann Gottfried Schadow (?), 1797
(Cat. no. 93)